LIBRARY OF ART

PUBLISHER - DIRECTOR: GEORGE RAYAS

BYZANTINE ART IN GREECE

MOSAICS~ WALL PAINTINGS

General Editor

MANOLIS CHATZIDAKIS
Member of the Academy of Athens

"MELISSA" Publishing House

Translation: HELEN ZIGADA

Editorial Supervisor: LAMBRINI VAYENA-PAPAIOANNOY, philologist

Design: RACHEL MISDRACHI-CAPON

Colour Photographs: VELIS VOUTSAS

Plans: YOTA ZACHOPOULOU, architect

KASTORIA

† STYLIANOS PELEKANIDIS
Late Professor of Byzantine Archaeology in the University of Thessaloniki

MANOLIS CHATZIDAKIS
Member of the Academy of Athens
Former Director of the Byzantine Museum
and of the Benaki Museum, Athens

CONTENTS

PREFATORY NOTE

The sudden and untimely death of the author and dear colleague Professor Stylianos Pelekanidis (in 1980) left no time for discussing with him the possibility of adding to the initial text some useful supplementary information and of mentioning certain diverse opinions on controversial matters, which would update the material presented to the reader. In this exceptional case, therefore, it has been considered expedient to add a Supplementary Note for each church, making use of the latest international bibliography (of works published after 1979, the date when the initial text was written). The responsibility for these Supplementary Notes lies with the general editor of the work. The addition of a text on the church of Hagios Athanasios, which is storied with remarkable wall paintings, completes this presentation of the Byzantine churches of Kastoria.

It has been also considered indispensable for this publication to include plans indicating the positions of the representations in each of the churches, in a most concise and clear manner, i.e. in vertical perspective view with an identifying number for each representation. In this respect the reader should have in mind the following points that would facilitate reading of the plans:

a) Each part of the church (nave, aisles, narthex) has been drawn as an independent unit. In this way a wall common to two parts is repeated to permit identification on either side.

b) To facilitate orientation with respect to both the position and the direction of the representations, the reader must visualize himself every time as standing in front of the particular wall he wishes to examine, as if he were actually standing in this area of the church.

c) An effort has been made to number the representations in accordance with the sequence of the iconographic programme, starting from the holy bema. To distinguish wall paintings of different chronologies, a different system of numerals has been used for each layer, i.e. Greek and Arabic symbols.

The perspective plans of the churches showing the position of the wall paintings have been drawn conscientiously and with great skill by the architect Mrs. Yota Zachopoulou in collaboration with the archaeologist Miss Yanna Bitha. However, responsibility for the identification of the representations lies with the writer of this note. Most of the colour photographs were taken by V. Voutsas. Black and white photographs were prepared from negatives which the late Pelekanidis had used in his album. These were readily made available for this publication.

With regard to the rendering of colours in the photographs, it should be noted that the wall paintings of Kastoria have never been cleaned in a systematic way. Their true colours can be appraised only in some cleaned parts of certain churches (Fig. 12, p. 33, Fig. 19, p. 37), where photography has mainly insisted. In a few pictures (Fig. 6, p. 29) the reader can clearly appreciate the difference between the two states of these wall paintings.

M. CH.

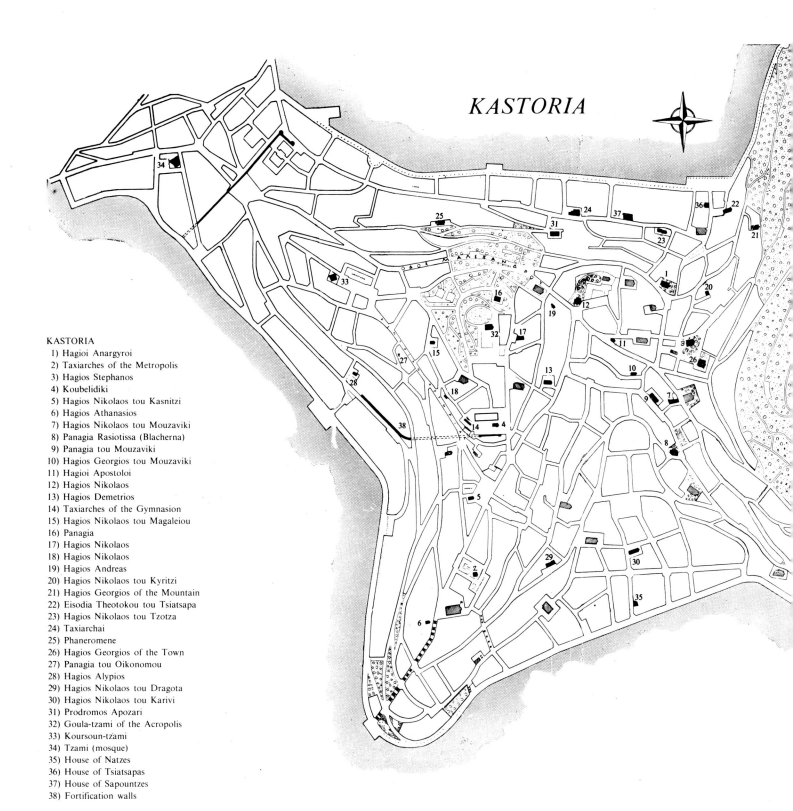

KASTORIA

KASTORIA

1) Hagioi Anargyroi
2) Taxiarches of the Metropolis
3) Hagios Stephanos
4) Koubelidiki
5) Hagios Nikolaos tou Kasnitzi
6) Hagios Athanasios
7) Hagios Nikolaos tou Mouzaviki
8) Panagia Rasiotissa (Blacherna)
9) Panagia tou Mouzaviki
10) Hagios Georgios tou Mouzaviki
11) Hagioi Apostoloi
12) Hagios Nikolaos
13) Hagios Demetrios
14) Taxiarches of the Gymnasion
15) Hagios Nikolaos tou Magaleiou
16) Panagia
17) Hagios Nikolaos
18) Hagios Nikolaos
19) Hagios Andreas
20) Hagios Nikolaos tou Kyritzi
21) Hagios Georgios of the Mountain
22) Eisodia Theotokou tou Tsiatsapa
23) Hagios Nikolaos tou Tzotza
24) Taxiarchai
25) Phaneromene
26) Hagios Georgios of the Town
27) Panagia tou Oikonomou
28) Hagios Alypios
29) Hagios Nikolaos tou Dragota
30) Hagios Nikolaos tou Karivi
31) Prodromos Apozari
32) Goula-tzami of the Acropolis
33) Koursoun-tzami
34) Tzami (mosque)
35) House of Natzes
36) House of Tsiatsapas
37) House of Sapountzes
38) Fortification walls

Map of Kastoria with its churches (after A. Orlandos)

KASTORIA AND ITS BYZANTINE MONUMENTS

Kastoria, one of the most notable towns in Northern Greece for its Byzantine and post–Byzantine monuments and for its old mansions (*archontika*), is built on a peninsula reaching into the lake of the same name. A narrow isthmus –mentioned as *aulon* in the writings of Anna Comnene– joins the land with the peninsula which widens towards the south and ends in a low stony mountain.

Kastoria has many monuments. The most ancient and important, dating from the Byzantine era, are the churches of Hagios Stephanos, of Hagioi Anargyroi tou Lemnioti, of Hagios Nikolaos tou Kasnitzi, of the Panagia Mavriotissa, of the Panagia Koubelidiki or Kastriotissa, of the Taxiarches of the Metropolis, of Hagios Athanasios tou Mouzaki and some other smaller ones.

These churches are of three types: a) three-aisled basilicas; two of these, Hagios Stephanos and Hagioi Anargyroi, have an interior division into three aisles; b) single–naved churches, such as those of Hagios Nikolaos tou Kasnitzi, of the Panagia Mavriotissa and of Hagios Athanasios; and c) triconchial churches, like the Panagia Koubelidiki. The main feature of the three-aisled basilicas is that the middle aisle is made prominent by the extraordinary height of the clerestory, which has single windows and a few double ones. This form of clerestory in combination with the short length of the basilicas creates the impression of a rectangular dome– or vault–like construction. The masonry is isodomic and rather irregular. Stones are used either undressed or with rounded corners, and are set with thick mortar of powdered brick (*kourasani*). Smaller stones are often supplemented with bricks placed horizontally or vertically, depending on the shape of the stone. The dominant method of construction consists of horizontal courses of stone separated from one another by two or more layers of bricks. To embellish the whole and lend it a picturesque quality bricks are placed between the stones of the horizontal courses, in various patterns which serve no purpose other than a decorative one. This masonry technique produces an even more colourful effect by employing stones of different hues, an abundance of mortar, bricks with slight variations in colour due to different firing, and a profusion of brick ornaments. The brickwork is used either independently in various parts of the building or in a variety of combinations decorating the tympana of blind arches (Fig. 3, p. 25, Fig. 3, p. 53). A special feature in the decoration of wall surfaces is the use of tiles. Rectangular, square or triangular, quite often with intercrossing diagonal incisions, they either form a frieze along the upper termination of walls, just below the roof, or encircle at various heights the main body of the monument and the domes. Many of these tiles have a coloured glazing. Toothed bands are another common decorative element of all the older churches of Kastoria. Their presence today only in certain parts of some monuments and their total absence from other monuments are due to later repairs. These bands decorate the buildings as finials or cornices, articulate the height of walls, frame the arches or all the windows and the ornamental blind arcading. Another characteristic feature is the use of decorative blind arches on the exterior of churches – except for the eastern side. Walls with one or more consecutive blind arches acquire a lighter appearance and are enlivened by the rich brickwork and by the portraits of apostles, saints, donors and dignitaries often painted on the surfaces of the blind arches.

HAGIOS STEPHANOS

The church of Hagios Stephanos (Fig. 2) stands on a low hill at the NE side of Kastoria, surrounded by old traditional houses which are slowly disappearing to be replaced by graceless modern apartment buildings. The two surviving painted inscriptions do not provide any concrete information on the history and dating of the monument.

The lack of historical evidence has led those who have studied the church and its wall paintings to different conclusions and chronologies. A. Orlandos, who was the first to study methodically the Byzantine monuments of Kastoria, was concerned neither with the dating of the church nor with the wall paintings of the first layer. Later investigations suggested that the church and the earlier wall paintings are datable in the mid-9th century, the wall paintings of the second layer in the late 12th and the 13th century, and a number of other wall paintings in various parts of the church in the 14th century.

Architecture

The church is a basilica of "Anatolian" type. It is divided into three aisles by walls pierced with two symmetrical openings giving access to the central aisle. This terminates to the east into an apse, semi-hexagonal in the exterior and semicircular in the interior, which has preserved a rudimentary *synthronon* with a bishop's throne at the centre. The narthex extends along the entire width of the western side. Three arched doors, one central and two lateral, lead from the narthex into the church proper. A narrow staircase gives access to the upper gallery above the narthex. The south part of the gallery is modelled as a small-sized chapel, the so-called *asketario*. The aisles and the narthex are covered with barrel-vaults and the upper gallery with a vault of quadrant section (Fig. 3).

The monument is well preserved. However, the addition –some fifty years ago– of a crudely built portico along the north and west sides has spoiled the harmony of proportions and has given the whole building a heavy appearance.

Painting

The architectural articulation of the building has limited the wall space available for the storying of the church. Two layers of wall paintings have survived in considerably damaged condition and very few representations of later date have covered the earlier ones in the lower parts of the walls.

First layer. The first layer of paintings is most probably preserved in the narthex, in extensive parts of the naos walls up to the level of the clerestory and in certain parts of the women's gallery. Of these paintings many have flaked off, some have been washed out and others have been covered by later wall paintings, mainly of the 13th and 14th century. In the nave and especially on the soffit of the lateral arches, as well as in the aisles, only figures of saints have survived so that it is now difficult to define the iconographic programme of the first layer. Two painters, A and B, worked simultaneously but independently of each other on this layer.

Painter A. The great composition of the Last Judgement covers the entire length of the barrel-vault spanning the narthex and extends to the walls of the narthex and the lateral walls of the stairway to the upper gallery (Fig. 4, 6, 7, Plan nos. 51-58). A polychrome zigzag band painted along the key of the vault divides the whole composition into two parts. On the east side are depicted enthroned apostles holding open books, and between them archangels and angels with sceptres in their right hand. On the west side the representation shows Christ among the Apostles. Above the figure of Christ, the vault of heaven is depicted as a half-circle with an inscription from the

Apocalypse of St. John the Divine reading "the heaven was rolled as a scroll". On the narrow surface of the north side little angels push the sinners to hell, on the north wall another angel carries the scales of justice, and next are depicted a few more scenes from the Last Judgement (Fig. 4, 7 and Plan nos. 55-58).

The lay-out of this extensive composition, which is one of the earliest known to this day in Christian iconography, reflects a marked decorative tendency. The symmetrical juxtaposition of the apostles and angels, the geometric motifs and pearls of the richly ornamented thrones, the three-lobed terminations of the angels' wings, the inscribed square tops of the angels' sceptres, the accompanying inscriptions and the semicircular designs that fill the vacant spaces of the black ground, all enhance the decorative character of the work. Thus, the barrel-vault is occupied by a strictly organized composition with a profuse and varied decoration which covers the entire surface.

The figures of the apostles and angels, rendered in regular proportions, are balanced, serene and humane. Scenes requiring movement, like that of the angel with the sinners or of the angel with the scales of justice or again of the giant surrounded by flames (Fig. 7, left), display both moderation and measure*.

It is difficult to establish a direct stylistic relation between the wall paintings of the first layer as a whole and other wall paintings. However, in certain parts, this mural decoration reveals a striking similarity with wall paintings of other securely dated monuments. In almost all the figures, the oval faces are treated in the same manner. The big eyes accented by thick eyebrows and large black irises, the wide area of the eye, the relatively thick nose, the small mouth, the projecting ears, are features encountered in the archaic wall paintings of Cappadocia. The facial treatment points chronologically to the 9th century and is matched by the figures' attire, which is transformed into a decorative element. In this way the effect of plasticity is neutralized and the natural structure of the body disappears under the garments. This tendency also is not foreign to the 9th century, both in monumental paintings and in certain groups of illuminated manuscripts, which were produced either in the Hellenizing Rome of the 8th and 9th century or by the artistic circles of Constantinople, and form the connecting links between works of the early and the middle Byzantine periods. The scenes of the Last Judgement and many of the figures of saints are closely related to these manuscripts, and particularly to the Paris Codex 923.

* The poor state of preservation of the wall paintings has revealed the technique used in the treatment of figures.

The first layer applied to the wall consists of a cream-coloured slip. On this are drawn the outlines of figures and particularly of faces, which are framed by schematic black hair. Vertical, horizontal or diagonal black lines or dots mark the position of the eyes, nose, chin and in general of all the parts and details of the face, which was painted last, after completion of the garments to the last detail. Over the smooth surface, following his guide-marks, the painter elaborated on the face using an underpaint of ochre and applying to it the colourings and highlights, which appear to have been worked *in seco*. This is the main reason why in many of the wall paintings the coloured parts have scaled or fallen off whereas the vivid outlines have been preserved, as for example in the representation of Mary the Egyptian, of the angel pushing the sinners in the composition of the Last Judgement etc. (Fig. 4, 5, 6).

Apart from this peeling of the paint, closer observation has revealed that the faces of some angels on the south side of the barrel-vault of the narthex and the face of Christ the Righteous Judge over the west entrance to the church are either completely unworked or left unfinished, whereas the rest of the figure is painted in detail. The rare instances of half-worked faces make possible the study of the preliminary stage of the painting. The outlines and guide-marks had been drawn with a free hand, without the use of drawing instruments, in circles or ovals either upright or somewhat aslant depending on the position of the face. The axis of the face, deviating from the centre of the circle or of the ellipse when the figure was inclined, had been drawn with ochre and a ruler. This incomplete work gives rise to the obvious question whether an unexpected event, such as an enemy raid or occupation of the town, had prevented the completion or continuation of the wall paintings in the church.

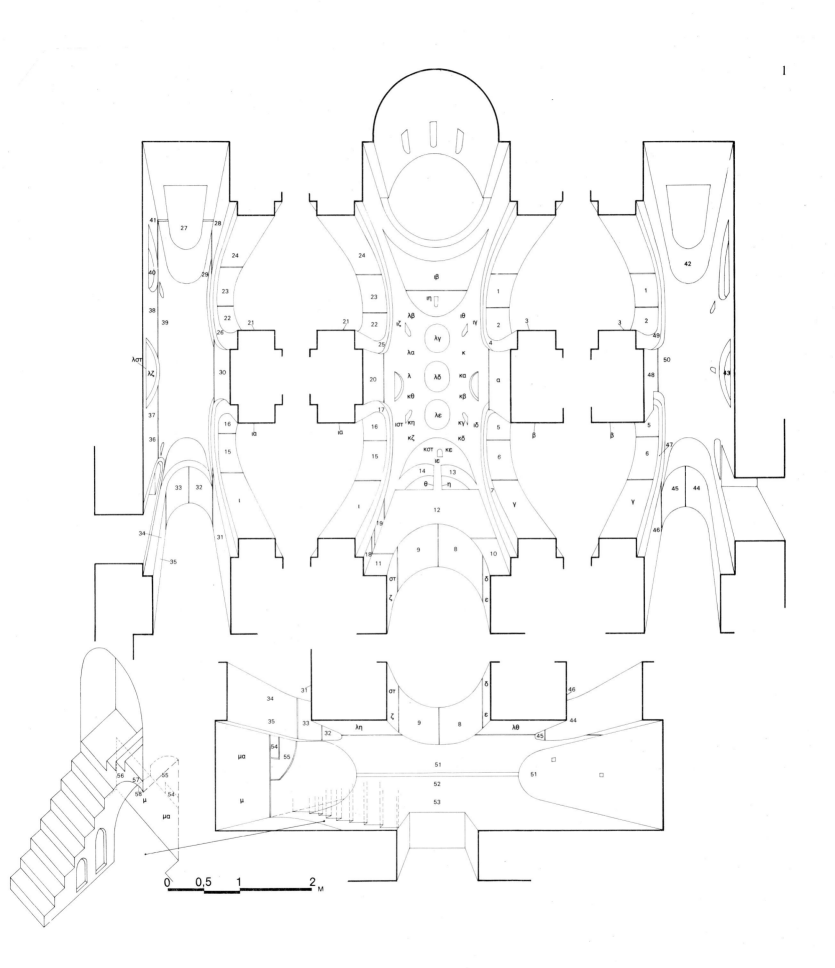

0 0,5 1 2 M

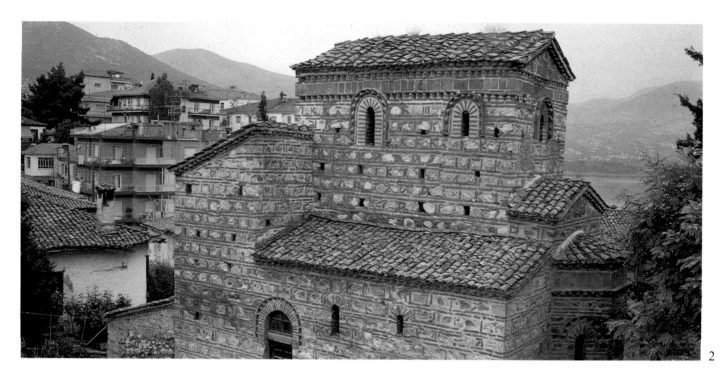

HAGIOS STEPHANOS

First layer. 1. *Saint.* **2.** *Saint.* **3.** *Deacon.* **4.** *Decorative foliage.* **5.** *Saint.* **6.** *Saint.* **7.** *Saints in roundels.* **8.** *St. ... manetos (?).* **9.** *St. Christophoros.* **10.** *Stylite saint.* **11.** *Elderly saint.* **12.** *The Crucifixion.* **13.** *Three figures.* **14.** *Two figures.* **15.** *Warrior saint.* **16.** *Saint.* **17.** *Saints in roundels.* **18.** *Saint.* **19.** *Stylite saint.* **20.** *St. Nicholas.* **21.** *St. Stephanos (?).* **22.** *St. Panteleimon.* **23.** *Saint.* **24.** *Saint.* **25.** *Foliage decoration.* **26.** *Saints in roundels.* **27.** *Hierarch.* **28.** *Saint.* **29.** *Traces of a saint.* **30.** *Saint.* **31.** *St. Demetrios.* **32.** *Woman saint.* **33.** *St. Theodora.* **34.** *St. Zosimas.* **35.** *St. Mary the Egyptian.* **36.** *Saint.* **37.** *Saint.* **38.** *Traces of a saint.* **39.** *Traces of a saint.* **40.** *Evangelist enthroned.* **41.** *Traces of a saint.* **42.** *Traces of a saint.* **43.** *Christ blessing two saints.* **44.** *Holy monk.* **45.** *Saint.* **46.** *St. George on horseback.* **47.** *Saints in roundels.* **48.** *Full-length figure of warrior saint.* **49.** *Saints in roundels.* **50.** *Traces of a saint.* **Narthex. 51.** *The Last Judgement, the Apostles Mark and Bartholomew on the south wall.* **52.** *The Last Judgement, Apostles.* **53.** *The Last Judgement, Eve (?).* **54.** *Saint.* **55.** *The Last Judgement, angel with the scales of justice.* **56.** *The Last Judgement, angel and three sinners.* **57.** *The Last Judgement, giant Hades in flames.* **58.** *The Last Judgement, angel and souls of the dead.* **Later layers. a.** *Christ.* **β.** *St. Stephanos,* **γ.** *St. Procopios.* **δ.** *St. Cosmas.* **ε.** *St. Damian.* **στ.** *St. Constantine.* **ζ.** *St. Helen.* **η.** *St. Anne nursing the Virgin.* **θ.** *St. Anne.* **ι.** *St. George.* **ια.** *St. Nicholas.* **ιβ.** *The Annunciation.* **ιγ.** *The Nativity.* **ιδ.** *The Presentation in the Temple.* **ιε.** *The Raising of Lazarus.* **ιστ.** *The Entry into Jerusalem.* **ιζ.** *The Resurrection.* **ιη.** *The Transfiguration.* **ιθ.** *The Prophet David.* **κ.** *The Prophet Habakkuk.* **κα.** *The Prophet Solomon.* **κβ.** *The Prophet Nahum.* **κγ.** *The Prophet Sophonias.* **κδ.** *The Prophet Ezekiel.* **κε.** *The Prophet Aaron.* **κστ.** *The Prophet Zechariah.* **κζ.** *The Prophet Moses.* **κη.** *The Prophet Joel.* **κθ.** *Prophet.* **λ.** *Prophet.* **λα.** *The Prophet Daniel.* **λβ.** *Prophet.* **λγ.** *Christ Emmanuel.* **λδ.** *The Ancient of Days.* **λε.** *The Pantokrator.* **λστ.** *Donor's inscription.* **λζ.** *The Virgin Gorgoepekoos.* **λη.** *The Virgin enthroned with donor.* **λθ.** *The Baptism.* **μ.** *Theodoros Lemniotes.* **μα.** *St. Stephanos.*

1. *Hagios Stephanos. Perspective plan.*

2. *Hagios Stephanos. View from the SE.*

3. *Hagios Stephanos. Section.*

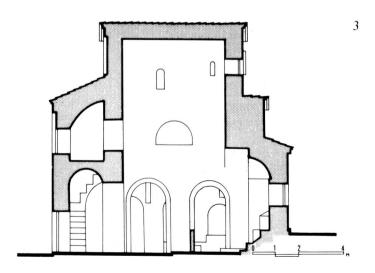

Painter B. This painter has used a different palette and style, but he shares with painter A many common decorative and technical elements.

The bodies of figures retain their plasticity, in spite of the marked linear treatment of draperies, and remain close to the style of the early period of the Macedonian painting, in which several stylistic tendencies had co-existed. A fine example of this trend has survived on the NE arch of the basilica. Two unidentified saints have been portrayed opposite each other, on the soffit of the arch. The body of the one saint is rendered with plasticity, and the garment covers it in a manner underlining the corporality of the whole figure. The same tendency is observed in the treatment of the face, the hair and the beard, so that the figure, both as a whole and in parts, shows

affinities with the illuminated manuscripts, mosaics and wall paintings of the 9th century both in Byzantium and the West. The second saint illustrates an attempt to eliminate matter. The shape of the body vanishes under the *himation* with the schematic folds, the plasticity of the face disappears, the curly hair frames the head (Fig. 5), exactly as in the figures of painter A and in those of the early wall paintings of Cappadocia.

Quite independently of the above observations, pragmatic evidence also strongly suggests that the wall paintings by painter B, like those by painter A, should be dated in the mid-9th century.

Second layer. Paintings of the second layer have survived on the high clerestory and figures of Christ the Eleimon (Merciful) and of saints on the piers

4. Hagios Stephanos. The angel "flaming sword", under the staircase of the narthex (cf. Fig. 7).

5. Hagios Stephanos. St. Panteleimon.

6. Hagios Stephanos, narthex, facing S. Barrel-vault

with the composition of the Last Judgement.

7. Hagios Stephanos, narthex, facing N. Above left, St. Christophoros (first layer). Below, the Virgin and the Sts. Constantine and Helen (second layer).

4

5

formed between the arched openings giving access from the nave to the women's gallery. Their state of preservation is generally good. (Fig. 7 right, 8, Plan nos. δ, ε, στ, ζ).

The organized iconographic programme is composed of only a few scenes from the Twelve Feasts cycle –the Annunciation on the east wall, the Nativity and the Presentation in the Temple on the south wall, the Transfiguration on the west wall, the Entry into Jerusalem and the Descent into Hell on the north wall (Fig. 9, 12, 13, Plan nos. ιβ, ιγ, ιδ, ιη). For special reasons of functionality, the Baptism is depicted in the narthex (Fig. 14, 15, Plan no. λθ). Along the axis of the barrel–vault spanning the central aisle, Christ has been represented in three roundels as Emmanuel (Fig. 18, Plan no. λγ), as Pantokrator and as the Ancient of Days (Fig. 19, Plan no. λδ). The piers are painted with saints, either single or in pairs, and with a full-length representation of Christ the Merciful and Compassionate, dedicated by the "servant of God Constantine and his wife Anna" (Fig. 8, Plan no. α). Finally, two dedicatory portraits have been preserved, one under the staircase on the north side of the narthex, the other on a blind arch in the north wall of the naos. The first portrays the priest Theodoros Lemniotes offering with a slight bow a model of the church to St. Stephanos (Fig. 16, Plan no. μ). The other, dated in 1338 and painted over, shows the "least of suppliants, Georgios" in *proskynesis* (prostration) before the Virgin Gorgoepekoos.

The lack of homogeneity noted in the technique and style of the wall paintings presents many problems, particularly in connection with their dating. Nevertheless, two groups can be distinguished:

a) The group composed of the Sts. Cosmas and Damian (Fig. 17, Plan no. δ, ε), St. Demetrios and St. Nicholas (Fig. 20, Plan no. ι, ια). A fine contour delineates the faces, which are painted in subdued tones and display a somewhat flowing treatment of the whole. The cheek-bones are accentuated either by brush strokes of red colour forming successive curves or by small circular patches of the same colour. Although more than one artists have worked here, each according to his own expressive means, the rendering of eyes, nose, mouth, ears, follows the same

general lines with only slight variations. Differences are noted in the way the hair is dressed, but the technique is again similar. All technical and stylistic features strongly suggest a dating of the few wall paintings of this group in the second half of the 12th century.

b) The second group comprises the scenes from the cycle of the Twelve Feasts, the representations of Christ in his three ages, of Christ the Merciful etc.

The extensive scenes are noted for the well-planned organization and the appropriate position of figures in the setting, so as to avoid a disruption of the iconographic unity and accomplish a well balanced composition. The faces have been rendered with plasticity and a fairly sophisticated elegance of line, which makes them rather cold and lifeless and gives the impression that they do not participate in the happenings. The facial types do not vary, except in rare instances, as for example in the Ancient of Days, the elderly magus (Fig. 10, 19) and the young shepherd of the Nativity, and even then they conform with the general trend.

The painter's effort to enliven the compositions and figures with the use of polychromy and colour contrasts does not succeed in eliminating the academic dryness of his work. Despite these peculiarities, which lower the artistic standard of this painter's work, the modelling of the hair in its different variations, the almond-shaped eyes and the details with which they are worked, the straight nose, the thin-lipped mouth, the shape of the beard, the softness of the garments and the naturalistic fall of the draperies, through which the articulation of the body is often discernible, place these wall paintings of the second layer in the second half of the 13th century.

Bibliography

A. Orlandos, «Τά βυζαντινά μνημεῖα τῆς Καστοριᾶς», ʾΑρχεῖον Βυζαντινῶν Μνημείων ʿΕλλάδος, vol. Δ´, 1938, p. 107-124.
S. Pelekanidis, Καστοριά. Βυζαντιναί τοιχογραφίαι, Thessaloniki 1953; pl. 87-101.
S. Pelekanidis, "I più antichi affreschi di Kastoria", *Corsi di cultura sull' arte Ravennate e Bizantina*, Ραβέννα 1964, p. 351 ff.
Id., "Kastoria", *Reallexikon zur byzantinischen Kunst*, I. 1190 ff.

S.P.

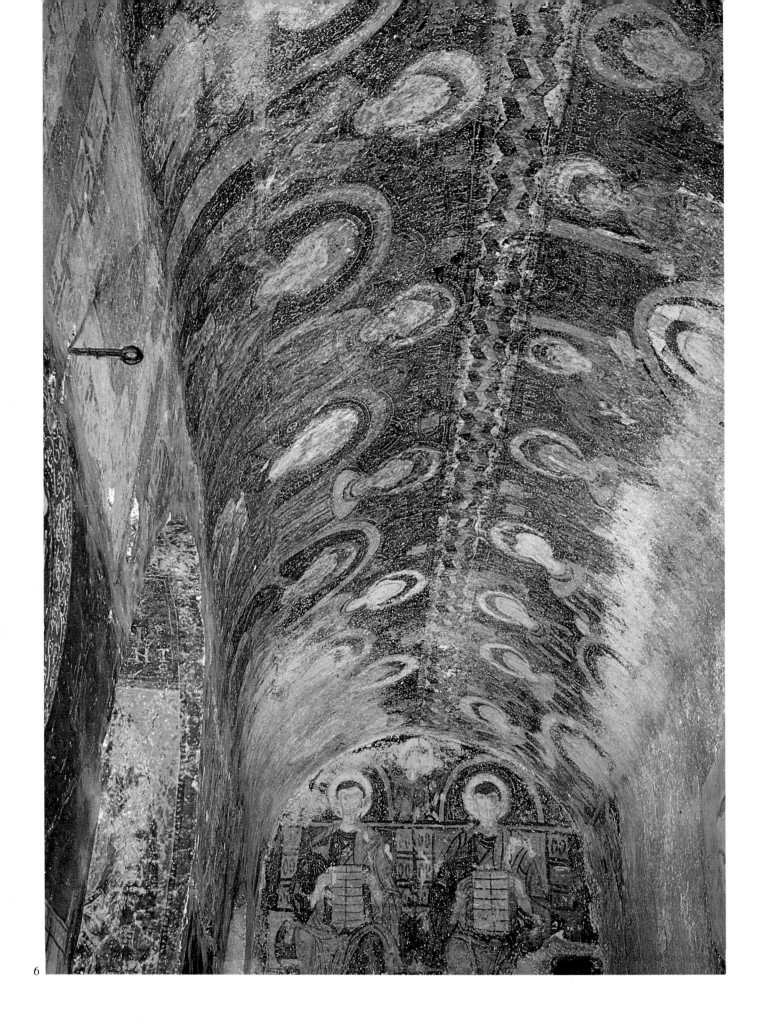

6

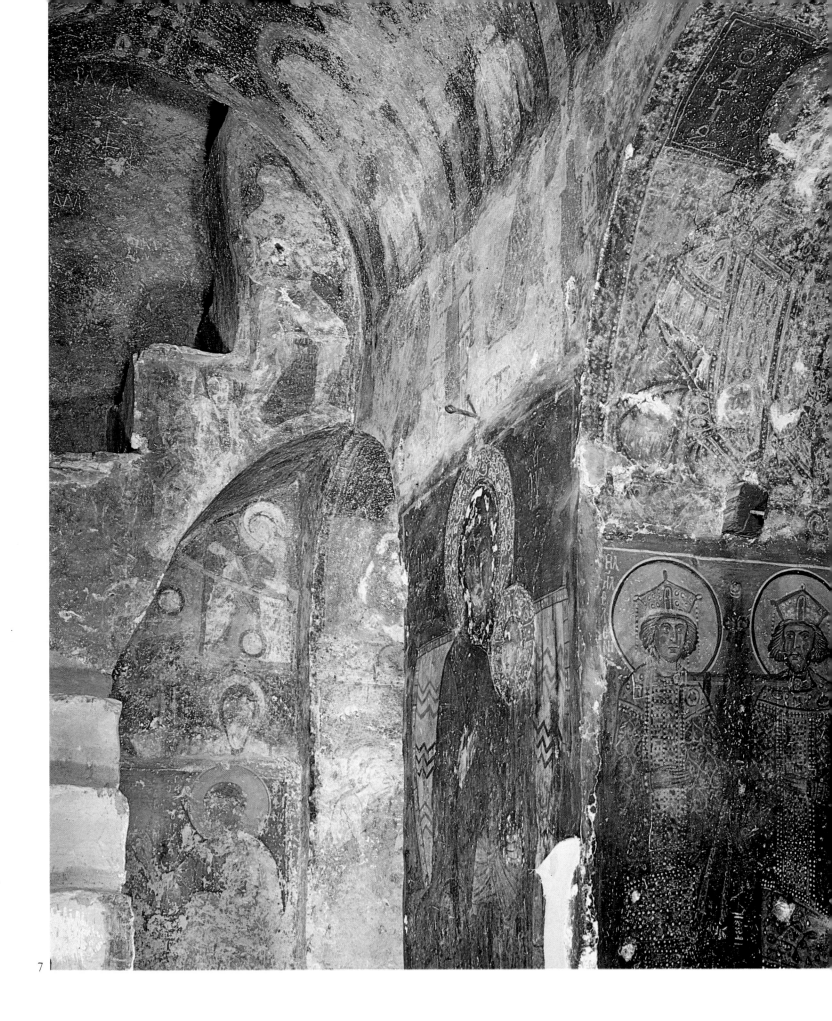

HAGIOS STEPHANOS
Supplementary Note

Architecture

When compared with the other basilicas of Kastoria, and especially with the Hagioi Anargyroi which is the closest to it typologically, the church of Hagios Stephanos presents certain peculiarities: 1) the interior structure is more complex, as the church has the lateral walls articulated with blind arches, an upper gallery for women (*gynaeceum*), unique among the Byzantine churches of Kastoria, and, within this, a separate chapel dedicated to St. Anne (*asketario*); 2) in the exterior the walls are without blind arches, unlike those of the other churches; 3) the plan of construction is more geometrical with almost right angles and a symmetrical division of the aisles; and 4) the three-sided apse belongs to a stage of technique more advanced than the locally prevalent semicircular form used in the Hagioi Anargyroi and in the Taxiarches of the Metropolis (Hagioi Anargyroi Fig. 3, and Taxiarches Fig. 3). These features, most of which had originated in Greek territory (the Panagia of Hosios Loukas), account for the somewhat peculiar physiognomy of the church. The presence in the sanctuary of a fairly massive episcopal throne of masonry, set up on the axis of the building and surrounded by a low *synthronon* (bench for the clergy) unique in Kastoria, suggests that the church was the Bishop's seat. The low, built templon (Fig. 3) must be the original one, as is evident from the surviving traces of the painting decoration. In fact, the liturgical use of the Bishop's throne required a templon of this type. In Byzantine and post-Byzantine Kastoria, therefore, one of the largest central churches has preserved undisturbed to this day the sanctuary's original arrangement which is of archaic form.

Painting

First layer. It has been ascertained that in the nave and the narthex at ground-floor level and in the women's gallery the greater part of the original painting decoration has been preserved uncovered, though in very modest condition. Only a few parts –especially in the area giving access from the narthex to the naos– have been covered sporadically by some later wall paintings executed at random rather than as dedicatory paintings of same date (in any event, only these have preserved a number of inscriptions). It is more than likely that the original mural decoration had been already in this almost uniform stage of decay, when the first dedicatory wall paintings were added. The preservation of this antique character in the ground-floor areas of the church seems to have been planned. This impression is enhanced by the fact that the second layer of scenes from the cycle of the Twelve Feasts, painted on the walls of the higher middle vault (of the clerestory), no doubt over the already damaged original wall paintings, stopped at the exact limit between clerestory and naos, even though most of the representations below this line would have been barely discernible by that time. Pelekanidis has described the present state of the original wall paintings with precision but without detailed differentiation. We shall add here some further observations that have been considered useful.

First, we would draw attention to two rather technical points, which are nevertheless helpful in assigning a chronology to these wall paintings and in classing them to a certain category. The saints' haloes, as a rule small, have a grey ground and a thick reddish contour. Several saintly figures, however, such as the full-length St. Stephanos, in the women's gallery, the apostles in the composition of the Last Judgement etc., have a larger halo with an additional grey outline adorned by double rows of pearls with red gems at intervals (Fig. 6, 7). It would be worth remembering that similar haloes occur in the first layer of wall paintings in the Taxiarches (Fig. 8) and that it has been suggested (by Mango) that the painting of such haloes was discontinued after the 9th century. We also note that the larger icons of saints are framed by a similar grey border adorned with a single row of white pearls and that the ornamental bands, which are quite lavishly decorated, have the same border. Finally, another technical detail is that the brick-reddish background stops invariably at the height of the

shoulders and from there upwards it is painted black (Fig. 5, 7 – St. Christophoros).

Though the state of preservation of the first layer ranges from medium to bad, we can visualize on the basis of some better-preserved examples their original aspect, as in the case of at least two of the apostles in the composition of the Last Judgement, notably Mark and Bartholomew, on the south tympanum of the narthex (Fig. 6, below). Their garments and thrones have remained almost intact but the paint of the faces has peeled. Both are dressed in a deep-green *chiton* (tunic) with dark schematic folds outlined by dense white brush strokes. The heavy *himation* (cloak) of light brick colour shows a similar disrupted arrangement of folds, which form geometrical patterns defined by black and white lines. The back of the throne would be covered by a dark-coloured fabric with white ornaments. The representation of St. Christophoros on the soffit of an arch in the narthex, is in more or less the same condition. The saint is portrayed in official military costume of brick-coloured fabric heavily decorated with applied badges (*tablia*) with gems and grey trimmings with pearls. The garment shows a sparing use of folds, but the brick-red background imitates cloth hangings with white ornamental designs (Fig. 7, above right). It is quite likely that the reddish ground of the paintings had been meant to serve as scenery. The same arrangement of folds is noted in the grey garment of a saint with curly hair, who holds a richly ornamented little box in the left hand and some instrument in the right (St. Panteleimon?). This figure, which occupies the west side of the soffit of the northeast arch of the middle aisle, has been attributed by Pelekanidis to Painter B. The garment has brick-coloured applied ornaments with white motifs (Fig. 5). Indeed, the colour scheme is remarkably limited, the dominant colours being grey –with a dark-green hue– and black, brick-red and white, with the occasional use of a few additional chromatic tones.

Very few of the faces have been preserved almost intact, while most show only traces of the preliminary drawing. The best preserved one is on the narrow east side of the northwest pier. The face belongs to an elderly saint –stylite?– and the middle section appears

remarkably undamaged. The eyes are very large with equally large irises, the nose is delineated by a red and a grey shade and the cheeks are reddish. There are reasons to believe that all faces were not painted in the same manner.

The sole surviving composition from the Evangelical cycle in this layer is the Crucifixion –which only Orlandos has noted but not described– painted on the west wall below the women's gallery (Plan no. 12). The representation has retained its drawing faintly but clearly enough to show that Christ was depicted frontally, in a rigid pose with head held up, wearing a long loin-cloth from the waist down, surrounded by few indiscernible figures to the right and left of the broad arch. This type is known from monuments of the 9th century (the Episkope in Evrytania, at Cimitile, etc.).

With respect to the composition of the Last Judgement –the other surviving wall painting in the narthex– we would add that the seated figures number fifteen. Therefore, in addition to Christ and the apostles, they included the Virgin and St. John the Baptist, i.e. the Deesis. All these figures are seated on voluminous richly-gemmed high-backed thrones with semicircular finials (Fig. 6). It seems that the full-length figures reached to the foot of the arches, that is to say they were painted on a scale far too large for the restricted space available, which was decorated in an extremely profuse manner (*horror vacui*). Of the now lost representations below the imposing array of the enthroned Body of Judges, only one youthful figure (Eve?) has been preserved below Christ's feet. In contrast to the dimensions of this composition, a limited number of scenes noted by Pelekanidis (see above, p. 7), on the small lateral surfaces of the narrow stairs leading up to the women's gallery (Fig. 7, Plan nos. 55-58), appear to be almost of miniature size. Especially noteworthy is the representation of the "flaming sword" in the form of an angel's figure in red: the graceful posture of the figure and the precision of the neat drawing are elements of purely Hellenistic origin, quite unexpectedly encountered in this pre-eminently anticlassical decoration (Fig. 4).

From the perspective plan which marks the position of the representations in the church (Fig. 1),

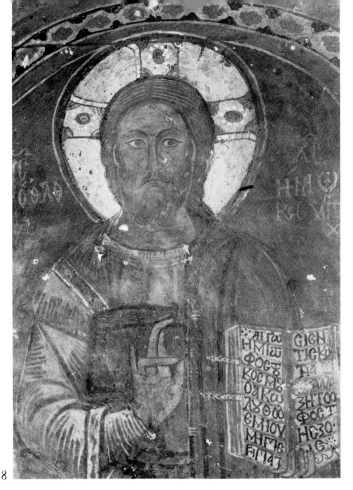

8

8. *Hagios Stephanos, naos. Christ the Merciful.*

9. *Hagios Stephanos, naos. The Annunciation.*

10. *Hagios Stephanos, naos. The Nativity (detail).*

11. *Hagios Stephanos, naos. The Raising of Lazarus.*

12. *Hagios Stephanos, naos. The Presentation of Christ in the Temple.*

13. *Hagios Stephanos, naos. The Transfiguration (detail).*

9

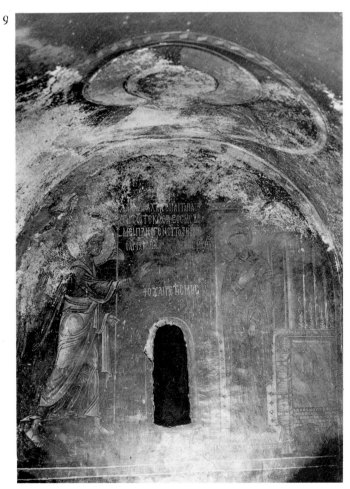

10

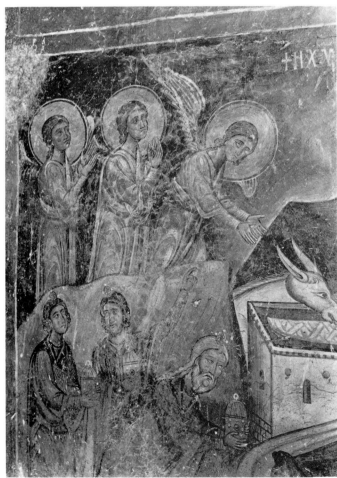

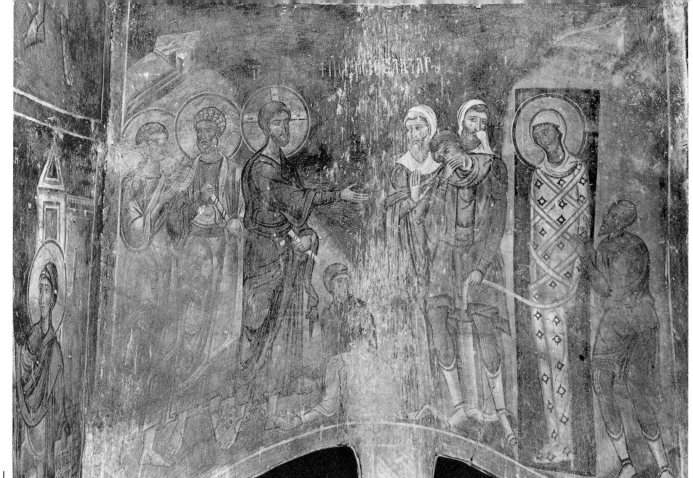

11

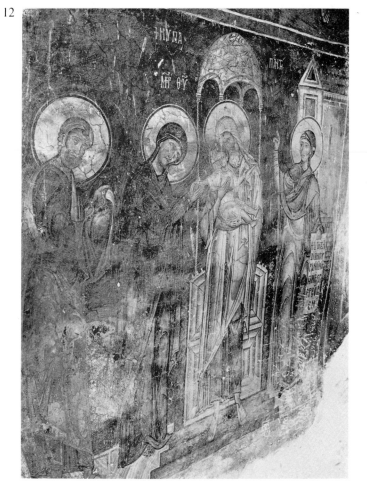

12

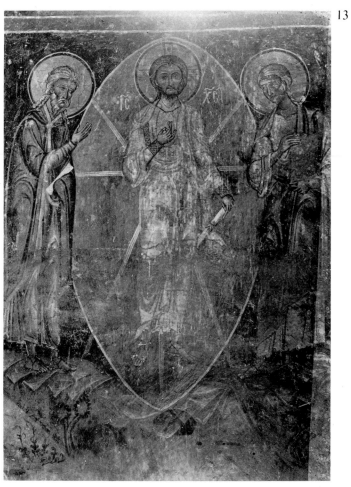

13

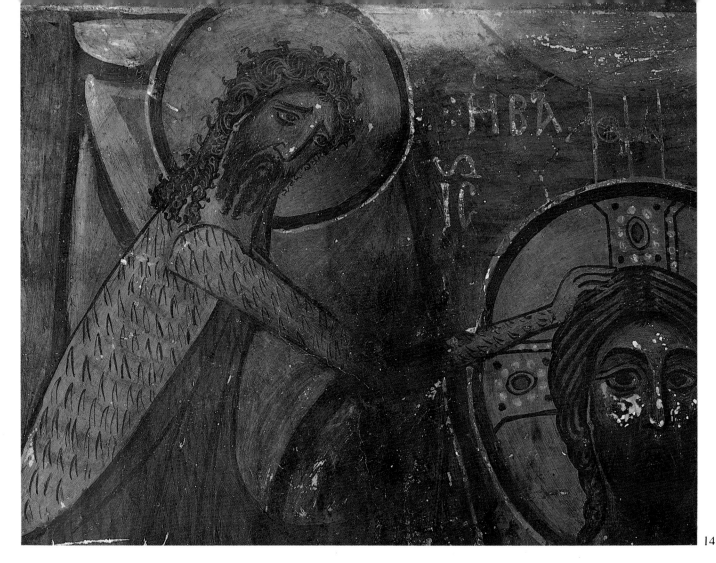

14. Hagios Stephanos, narthex. The Baptism (detail).

one can estimate how great was originally the number of saints of all types pictured in different dimensions. Among the relatively few large-scale representations of full-length figures of saints, we may distinguish that of St. Nicholas on the south side of the north middle pier. An unusual feature here is that –instead of the Virgin– an angel, over the saint's left shoulder, hands him the *epitrachelion* (priest's stole). The representation of St. Stephanos, to whom the church is dedicated, probably occupied the now vacant half-dome of the sanctuary.

In conclusion we might say that the church of Hagios Stephanos has an extensive layer of very important early Byzantine paintings, of fairly high iconographical and artistic standard, which exceeds the limits of local art and must therefore be studied in association with other contemporary mural ensembles in Kastoria and elsewhere. The painting is flat, with marked linear features and outlines, with a schematic treatment of draperies showing a tendency for "disrupted" surfaces forming geometric shapes. A similar style is encountered in churches of Naxos (Protothrone, Hagios Georgios, Kaloritsa) and in certain illuminated manuscripts, as for example in the Book of Job, Vatican 749, and –as rightly paralleled by Pelekanidis– in the Paris Codex 923, but only with respect to the preliminary drawing of the wall paintings. This art is of the last quarter of the 9th century, pre-eminently represented on a monumental scale by the mosaics on the dome of St. Sophia in Thessaloniki. However, this date is not to be necessarily assigned to the first layer of paintings in Hagios Stephanos. A similar style, perhaps slightly more schematic, along with an equally early representation of the Last Judgement with pearl–studded haloes, is encountered in other peripheral works, in a group of dated wall paintings in Cappadocia, such as those of Gülli Dere (dated to 913-920) and the contemporary ones of Tokali I, and elsewhere.

Second layer. We believe that the second layer comprises only the paintings covering the clerestory

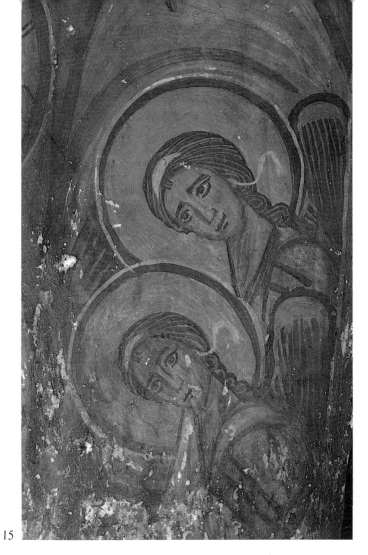

15

15. *Hagios Stephanos, narthex. The Baptism (detail).*

with a few Evangelical scenes and the middle vault with the three ages of Christ in roundels (Fig. 18, 19, Plan no. λγ, λδ, λε).

The scenes are distinguished for their size (cf. Hagios Nikolaos tou Kasnitzi) and for the small number of figures included in the unadorned and strictly organized compositions. The figures are tall, without exaggeration, and noble (Fig. 9-13), with a broad and soft modelling of the faces. The folds of draperies are treated in ways similar to those found in the Hagios Nikolaos tou Kasnitzi, with an obvious tendency to purer forms with fewer undulations at the edges of garments. Nothing can be said about the colour scheme as yet.

The best preserved paintings of Christ in His three ages display an elegant and fine workmanship of the type encountered in portable icons, with all the characteristics of a somewhat academic art, which had modelled the typical features of 12th century painting –including the protruding eye-balls (cf. Hagios Niko-

laos tou Kasnitzi), the linear treatment of hair, and the soft chiaroscuro effects with the use of greenish shades– and had been continued into the early 13th century. A more precise dating would be difficult before the cleaning of the wall paintings.

Other wall paintings. As already mentioned earlier in the text, in various parts of the walls and piers at ground-floor level have been added paintings by several donors at different times. It is therefore difficult to class these paintings into groups (Fig. 16, 17, 20 and 7, below right). At this point however, we would draw attention to a large painting of the Virgin enthroned, in the narthex. The representation, which as far as I know has not been mentioned before, is quite imposing. The lyre-shaped back of the throne is decorated with a simple Frankish pattern of triple zigzag lines, and the haloes have a relief floral ornament (Fig. 7, centre, Plan no. λη) like those of the Sts. Anargyroi in the church bearing their name (Fig. 7, 10, Plan no. 26, 28). The faces with the protruding eye-balls are reminiscent of countenances painted in the "Crusaders' style". When this wall painting is cleaned it will be possible to read the dedicatory inscription which accompanies the kneeling figure of the donor (male or female ?).

The fine painting in the narthex, portraying the priest Theodoros Lemniotes as *ktetor,* with the melancholy expression of a spiritual man (Fig. 16, plan no. μ), over his grave, is to be placed in the advanced 13th or in the 14th century. The question remains, however, of which wall paintings was he the "donor" to be offering a model of the church to St. Stephen?

Bibliography

N. and M. Thierry, "Ayvali Kilise ou pigeonnier de Gülli Dere, église inédite de Cappadoce", *Cahiers Archéologiques*, vol. XV, 1965, p. 97-154.

Beat Brenk, *Tradition und Neuerung in der christichen Kunst des ersten Jahrhunderts. Studien zur Geschichte des Weltgerichts Bildes*, Vienna 1966, p. 79-103.

P. Vokotopoulos, *Ἡ ἐκκλησιαστική ἀρχιτεκτονική εἰς τήν Δυτικήν Στερεάν Ἑλλάδα καί τήν Ἤπειρον, ἀπό τό τέλος τοῦ 7ου μέχρι τοῦ τέλους τοῦ 10ου αἰῶνος*, Thessaloniki 1975, sporadically.

A. Wharton–Epstein, "Middle Byzantine Churches of Kastoria: Dates and Implications", *The Art Bulletin*, vol. LXII, June 1980, p. 190 ff.

M.CH.

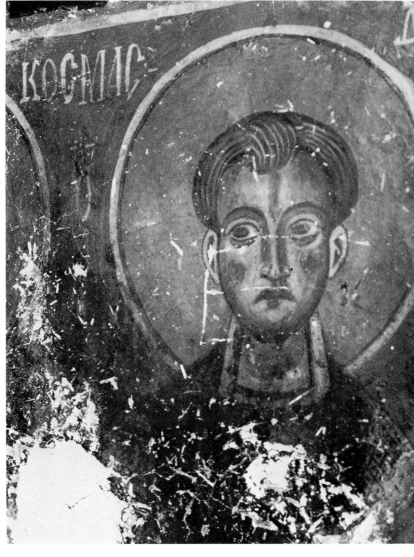

18

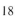

16. *Hagios Stephanos, narthex. Theodoros Lemniotes, priest.*

17. *Hagios Stephanos, narthex. St. Damian.*

18. *Hagios Stephanos, naos, vault. Christ Emmanuel.*

19. *Hagios Stephanos, naos, vault. The Ancient of Days.*

20. *Hagios Stephanos, narthex. St. Nicholas.*

19

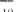

20

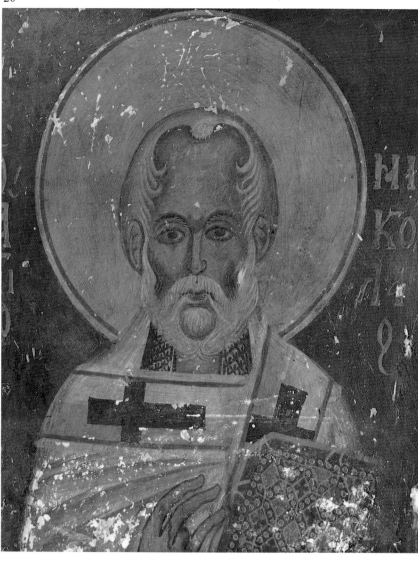

HAGIOI ANARGYROI

The church of the Sts. Anargyroi, one of the largest in Kastoria, rises majestically on the steep slope at the north side of the town (Fig. 3).

The only historical evidence available for this monument is provided by painted inscriptions, one on the tympanum over the Royal Door, the other, in three parts, next to the portrait of each of the founders, who are pictured on the north face of the wall dividing the north from the central aisle. The inscriptions tell us that the church, which had begun to suffer damage with the passing of time, was renovated and restored to its old splendour by Theodoros Lemniotes and his wife Anna Radene, who dedicated the church to the Sts. Anargyroi, so as to be deemed worthy of "the healing of ailing flesh and of the gift of physical well-being" (Fig. 22, 23, Plan nos. 84, 86, 87).

The renovation mentioned in the inscriptions was confirmed by the investigation carried out in the monument during its restoration in 1950-51. It included the replacement of the barrel-vaulted roof of the central aisle by a two-pitched timber roof, some lesser and rather insignificant modifications and the restorying of the church with a new layer of wall paintings (b) without destroying the original one.

Architecture

The church is a three-aisled basilica of quadrangular plan with the north side shorter. The aisles are divided by walls pierced asymmetrically with arched openings, two in the north wall and one at the centre of the south wall. The middle aisle, wider than the side-aisles and marked off by the excessive height of the clerestory, as in all the three-aisled basilicas of Kastoria, terminates on the east side into a semi-cylindrical apse (Fig. 2). The conches of the side-aisles, also semi-cylindrical but considerably smaller, are hollowed into the thickness of the walls. Three doors lead from the narthex to the body of the church, but the south one has been put out of use since Byzantine times. The ceiling of the narthex is divided into three parts by a transverse vault in the centre and by a "scaphoid" vault on either side (Fig. 1). The church is dimly lit by the few double windows of the high clerestory, two on each of the long sides and one at each of the narrow, east and west ends.

The Hagioi Anargyroi is the only church in Kastoria with a marble decoration comprising double colonnettes, impost blocks and door-frames ornamented with a variety of reliefs. Also richly and finely worked was the decoration of the marble templon, many fragments of which were retrieved during restoration works and are now kept in the church.

Painting

The entire painting decoration of the church, in two superimposed layers, has been preserved intact in the central and side aisles (except for their ceilings) and in the narthex. A few paintings have also survived on the outer face of the west wall of the narthex.

It is impossible to determine the iconographic programme of the first layer, as it is covered by the second layer of wall paintings. Only in the narthex, some works performed at an earlier date have uncovered on the soffit of the south transverse arch the figures of St. Basil and St. Nicholas (Fig. 4, 5, Plan nos. 39, 38), on the narrow north wall the portraits of the Sts. Constantine and Helen, and nearby, in the NE

corner, the portrait of the "departed" Constantine with the accompanying inscription (Fig. 6, Plan nos. β, γ, δ).

The second layer of painting has divided the surfaces of walls into three zones. In the upper zone are depicted full-length figures of prophets, in the middle the Twelve Feasts cycle and other Christological scenes, and in the lower full-length figures of saints. In spite of this main division, the interior articulation of the monument with arches, passageways, narrow walls and the vaulted coverings of the superstructure, produces some irregularities in the system of parallel zones (Fig. 10).

The decoration in the holy bema is foreign to the established iconographic programmes. The frontal pediment crowning the east wall bears a representation of the Deesis with only busts of the holy figures. Below the Deesis, the Annunciation shows, in the centre above, the Ancient of Days in a semicircle. Christ Emmanuel is depicted on the tympanum over the conch and the *Hetoimasia* (the Preparation of the Throne) on the soffit of the same arch. Finally, on the half-dome of the semi-cylindrical apse there is a representation of the enthroned Virgin Platytera, and, below this, a depiction of the *Melismos* (the Breaking of Bread) surrounded by figures of co-officiating hierarchs (Fig. 7, Plan nos. 1–6).

The presentation of the three ages of Christ, as well as of the Annunciation, the Virgin Platytera and Child, the *Hetoimasia* and the *Melismos*, emphasizes the eternal nature of the *Theanthropos* and the redeeming act of His sacrifice. This view is enhanced by the fact that the scene of the Annunciation is depicted twice in the same church – a very rare if not unique instance. One painting of the Annunciation belongs to the autonomous (in the sence mentioned above) iconographic programme on the east wall and marks the beginning of the Twelve Feasts and the Christological cycle in general.

The north aisle, apart from the Deesis with the three figures depicted full-length on the east wall (Fig. 13, Plan nos. 79, 80, 81), is dedicated to the iconography of the martyrdom and miracles of St.

George. In the south aisle the paintings depict miracles mainly of Christ – as it appears from the surviving fragments on the remains of the fallen vault, which show the Healing of the Dropsical Man and the Healing of the Blind Man (Plan nos. 121-124) – and also the miracle of the Archangel Michael at Chonae (Plan no. 114), as well as figures of holy monks (Fig. 25, 26, Plan nos. 117-120).

The varied iconography of the narthex includes the Ascension (Fig. 28-30, Plan nos. 132-135), the Pentecost (Plan no 152), rare scenes from the earthly life of Christ –Jesus and Nathanael, "He that is without sin let him first cast a stone"– compositions from the Old Testament, full-length figures of saints and busts of saints in round frames imitating suspended portable icons (Fig. 29) and, in the lower zone, full-length portraits of holy women (Plan nos. 149-157).

First layer. The small number of visible wall paintings from this layer reveal only a few stylistic elements. The painting is restricted to three basic colours: raw sienna, burnt sienna and natural ochre. A marked and steady outline defines the hair from the forehead and continues uninterrupted around the face or the edge of the beard. Sparse shading around the nose and the chin lend a quality of plasticity to the face. The large eyes with the round irises are wide-open, the eyebrows, either thick or thin, are arched. The wrinkles of the forehead are rendered linearly with strong double or triple successive lines curving upwards, and are intensified by faint broad highlights over the eyebrows (Fig. 4,5). With the exception of the heavy royal attire of the Sts. Constantine and Helen, garments envelop the body in conventionally treated dark-coloured folds, which have their centre stressed with a thin luminous brush stroke and divide the fabric subtly into large triangular surfaces.

The archaic character of the style, the limited colour scheme, the overall treatment of the few figures of the first layer and their close relation to those in painting monuments of the East and of the Byzantine West strongly suggest a dating of the wall paintings in the second half of the 10th century.

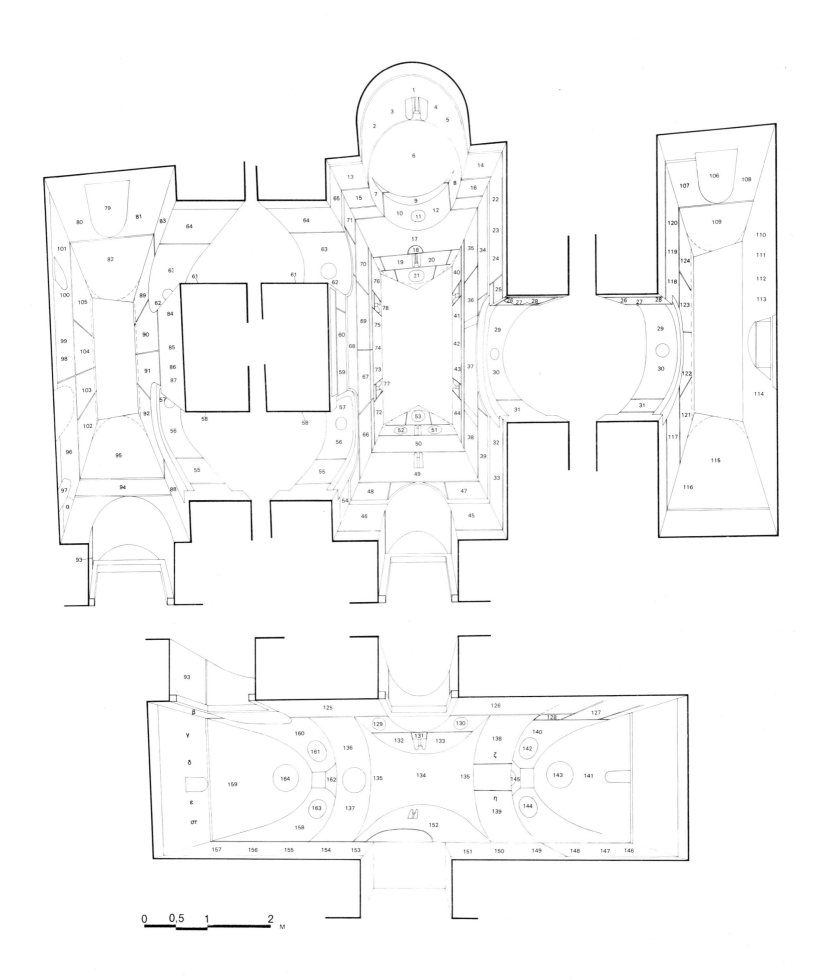

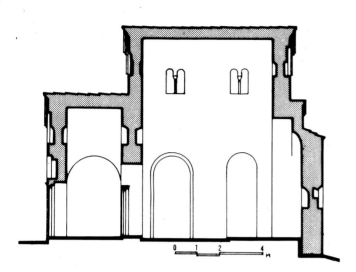

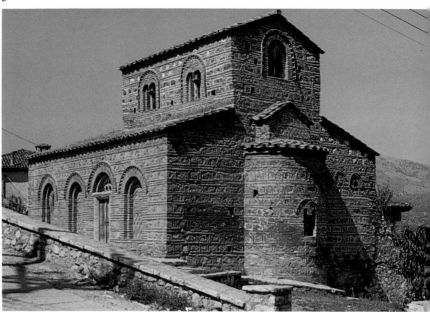

HAGIOI ANARGYROI

1. *Hagioi Anargyroi. Perspective plan.*

2. *Hagioi Anargyroi. Section.*

3. *Hagioi Anargyroi. View form the SE.*

Layer A. a. *The Virgin of the Deesis.* **β.** *The deceased Constantine.* **γ.** *St. Helen.* **δ.** *St. Constantine.* **ε.** *Angel.* **στ.** *Angel.* **Layer B. 1.** *Holy Table.* **2.** *St. Gregory the Theologian,* **3.** *St. Basil.* **4.** *St. John Chrysostom.* **5.** *St. Nicholas.* **6.** *Enthroned Virgin and Child.* **7.** *Angel.* **8.** *Angel.* **9.** *Christ Emmanuel.* **10.** *The Archangel Michael.* **11.** *The Hetoimasia.* **12.** *The Archangel Gabriel.* **13.** *St. Stephanos.* **14.** *St. Euplous.* **15.** *St. Cosmas.* **16.** *St. Damian.* **17.** *The Annunciation.* **18.** *The Ancient of Days.* **19.** *The Virgin.* **20.** *St. John the Baptist.* **21.** *Christ.* **22.** *St. Hierotheos.* **23.** *St. Gregory the Younger.* **24.** *St. John the Eleimon.* **25.** *Inscription.* **26.** *St. Cosmas.* **27.** *Christ.* **28.** *St. Damian.* **29.** *St. Panteleimon.* **30.** *St. Hermolaos.* **31.** *The Virgin Paraklesis.* **32.** *St. Theodoros Stratelates.* **33.** *St. Theodoros Tiro.* **34.** *The Annunciation at the Well.* **35.** *The Visitation.* **36.** *The Nativity.* **37.** *The Presentation in the Temple.* **38.** *The Transfiguration.* **39.** *The Entry into Jerusalem.* **40.** *The Prophet David.* **41.** *The Prophet Isaiah.* **42.** *The Prophet Zechariah.* **43.** *The Prophet Jonah.* **44.** *Prophet ?* **45.** *St. Procopios.* **46.** *St. Christophoros.* **47.** *St. Cyrus.* **48.** *St. John the Anargyros.* **49.** *The Raising of Lazarus.* **50.** *The Dormition of the Virgin.* **51.** *The Archangel Michael.* **52.** *The Archangel Gabriel.* **53.** *The Virgin.* **54.** *St. Daniel the Stylite.* **55.** *St. Nestor.* **56.** *St. Floros.* **57.** *St. Loros.* **58.** *St. Nicholas.* **59.** *St. George.* **60.** *St. Demetrios.* **61.** *St. Achilleios.* **62.** *St. Leo Pope of Rome.* **63.** *St. Eleutherios.* **64.** *St. Gregory the Thaumaturge.* **65.** *St. Romanos the Deacon.* **66.** *The Crucifixion.* **67.** *The Deposition.* **68.** *The Entombment.* **69.** *The Myrrh-bearing Women.* **70.** *The Resurrection.* **71.** *St. Symeon the Stylite.* **72.** *The Prophet Daniel.* **73.** *Prophet.* **74.** *Prophet.* **75.** *Prophet.* **76.** *The Prophet Solomon.* **77.** *Angel.* **78.** *Angel.* **79.** *Christ Emmanuel.* **80.** *The Virgin Deesis.* **81.** *St. John the Baptist.* **82.** *The martyrdom of St. George.* **83.** *St. Lavrentios the Deacon.* **84.** *Anna Radene.* **85.** *The Virgin with Christ.* **86.** *Theodoros Lemniotes.* **87.** *John Lemniotes.* **88.** *St. David of* *Thessaloniki.* **89.** *The martyrdom of St. George.* **90.** *The martyrdom of St. George.* **91.** *The martyrdom of St. George.* **92.** *The martyrdom of St. George.* **93.** *Hierarch.* **94.** *Inscription.* **95.** *Miracle of St. George.* **96.** *St. George.* **97.** *Donor or deceased.* **98.** *Hierarch.* **99.** *Hierarch.* **100.** *St. Patapios.* **101.** *St. Hypatios.* **102.** *Miracle of St. George.* **103.** *Miracle of St. George.* **104.** *Miracle of St. George.* **105.** *Miracle of St. George.* **106.** *The Virgin.* **107.** *The Archangel Gabriel.* **108.** *The Archangel Michael.* **109.** *Miracle of the Sts. Cosmas and Damian.* **110.** *St. Euphrosynos (not preserved).* **111.** *St. Theodoros (not preserved).* **112.** *St. Sabbas (not preserved).* **113.** *St. Ephraim Syrus (not preserved).* **114.** *The miracle at Chonae (not preserved).* **115.** *Christ.* **116.** *Theophilos Lemniotes.* **117.** *The Archangel Michael.* **118.** *St. Antony.* **119.** *St. Euthymios.* **120.** *St. Arsenios.* **121.** *Miracle of the Sts. Cosmas and Damian.* **122.** *Miracle of the Sts. Cosmas and Damian.* **123.** *Miracle of the Sts. Cosmas and Damian.* **124.** *Miracle of the Sts. Cosmas and Damian.*

Narthex. 125. *19th cent. painting.* **126.** *19th cent. painting.* **127.** *St. Anne and the Virgin.* **128.** *St. Irene.* **129.** *St. Photios.* **130.** *St. Aniketos.* **131.** *The Ascension (the Virgin).* **132.** *The Ascension (angel).* **133.** *The Ascension (angel).* **134.** *The Ascension (Christ).* **135.** *The Ascension (Apostles).* **136.** *St. John the Baptist.* **137.** *The Prophet Zechariah.* **138.** *St. Nicholas.* **139.** *St. Basil.* **140.** *Abraham and Sarah.* **141.** *The Hospitality of Abraham.* **142.** *Saint.* **143.** *Saint.* **144.** *Saint.* **145.** *Saint.* **146.** *St. Sekendos.* **147.** *St. Jerusalem.* **148.** *St. Sekendikos.* **149.** *St. Euphemia the Panephemos.* **150.** *St. Thekla.* **151.** *St. Anastasia the Pharmakolytria.* **152.** *The Pentecost.* **153.** *St. Kyriake.* **154.** *St. Julitta.* **155.** *St. Kerykos.* **156.** *St. Marina.* **157.** *St. Theodora.* **158.** *Christ and Nathanael.* **159.** *The Three Youths in the Fiery Furnace.* **160.** *Adulteress.* **161.** *Saint.* **162.** *Saint.* **163.** *Saint.* **164.** *Saint.*

Second layer. The wall paintings of this layer show a lack of stylistic unity. Two main artists, painter A and painter B, had worked simultaneously, not seldom even side by side, although each with a different conception of painting, using a different palette and a different style.

Painter A is distinguished in the larger compositions for his vigorous manner and his ingenious ways of expressing emotions. By contrast, his saints are portrayed in hieratic pose, with an austere expression and a marked spiritual reflection, especially noted in the portraits of youthful saints and of holy monks. The oval faces, either thin or fleshy depending on the subject depicted, and in some instances distorted by the intensity of painful emotions or inner turmoil, are shaped with a pale yellow preliminary underpaint (*proplasmos*). Over this, green shades start from the edges and spread gently towards the cheeks, where light pink fades imperceptibly to off-white. The cheek-bones are marked by brick-red spots. The eyes, large and rather round-shaped, with their equally large and moving irises, are intensified with sienna shades on the lower eyelid, while a thin red line starting from the corner and continuing along the upper eyelid adds depth to the eye socket. The eyebrows arch towards the outer extremity and form a curve which meets an horizontal thin shade issuing from the outer corner of the eye. Broad highlights over the eyebrows intensify the soft green shades of the forehead. The hair, of different types, curly or straight, luxuriant or thin, is arranged in a way befitting the face (Fig. 9, 15). Garments, usually rich and of various colours –deep blue, wine-red, deep and light pink– are ample with broad folds adapted to the expressive, though restrained, attitudes and movements of the body. In a few cases, the movement of the drapery, particularly in the lower part of the garment, reaches the point of exaggeration. This tendency is noted in a large group of wall paintings dating from the time of the Comneni (Fig. 9, 12).

The way compositions are organized with a landscape and an architecture-scape in a warm setting allows both the main personages and the secondary figures to move easily and take an active part in the event. This particular skill is perceptible in all the representations attributed to this painter and especially wherever the space available created difficulties. For example, the composition of the Raising of Lazarus, on the west wall, above the arched entrance to the main body of the church, is divided in two by the bipartite window. This, however, does not disrupt the unity of the representation, because the artist has exploited the narrow surface between the window and the arch of the entrance to paint there a low rock, the stone of the grave, and Lazarus' sisters prostrate at the feet of Christ. Likewise, the difficulty presented by the lack of sufficient wall space in the right part of the representation was overcome by a unique iconographic device: an elderly Jew is depicted in attitude of prayer with raised arms, between which appear four smaller heads of Jews giving the impression of a crowd (Fig. 11, Plan no. 49).

Painter B differs from painter A in the style and drawing, in the figures and expressions, and in the scenery.

The figures are graceless, somewhat rigid, often expressionless, and the linearism with which the painter treats the faces and draperies gives them a conventional appearance. These oversized figures dominate the composition, creating a certain disproportion between principal and secondary figures as well as in the overall effect. Consequently, in most of the representations there is an absence of both architecture-scape and landscape, a suggestion of which may be found in the ground with the undulating green edging at the lower part of the compositions. Usually the scene is depicted against an all-green background. The compositions are rendered on a single plane. If there is a second plane, the figures there are of equal size, arrayed with heads at nearly the same level.

The faces are broad and rather square-looking, by reason of the usually prominent lower jaw. Other distinctive features are the rather low brow, the small oblong eyes, the thin arched eyebrows, the long thin and slightly aquiline nose. The overall modelling of the

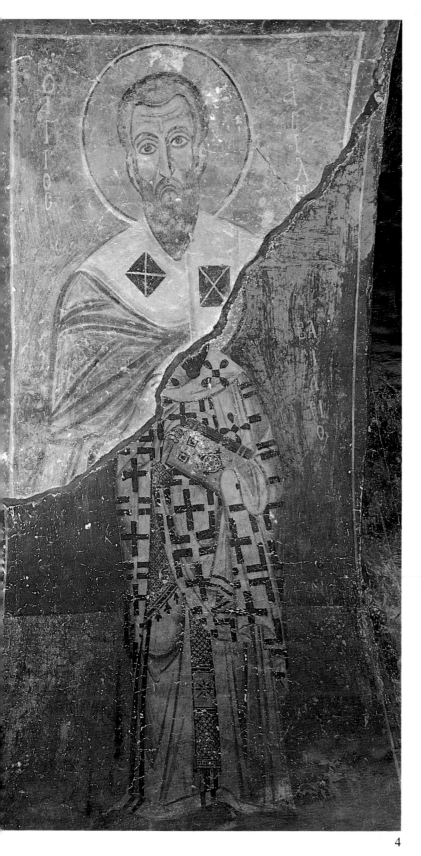

4 5

4. *Hagioi Anargyroi, narthex. St. Basil.* 5. *Hagioi Anargyroi, narthex. St. Nicholas.*

face in light pink is accentuated with green shades and soft hues. In some figures the prominent cheek-bones are marked by two red patches (Fig. 8, above).

The hair of female figures and angels is curly, the ringlets crowning the forehead in regular fashion and sharply outlined with black brush strokes. By contrast, the hair of male figures is smooth, tidy and likewise outlined in black.

The garments, of stiff and heavy fabrics, form angular projections giving rise to straight or curved folds, which lack natural grace. The painter has tried to compensate for the coarseness and rigidity of his draperies by making use of contrasting colours (green-blue with pink, blue with blue-green, blue with light pink). Differences in the artistic notions of the two painters become more obvious if one compares the two representations of the Annunciation – that by painter B on the east wall over the conch, and the other by painter A in the second register decorating the eastern part of the south wall of the middle aisle.

The Annunciation by painter B displays an affected simplicity (Plan no. 17). The green-blue ground dominates the scenery and is interrupted only by a tall light-coloured building forming a background frame for the figure of the Theotokos. Wearing a deep-blue *maphorion* (mantle covering the head and shoulders), the Virgin is portrayed frontally, standing in an idol-like pose, as if not participating in the event. The angel, with a light-coloured richly-draped *himation* (cloak) walks to the right. The distance between the two figures is not great, but their association is not clear. The same principle is noted in all the compositions by painter B.

Quite different is the representation of the Annunciation by painter A, who resorts to James' apocryphal Protoevangelion to paint the Annunciation at the Well (Fig. 14, Plan no. 34). The depiction of figures here is reversed. The small architecture-scape has been confined to the left end of the scene, behind the figure of the Theotokos. The strong contrast of movement between the upper and the lower part of the Virgin's body reflects her psychological state of the moment, as it conveys the impression that the

frightened Maiden is trying to flee and her quick little steps cause dense irregular folds to be formed around the knees and the lower part of the legs. The upper part of her body is turned towards the angel, who stands at the right end of the scene, motionless, splendidly dressed in his luminous pink *himation*, serene and majestic. The well with its windlass at the centre of the scene forms the vertical axis of the composition. The painter's originality in using for the well an inverted Theodosian capital adorned with a fresh-looking naturalistic acanthus, betrays his talent to enliven even lifeless objects.

The life-like effect of the composition, the skill in portraying psychological states, the dramatic element, the balanced and calculated distribution of masses, the interplay of vertical and horizontal axes, are all encountered to the smallest detail in the representation of the Entombment (Fig. 12, Plan no. 68). This is one of the most perfect compositions of the Byzantine art, or indeed of the entire European art, of that age. In this representation, which foreshadows the Western Pietà, the dynamic articulation of the subject elevates the drama of maternal sorrow to the level of a universal symbol.

On the evidence derived from large works of painting and from miniatures of illuminated manuscripts, the second layer of mural decoration by both painters may be chronologically placed –in spite of some contrary opinions– in the late 11th-early 12th century, notably in the reign of the first Comneni.

Bibliography

A. Orlandos, «Τά βυζαντινά μνημεῖα τῆς Καστοριᾶς», ᾿Αρχεῖον Βυζαντινῶν Μνημείων ῾Ελλάδος, vol. Δ΄, 1938, p. 10 ff.
P. Tsamisis, ῾Η Καστοριά καί τά μνημεῖα της, Athens 1949, p. 104.
S. Pelekanidis, Καστοριά. Βυζαντιναί τοιχογραφίαι, Thessaloniki 1953, p. 21 ff., pl. 1-42.
S. Pelekanidis, "I più antichi affreschi di Kastoria", *Corsi di cultura sull' arte Ravennate e Bizantina*, Ravenna 1964, p. 351 ff.
Id., "Kastoria", *Reallexikon zur byzantinischen Kunst*, I. 1190 ff.
I. Hadermann-Misguich, *Kurbinovo*, Brussels 1975, p. 563 ff.

S.P.

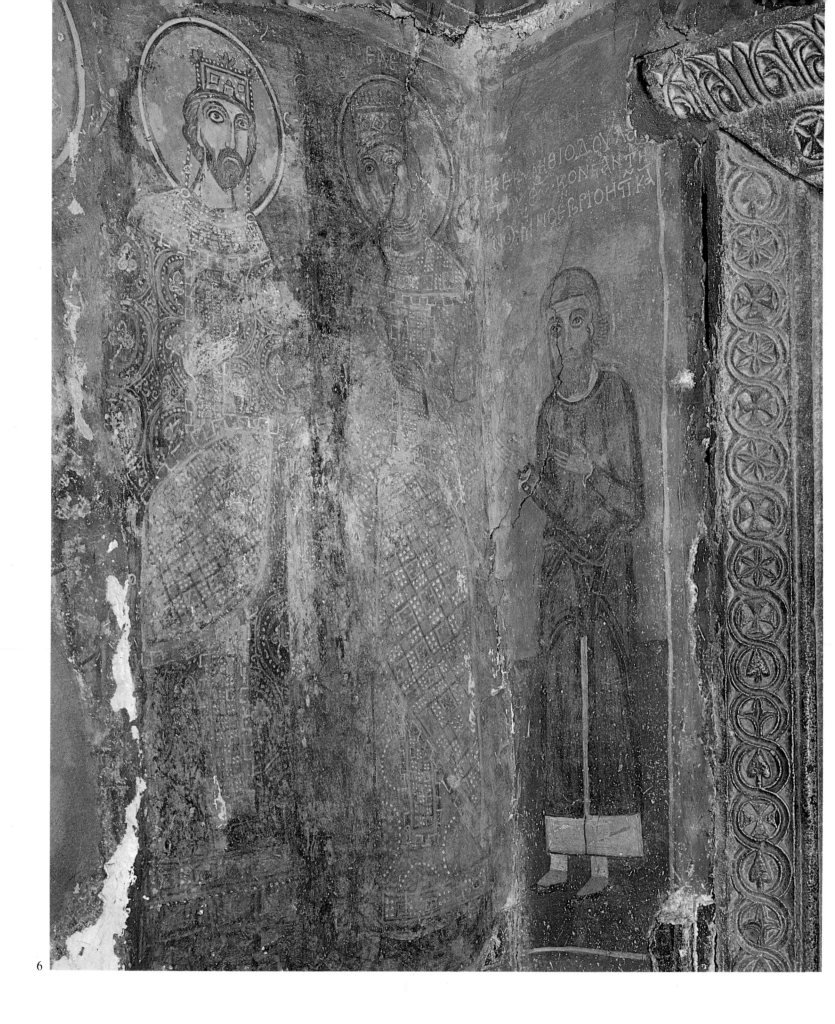

6. *Hagioi Anargyroi, narthex. The Sts. Constantine and Helen and the deceased Constantine.*

7. *Hagioi Anargyroi. Interior, facing the sanctuary.*

8. *Hagioi Anargyroi. South side of the apse.*

9. *Hagioi Anargyroi. The angel of Fig. 8.*

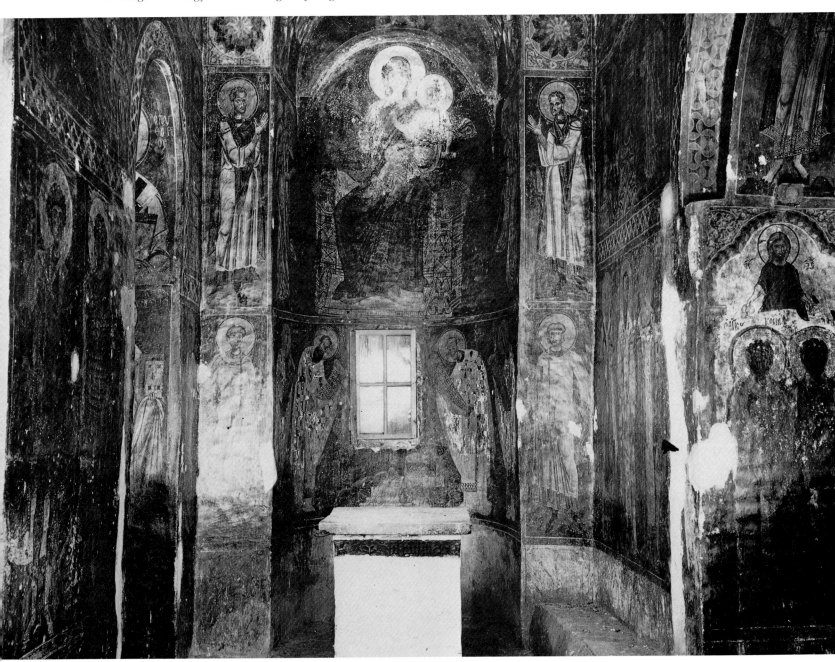

8

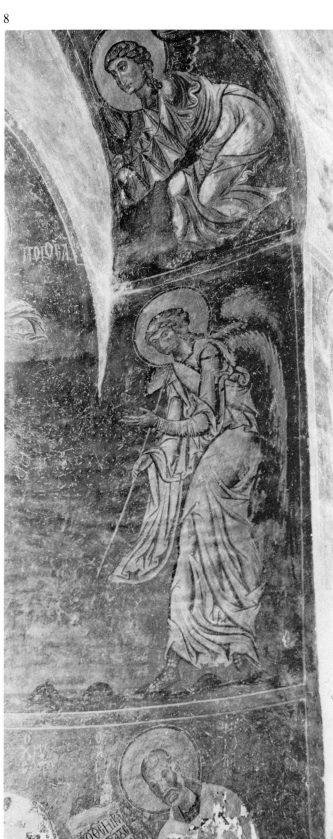

9

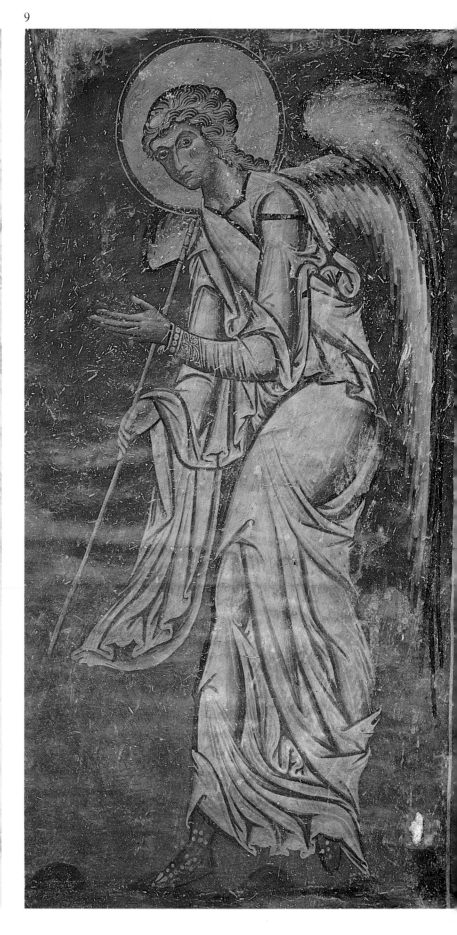

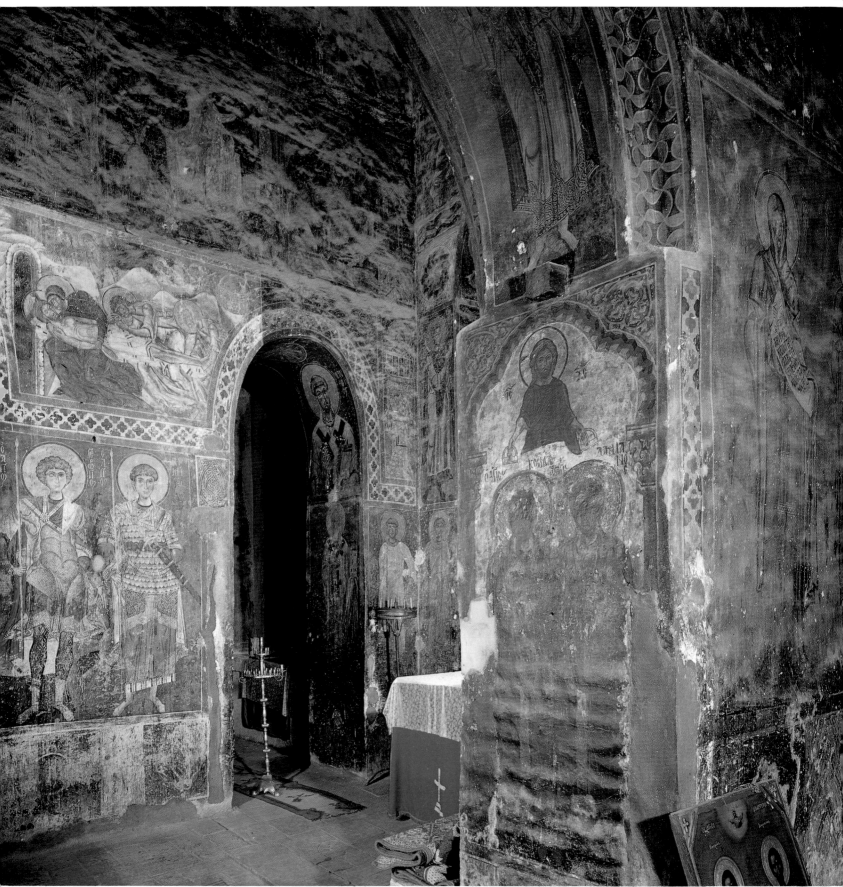

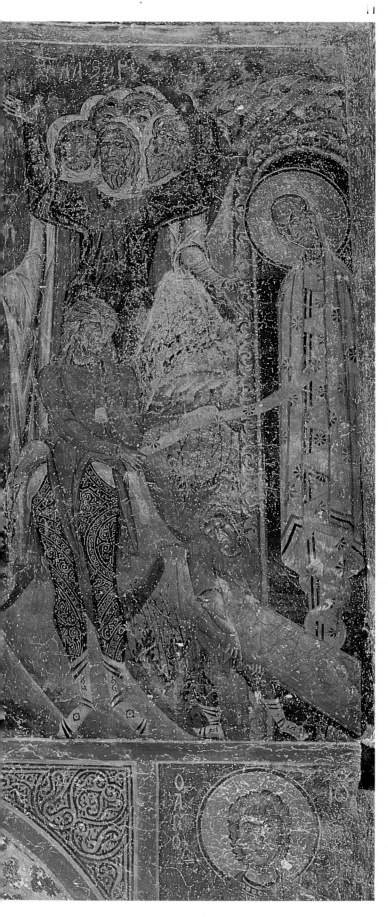

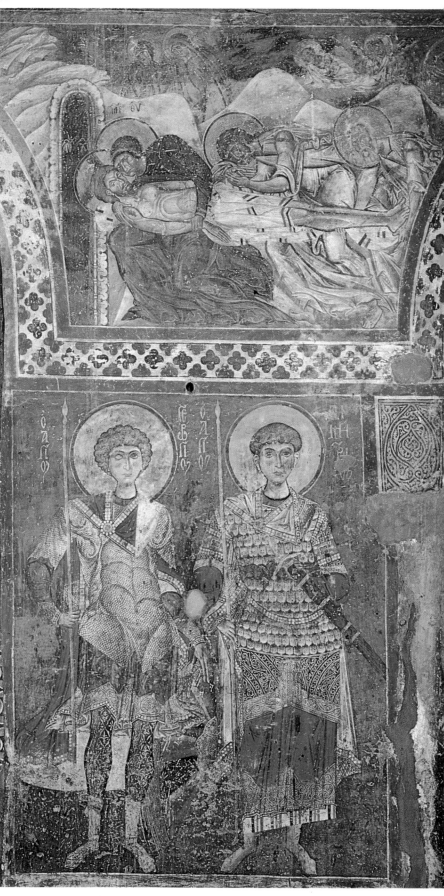

13

14

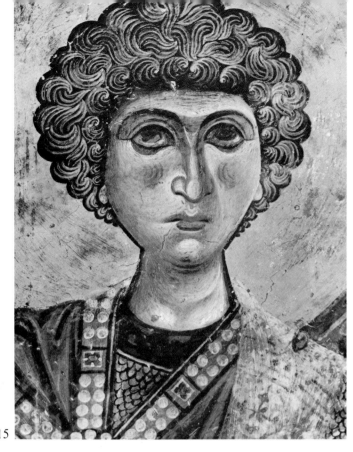

15

10. *Hagioi Anargyroi. Interior, facing the south and central aisle.*

11. *Hagioi Anargyroi, naos. The Raising of Lazarus (detail) and St. John the Anargyros.*

12. *Hagioi Anargyroi, naos. The Sts. George and Demetrios and the Lamentation at the Tomb.*

13. *Hagioi Anargyroi, north aisle, conch. Deesis with Christ Emmanuel.*

14. *Hagioi Anargyroi, central aisle. The Annunciation at the Well.*

15. *Hagioi Anargyroi. St. George, detail of Fig. 12.*

16. *Hagioi Anargyroi, naos. The Entry into Jerusalem.*

16

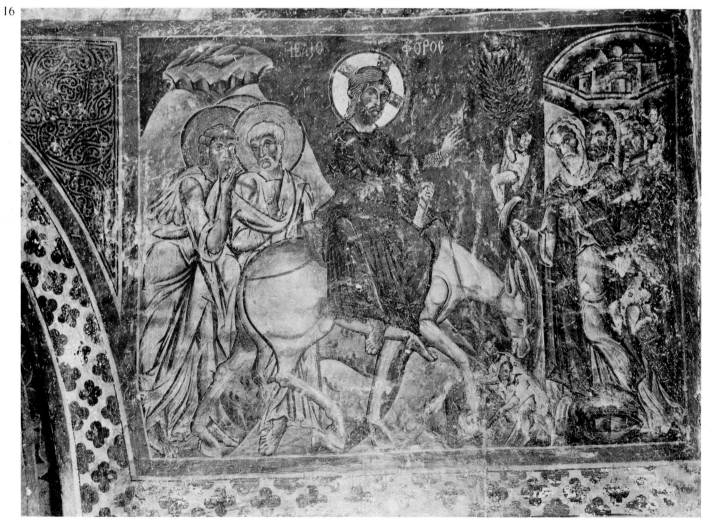

17. *Hagioi Anargyroi, naos. St. Eleutherios.*

18. *Hagioi Anargyroi, apse. St. Nicholas.*

19. *Hagioi Anargyroi. St. Demetrios, detail of Fig. 12.*

17 18

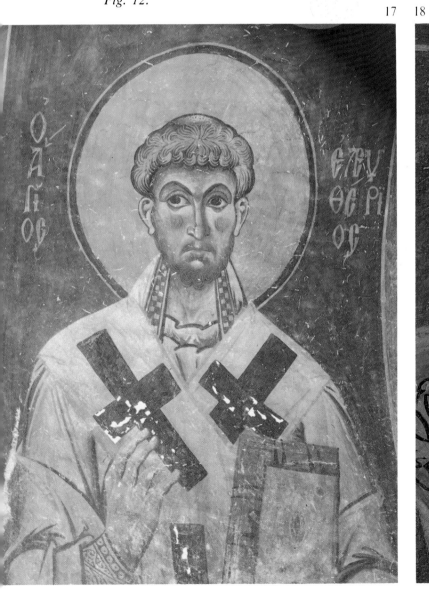 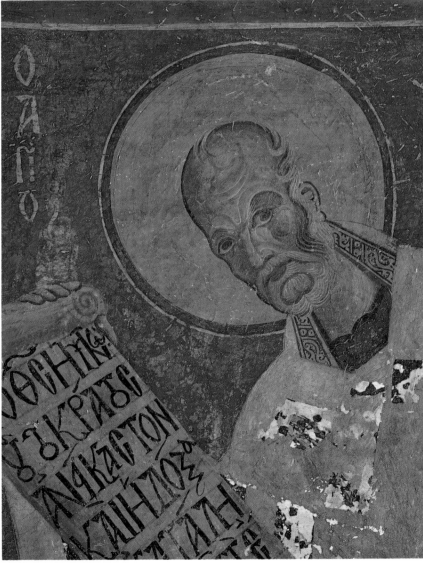

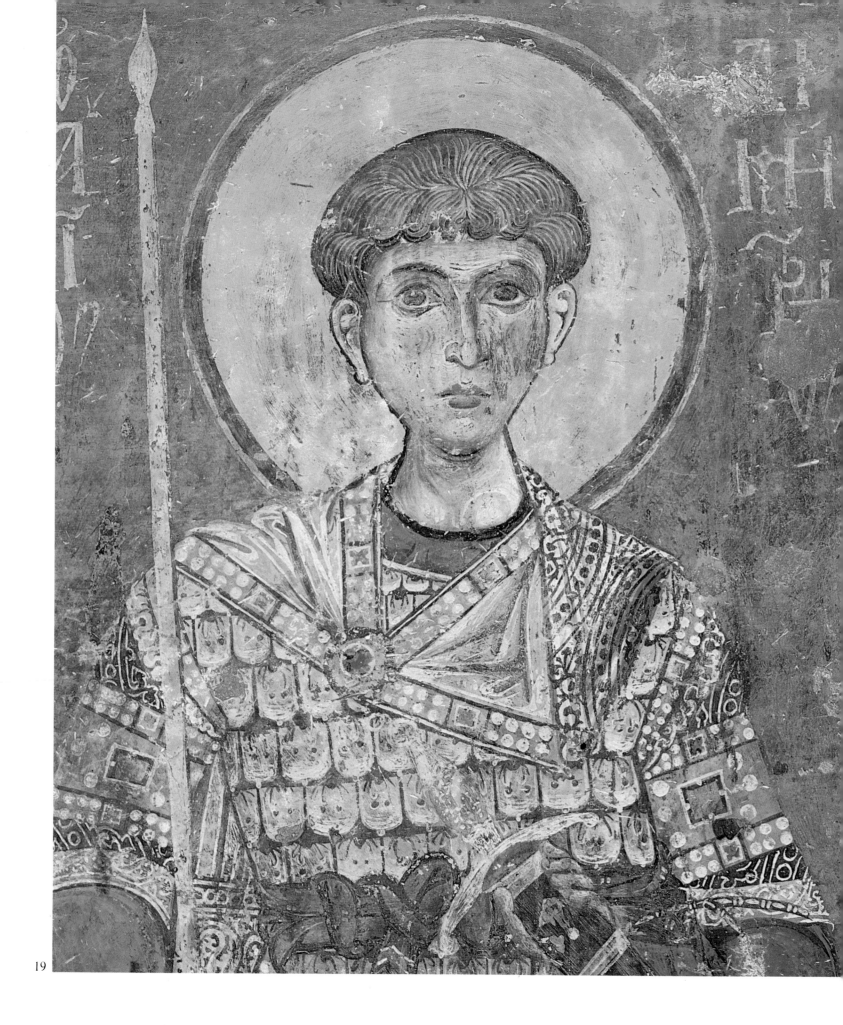

19

HAGIOI ANARGYROI
Supplementary Note

a. Chronology of the basilica and of the first painting layer

The church is dated by some (Pelekanidis, Vokoto-poulos) in the second half of the 10th century and by others (Krautheimer, Wharton-Epstein) in the first half of the 11th century.

The peculiarities in the structure and masonry of the building –which are common to the churches of Kastoria– do not permit a more precise dating. The problem is whether the church was built during the second Bulgarian occupation or in the period follow-ing the victory of Basil II (1014), which afforded greater possibilities for the construction of new churches. The sculptural decoration of the church (Fig. 6, 29), not all of the same date, does not help in assigning a more accurate chronology. The few wall paintings from the first layer may prove more helpful.

Probably a large part of the earlier layer has survived under that of the 12th century. The sections uncovered so far –under unverified circumstances and at an uncertain time– have been dated by Orlandos in the mid-11th century, by Pelekanidis (see above, p. 23) in the second half of the 10th century and, recently, by Wharton-Epstein in the first three decades of the 11th century. They all believe that these wall paintings must not be chronologically distant from the initial con-struction of the church.

To the list of uncovered representations of the first layer mentioned by Pelekanidis (p. 23), the following may be added: in the narthex, to the left of St. Constantine's painting, the figure of an angel (?) pictured behind part of a throne (the rest of the representation has been ruined by the insertion of a window at a later date), and at the corner of the same wall, the figure of another angel turning towards the west wall. These indications, along with the portrait of Constantine whom the inscription mentions as "asleep" (Fig. 6), suggest an absence of iconographic program-me, which might be explained by the use of this side of the narthex and perhaps also of the naos as a burial place. This view is supported further by the remaining relatively small bust of the Virgin from a three-figured

Deesis –on the north wall of the north aisle adjacent to the narthex, in the first layer and below the later figure of St. George– a representation justified only by the presence of a grave in this place (Fig. 20).

The quality of this flat painting with the marked outlines, the hieratic poses, the expressionless faces and the simple treatment of folds, assigns it to a peripheral art of regional character, the expressive means of which are as poor as the garment of the deceased portrayed next to St. Constantine. This category of painting can be dated with greater difficulty by reason of its conservative character. In any event, it belongs to a class quite different from that of the wall paintings of St. Sophia in Ochrid, of the Panagia Chalkeon and of Hosios Loukas, and is therefore not comparable with them. A comparison with similar works in Kastoria (Taxiarches, Hagios Stephanos, which are older) and in other parts of Greece (such as the second layer of the Episkope in Evrytania and a number of wall paintings in Mani and in Naxos, some of which are dated) suggests a dating around 1000. The depiction of the two Great Fathers of the Church in the narthex is another archaic feature. The wall paintings therefore, and consequently the building itself, may well belong to the time when Kastoria was still under Bulgarian occupation, in which case the evidence of these wall paintings is significant from the historical point of view.

b. The second painting layer, the donors and the dedicatory inscriptions

Both the donor and the quality of the second layer of wall paintings are of an entirely different class. It is worth noting that, in the narthex at least, the 12th century painter seems to have repeated the iconogra-phic programme of the first layer, and it is perhaps to this limitation that its unorganized and somewhat fragmentary character should be attributed. On the other hand, the Hospitality of Abraham, which must have been painted on the tympanum of the south wall of the narthex, should have been followed, on the east wall, by the representation of Abraham and Sarah

(rather than by a scene from the life of the Virgin).

There are at least three painted inscriptions referring to the donor and his family, and the information they contain has not been fully studied as yet. According to their position and the probable order in which they had been written, from east to west, the first group of inscriptions is on the south wall of the north aisle and accompanies the group portraits of Theodoros Lemniotes, his wife Anna Radene and his son John, with the Virgin in the middle (Fig. 22, 23, Plan nos. 84-87). The inscriptions record only the names of the persons portrayed. The symmetrical disposition of the subjects is closely related to the mosaic in the galleries of Hagia Sophia, representing the emperor John Comnenos (1118-1143), his wife and his son around the figure of the Virgin. It is not easy to ascertain the reason for which the inscriptions were re-written a little later and the crudely painted model of the church was added on the right hand of Theodoros (Fig. 23).

A second inscription at the west end of this aisle, over the door leading to the narthex (Plan no. 94), is composed of 16 dodecasyllabic verses. From a more correct reading of the inscription, we give here the following few verses:

1 Ἔφθασα μέν γράψαι σε πρίν ἐν καρδίᾳ
πολύτλα μάρτυ μυστικαῖς βαφαῖς πόθου
τανῦν δέ καί χρώμασιν ὑλικω[τέροις]
τῶν θαυμάτων σου ζωγραφῶ τάς εἰκόνας
. .
15 ζητῶν κἀκεῖσε σήν ἀρωγήν ἐν κρίσει
Θεόδωρος σός οἰκέτης Λημνιώτης

1 *You were already painted in my heart,*
cruelly-tried martyr, with secret hues of longing
and now, with more material colours
I paint the pictures of your miracles
. .
15 *asking your help in the judgement to come*
your suppliant Theodoros Lemniotes

St. George is pictured on horseback next to the door (Fig. 21, Plan no. 96). The vault and walls of this aisle are painted with scenes showing the martyrdom and miracles of this saint (Plan nos. 82, 89-92 and 95, 102-105).

The third inscription, in large white capital letters on a green band of the blue ground, is in the narthex, opposite the entrance (Fig. 27, 29). Also in verse composed of 16 dodecasyllables, it records the same donor's address to the two Sts. Anargyroi: he offers them "εὐπρέπειαν τοῦ ναοῦ" ("embellishment of the church") and expects to find "ἐκεῖσε τήν ἀείδροσον χλόην" ("there the evergreen grass", i.e. Paradise) "τανῦν δέ ρῶσιν σαρκός ἠσθενημένης" ("and now the healing of ailing flesh") for himself, his wife and his son.

A fourth inscription –in a less prominent place in the naos– that has not been noted so far, refers also to the "[οἰκ]έτης Λημνιώτης" ("the supplicant Lemniotes") (Plan no. 25).

Each of the inscriptions is addressed, directly or indirectly, to one of the saints sharing the same church: to the Holy Virgin, to St. George, and mainly to the Sts. Cosmas and Damian. The latter flank the enthroned figure of the Virgin in the sanctuary (Fig. 7, plan nos. 15, 16), are depicted again on the front of the south pier at a small height as a devotional icon, and also figure on the western facade, on the tympanum over the doorway. Their miracles had been pictured on the fallen vault of the south aisle. Moreover, a portable icon of the Sts. Anargyroi from that age has been found in the church.

The donor Theodoros Lemniotes and his family, who are portrayed in strikingly sumptuous clothes and are mentioned in all four inscriptions at least, must have belonged to the local aristocracy of Kastoria rather than to an exiled noble family. Other members of this family are also known: the monk Theophilos Lemniotes, who is portrayed and recorded as a donor too, with a model of the church in his hands, on the west wall of the south aisle (Fig. 24, Plan no. 116), next to the colossal full-length image of Christ (is perhaps the donor's grave there?). If the decoration of the entire aisle is ascribed to this donor, as there is no serious indication to suggest its association with Theodoros, then the same painters had been commissioned to work here. This is evident in the two angels (Plan nos. 107, 108) on either side of the Virgin Orans (half-ruined) depicted in the east conch, in the imposing figure of the Archangel Michael portrayed frontally, with his splendid imperial costume and his

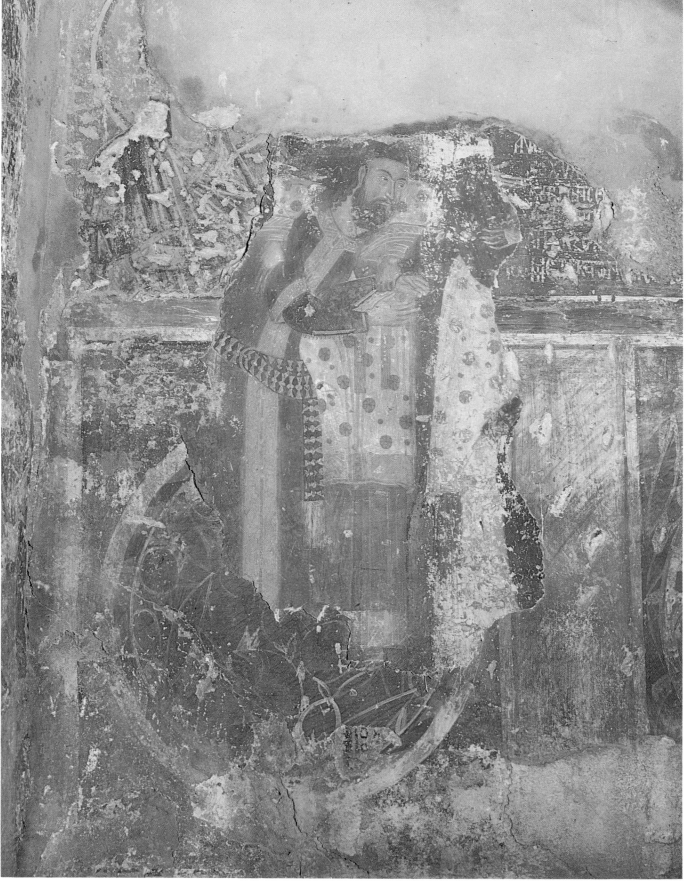

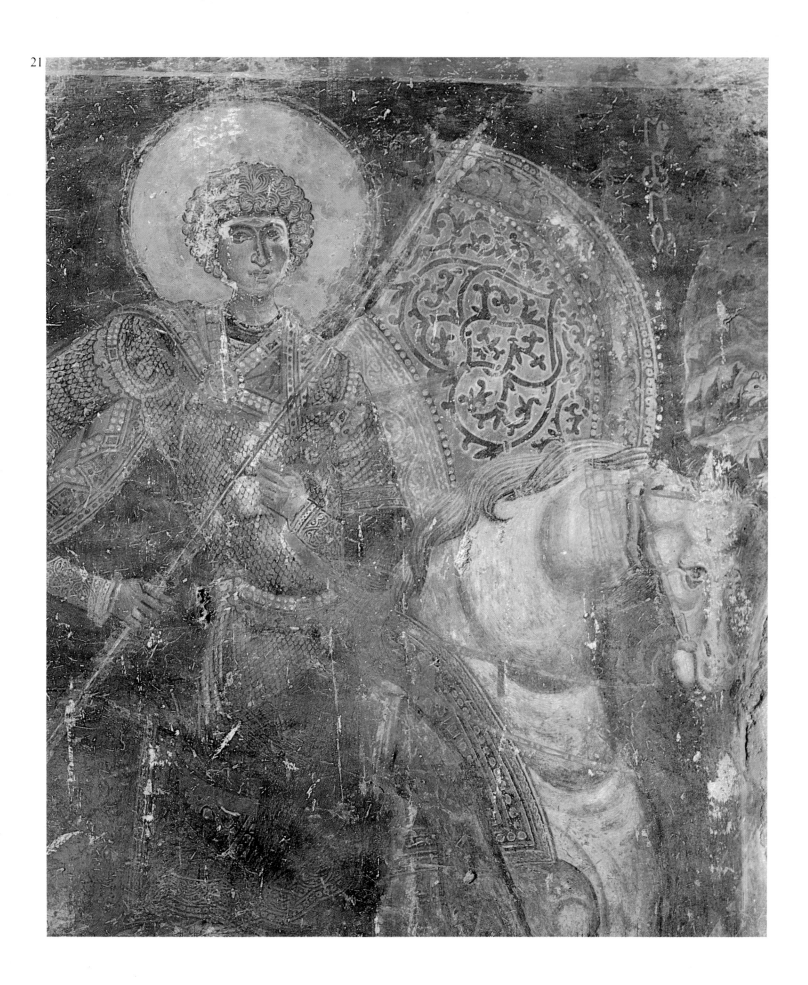

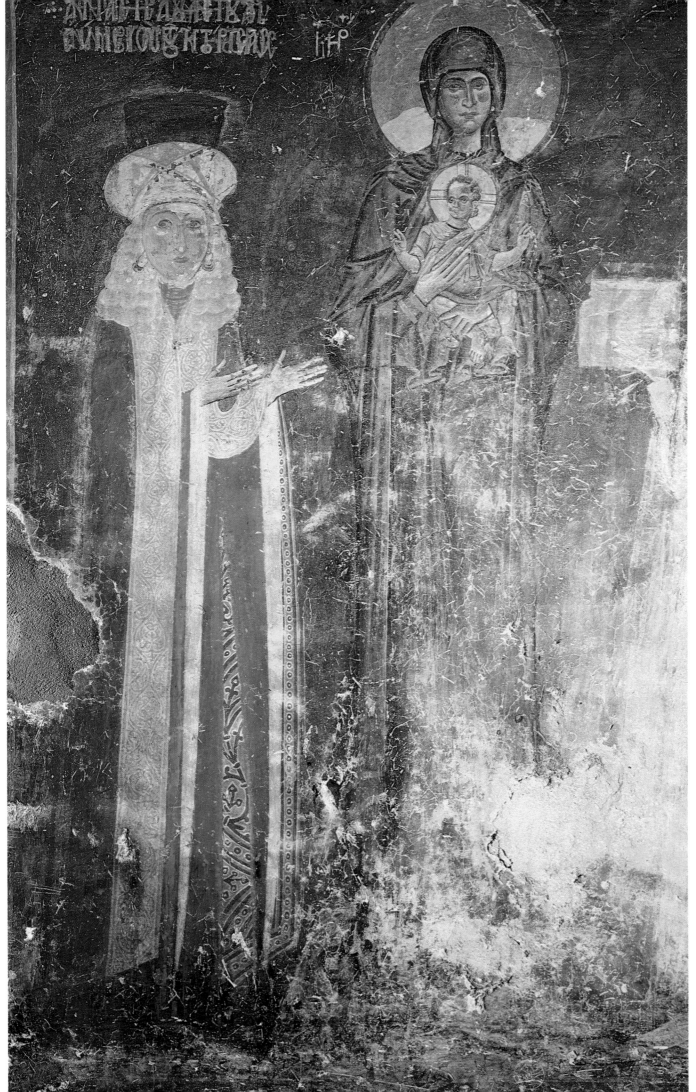

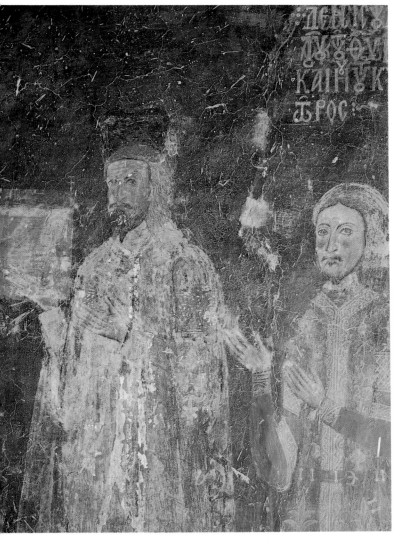

20. *Hagioi Anargyroi, north aisle. Donor (3 layers). Above left, the Virgin (first layer).*

21. *Hagioi Anargyroi, north aisle. St. George (detail).*

22. *Hagioi Anargyroi, north aisle. Anna Radene and the Virgin.*

23. *Hagioi Anargyroi. Theodoros Lemniotes and his son John.*

huge outspread wings, in the western part (Fig. 26, Plan no. 117) –his miracle at Chonae was depicted on the opposite wall– and finally in the miracles of the Sts. Anargyroi –and not those of Christ, since the scenes show two healers– visible in the partially preserved sections of the half-ruined vault.

From the same family must have come another Theodoros Lemniotes, a priest, who appears in a funerary representation of later date in the narthex of Hagios Stephanos (Fig. 16). In all these inscriptions

the word *ktetor* (literally founder) refers to the donors of the second layer of wall paintings.

Theodoros' two inscriptions in verse display a distinct preference for the dodecasyllable, with an archaic phraseology and an affectedly elegant circumlocution, as was customary in the major urban centres of the times and in buildings founded by the upper class to which the Lemniotes family belonged. The rare representation here of two regional saints, Hosios David (Plan no. 88) and St. Theodora (Plan no. 157), both of Thessaloniki, may denote a particular link with that city. This painting, too, is as scholarly as the poetry, with a profusion of elegantly designed decorative bands and other motifs, which recall rich illuminated manuscripts.

Another unidentified donor (or dead) is portrayed full-length, nobly dressed, in the north aisle, below the large representation of St. George. This portrait is assignable to the 13th-14th century (Fig. 20, Plan no. 97).

c. The painters

The distinction between painters A and B has been accepted (see bibliography). The decoration of the church was begun by B, who painted the huge Annunciation on the front of the apse (Plan no. 17), the Prophets on the lateral walls of the clerestory, and a number of scenes, notably the Visitation, the Nativity, the Presentation of Christ in the Temple, the Holy Women at the Sepulchre, the Descent into Hell and the Dormition of the Virgin (Plan nos. 35, 36, 37, 69, 70, 50). The painter is a provincial artisan whose work shows an absence of contact with contemporary artistic trends, although he does not lack the sense of monumentality that had prevailed in earlier times. Also to be noted is his distinctive tendency to attribute an often coarse moral fibre to the graceless figures, and especially to the faces with the low brow, the powerful jaws, the small eyes placed near the nose, the red spots on the cheeks and, generally speaking, with the indifferent expression (Fig. 8, Plan no. 12).

The rest of the decoration in the nave and the side-aisles, that is to say the majority of the wall paintings, has been executed by painter A, who is an artist of higher standard, well in command of the new means of expression utilized by this trend of the

"dynamic" Comnenian art: tall and elegant figures, a twist of the body, a flowing drapery of multiple folds adhering to the body, with undulating hems and folded back ends. The faces have a forceful expression of spiritual intensity (Fig. 7-19). These elements are treated by the painter in a personal manner. In our opinion, the indication "A" includes more than one painter, who worked in conformity with the same trend.

We should add at this point that the hand of a third notable painter, designated as C, has been detected in the narthex (Hadermann-Misguich), where he did most of the wall paintings. His standing figures, in particular, have postures of tranquillity and poise, with a broad modelling and a sparing use of folds in the drapery, in a rhythmic and more organic arrangement than that of A. The moral tone of the physiognomies portrayed by C is sober, pensive, without the expressive intensity of those painted by A (Fig. 27-30). Painter C has worked in conformity with the "academic" trend of his time (Chatzidakis), which co-existed with the "dynamic" style, the *"coene"* of Comnenian art, represented here by painter A.

The chronological relation between these three basic painters remains to be clarified. In the nave, on the south wall, the series of representations beginning with the Annunciation at the Well, executed by A, is painted on a layer of plaster protruding from the surface of the upper zone, painted with scenes by B (the Visitation, the Nativity etc.). This gives the impression that the work of A may have covered paintings by B. In this case, the succession of the two painters may have occurred with a considerable chronological difference.

The dominant presence of painter A associates chronologically as well these wall paintings with the "dynamic" style prevailing in the last 30 years of the 12th century, as exemplified by a large group of monuments, of which three are dated: the Enkleistra in 1183, the Panagia tou Arakos in 1192 –both in Cyprus– and the church of St. George at Kurbinovo in 1191 – the latter in Macedonia on lake Prespa. Painter A is so closely associated with the wall paintings of the Kurbinovo church as to provide one with good reason to maintain that the same artist had worked in both churches, though at different times (Hadermann-Mi-

sguich). Certain stylistic differences between the two mural ensembles –the excessive elongation in the lower part of bodies, the theatrical gestures, the harder modelling, the larger empty spaces in the compositions and other features of the Kurbinovo paintings– prevent a categorical affirmation of the painters' identity, but at the same time confirm that both mural ensembles belong to the same trend, with the slight difference that at Kurbinovo the dynamic style is pushed to its ultimate possibilities beyond every classical rule. Therefore, the Kastoria wall paintings can be dated safely one to two decades earlier, between the wall paintings at Nerezi (circa 1162) and those at Kurbinovo, i.e. in 1170-1180. This chronology is generally accepted in the respective international bibliography.

Relevant opinions after the discovery of the determining date, 1191, at Kurbinovo (1958) are of interest. Lazarev (1961, Congress of Ochrid) proposed the date of 1180, and so did Radojčić and Ljubinković. Demus suggested the end of the 12th century. Chatzidakis (1965 and 1979) proposed a date in circa 1180, and so did Hadermann-Misguich (1975) and lastly Malmquist (1979) and Wharton-Epstein (1980).

d. The façade

The west façade has preserved wall paintings in a symmetrical arrangement: on the tympanum over the door, the half-length figures of the Sts. Anargyroi; on either side of the door, the full-length figures of St. Peter and St. Paul; in the shallow niches, to the north, St. Nicholas "the ardent protector", portrayed full-length, with the accompanying small figures of Christ and the Virgin, and to the south, again the two full-length figures of the Sts. Anargyroi, turning towards the small figure of Christ pictured at the centre above. The door is flanked by two painted columns imitating "almond stone" and surmounted by cubic capitals with foliage ornaments. A broad arch resting on the capitals bears a decoration now indiscernible. The painted imitation of architectural elements is a feature of the Hellenistic tradition (Pompeii), also encountered in Byzantine manuscripts. A problem is presented by the two confronting busts of the Virgin and of St. John the Baptist, remnants of a Deesis from which the central figure of Christ is absent, as it would have occupied the place of the

bipartite window. The painted decoration of this, however, forms an organic part of the decoration in the interior of the 12th century narthex.

The exterior wall paintings covered the entire width of the façade. Those that have survived, though severely damaged, may be associated with the style of painter B. The wall paintings have suffered further damage from dense incisions. One of these, read by Orlandos, gives the date 1198, which provides a *terminus ante quem*.

Bibliography

O. Demus, "Die Enstehung des Paläologenstils in der Malerei", *Berichte zum XI. internationalen Byzantinistenkongress*, Munich 1958, p. 24 ff.

R. Ljubinković, "La peinture murale en Serbie et en Macédoine aux XIe et XIIe siècles", *IX Corsi di cultura sull' arte Ravennate e Bizantina*, Ravenna 1962, p. 405-441.

M. Chatzidakis in: Chatzidakis-A. Grabar , *Byzantine and Early Medieval Painting*, London (1965), p. 20.

V. Lazarev, *Storia della pittura bizantina*, Turin 1967, p. 210.

M. Chatzidakis, *Propyläen Kunstgeschichte*, vol. 3, Berlin 1968, p. 237, no. 178.

K. N. Bakirtzis, «Ἐπιγραφή στούς Ἁγίους Ἀναργύρους Καστοριᾶς», *Μακεδονικά*, vol. 11, 1971, p. 324 ff.

L. Hadermann-Misguish, *Kurbinovo*, Brussels 1975, p. 34-35, 563-584 and sporadically. "Une longue tradition byzantine. La decoration extérieure des églises", *Zograf*, vol. Z΄, 1976 (1977), p. 6-10.

R. Krautheimer, *Early Christian and Byzantine Architecture*, Penguin Books, 1975, p. 354-355, fig. 294.

M. Chatzidakis, Ἱστορία τοῦ Ἑλληνικοῦ Ἔθνους, vol. Θ΄, 1979, p. 404 ff.

T. Malmquist, *Byzantine 12th century Frescoes in Kastoria: Agioi Anargyroi and Agios Nikolaos tou Kasnitzi*, Upsala 1979.

A. Wharton-Epstein, "Middle Byzantine Churches of Kastoria: Dates and Implications", *The Art Bulletin*, vol. LXII, June 1980, p. 195 ff.

M. Chatzidakis in Weitzmann et al., *Le Icone*, Ed. Mondadori, Milan 1981, p. 131-132, fig. p. 150 (also published in English and French).

E.N. Kyriakoudis, «Ὁ κτίτορας τοῦ ναοῦ τῶν Ἁγ. Ἀναργύρων Καστοριᾶς Θεόδωρος (Θεόφιλος) Λημνιώτης», *Βαλκανικά Σύμμεικτα*, Ἵδρ. Μελετῶν Χερσονήσου τοῦ Αἵμου, I, Thessaloniki 1981, p. 3 ff.

Sv. Tomeković, «Les repercussions du choix du saint Patron sur le programme iconographique d' églises du 12e siècle à Macédoine et dans le Péloponnèse», *Zograf*, vol. IB΄, 1981, p. 25-42.

M.CH.

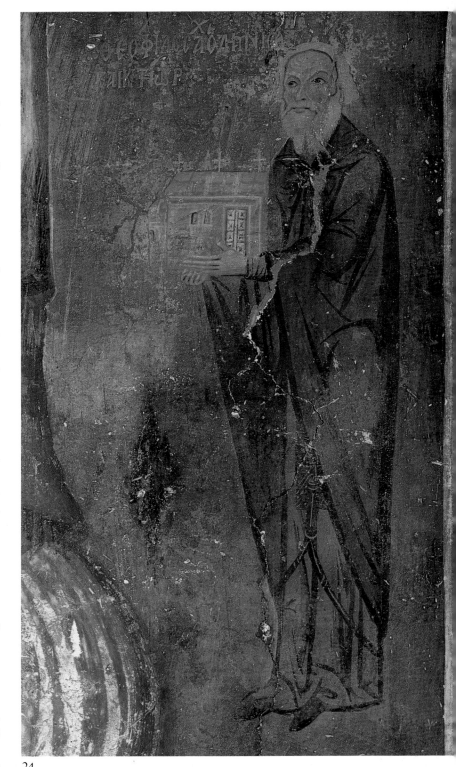

24

24. *Hagioi Anargyroi, south aisle. The monk Theophilos Lemniotes.*

25. *Hagioi Anargyroi, south aisle. The Sts. Antony, Euthymios and Arsenios.*

26. *Hagioi Anargyroi, south aisle. The Archangel Michael.*

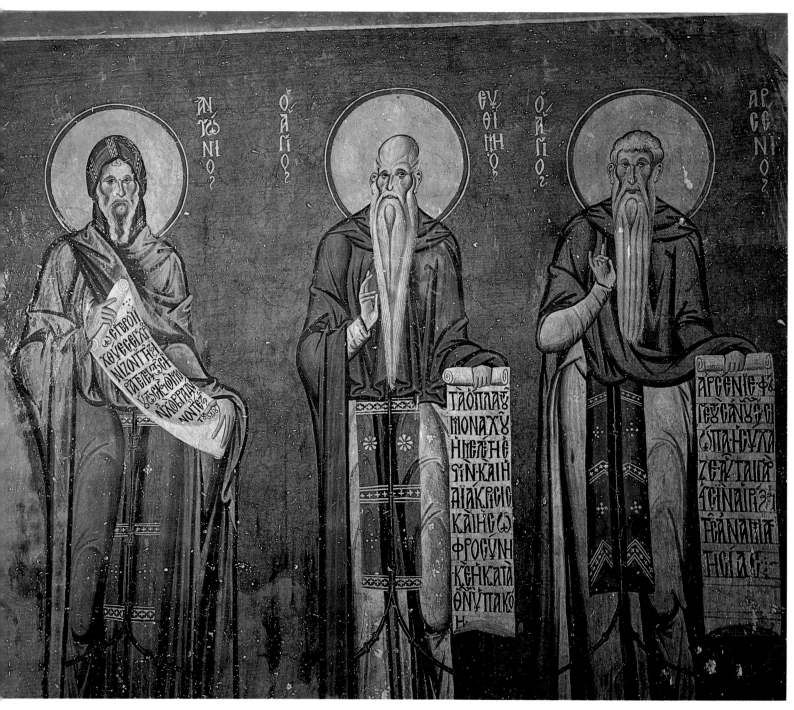

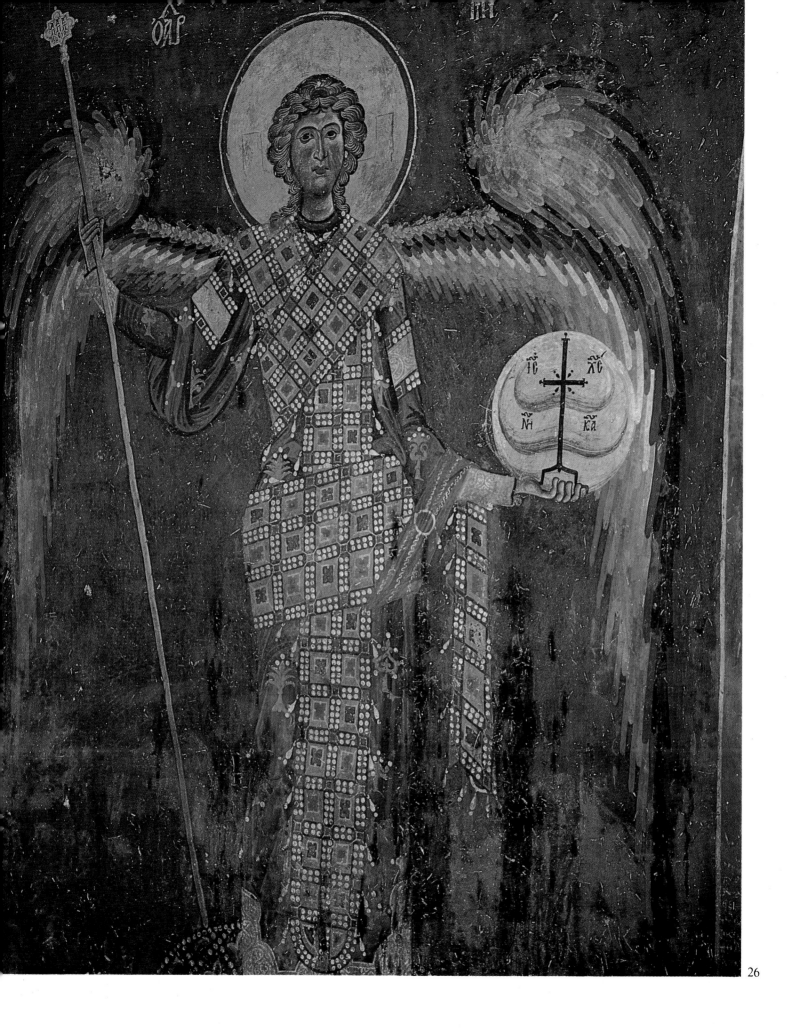

26

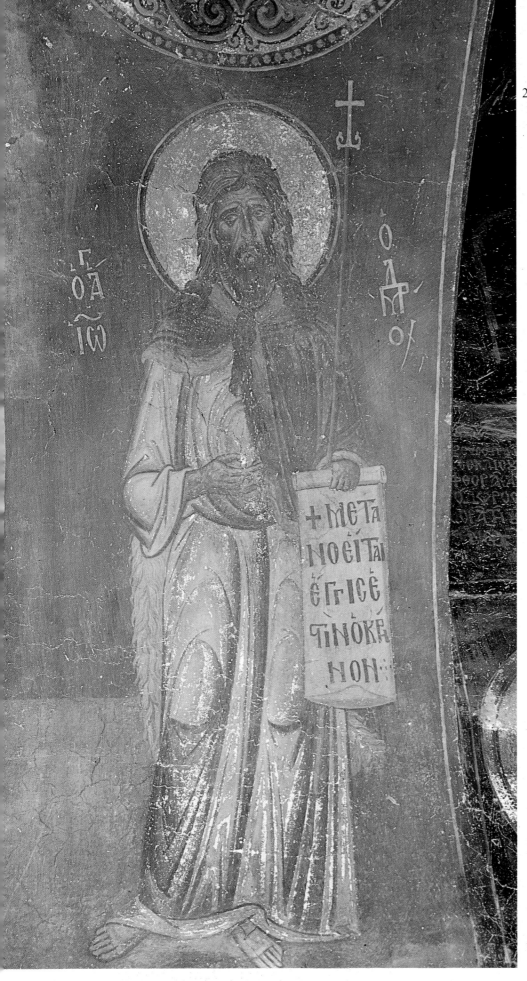

27. *Hagioi Anargyroi, narthex. St. John the Baptist.*

28. *Hagioi Anargyroi, narthex. The Ascension (detail).*

29. *Hagioi Anargyroi, narthex. Entrance to the naos.*

30. *Hagioi Anargyroi, narthex. The Ascension (detail).*

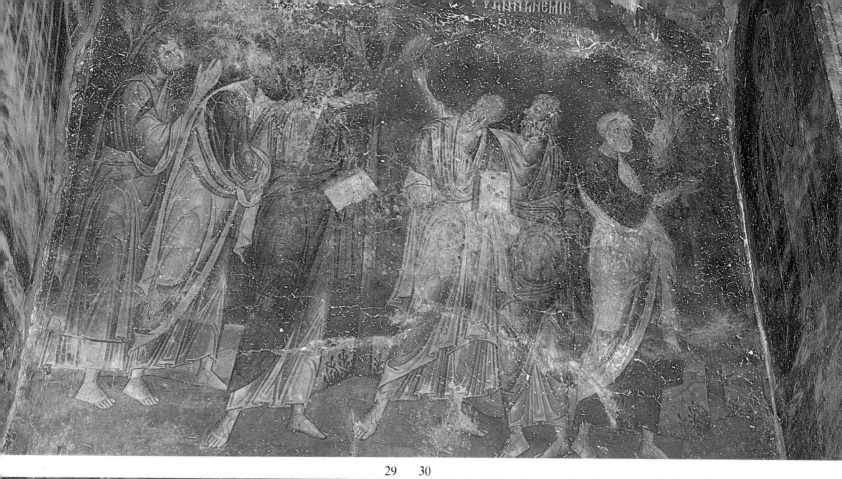

29 30

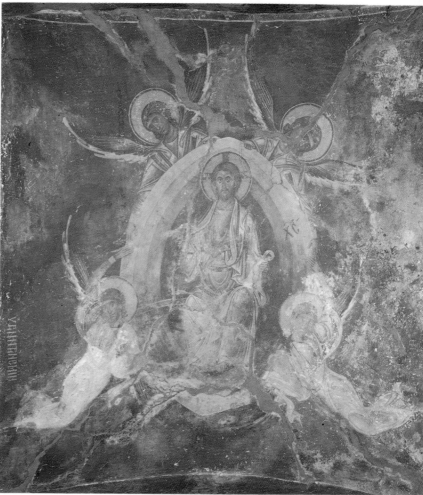

HAGIOS NIKOLAOS TOU KASNITZI

The small church of Hagios Nikolaos tou Kasnitzi stands in Omonoia Square, the upper square of the town (Fig. 3). The date of its foundation is unknown. The only information available on the history of the church is provided by three inscriptions, of which one on the west wall of the naos over the entrance leading from the narthex to the church proper. The other two inscriptions accompany the portraits of the founder and of his wife Anna, depicted on the east wall of the narthex on either side of the painted bust of St. Nicholas. From the inscriptions we learn: a) that the *magistros* (magister) Nikephoros Kasnitzes was the founder of the church and that he embellished it "with paint works and a variety of images"; b) that the church was a "return-gift" for the beneficence of the saint towards the founder; and c) that Kasnitzes had been exiled to Kastoria. It is indeed known that Kastoria had served as a place of exile for courtiers and other high ranking officials of the Byzantine state. Cedrinus records that the Empress Irene banished to Kastoria two officers who had helped her son Constantine in plotting against her.

Architecture

The church is single-naved with a projecting large semicircular apse on the east side. Two smaller conches are hollowed into the thickness of the east wall, on either side of the apse. The narthex extends along the whole width of the basilica. Two entrances, one in the west wall and a smaller one in the north wall, lead the first into the narthex and the second directly into the naos. A few small windows –a double and a single one high up in each of the long walls and another double one in the apse– light dimly the interior of the church (Fig. 4). A blind arch reaching to ground level is formed in the eastern part of the south wall and contains the painting of the patron-saint of the church

(Fig. 4, 11). The presence of an arch, in that part of the church, intended to be painted with the portrait of the titular saint is not a rare feature in the northern regions of Greece.

The masonry consists of courses of unworked stones separated by single, double or triple layers of bricks. This arrangement is quite often interrupted by the insertion of simple brickwork. A toothed band runs along the upper termination of the walls and, immediately below, a frieze of rectangular terracotta tiles decorated with diagonal incisions.

Works undertaken in 1952 included the restoration of the west wall of the narthex, the removal of the later horizontal wooden ceiling –which revealed the wall paintings of the two pediments– and the installation of a new pitched roof.

Painting

The interior walls of the church are wholly covered with paintings divided into two main horizontal zones. However, the presence of the blind arches and of the single– and double-arched windows in the long walls interferes with the division of surfaces, creating another narrow zone between the two main ones and several smaller surfaces (Fig. 4).

The iconographic decoration of the church, which is preserved in fairly good condition, follows the well-known programme. The large-scale compositions from the Twelve Feasts cycle in the upper zone start with the Annunciation (Fig. 9, 10), continue at the eastern end of the south wall with the Visitation and terminate at the eastern end of the north wall with the Descent into Hell (Fig. 25-27, 35, 37, 53-56). On the east wall, on the pediment above the Annunciation, a Deesis is depicted with the three figures in full length. The Ascension, the Transfiguration and the Dormition of the Virgin are painted on the west wall (Fig. 14). The

narrow zone formed between the two larger ones is painted with busts of saints in array, and the lower zone of the two long sides with full-length figures of warrior saints. In the lower zone of the west wall, which is interrupted by the doorway, are depicted full-length figures of doctor saints.

The narthex is decorated with scenes from the life of St. Nicholas (Fig. 18, Plan nos. 66-68, 73-74, 79-80). In the lower zone are depicted full-length saints and to the right of the Royal Door, for special reasons, the Baptism (Fig. 20, Plan no. 59). High on the eastern pediment is a rare composition of the Deesis with Christ as the Ancient of Days in the middle (Fig. 17, Plan no. 69).

The style and technique of the wall paintings in Hagios Nikolaos are very close to those of painter A in the church of the Hagioi Anargyroi, in spite of certain differences in design, treatment of figures and colour scheme. Differences in style noted between wall paintings in the church, have led some investigators to believe that more than one artists had worked simultaneously in this monument. However, a close observation of the details of the whole work shows convincingly that only one artist, probably working with a team of assistants, storied the church. Anyhow, the pursuit of different solutions in the presentation of particular scenes by the same artist and variations in the depiction of certain figures are familiar features of large painting in the years to which the wall paintings of Hagios Nikolaos are to be assigned. Along with his ingenious iconographic solutions, the artist has succeeded in presenting both the human and the divine element, by painting faces with liquid eyes reflecting gentleness, kindness and simplicity, rather than countenances with hard, austere and ascetic features. The colours used are luminous, transparent and of various hues: pink, light green, light blue, off-white, golden-yellow. Deeper colour tones are predominantly used only for traditional raiments, such as the *maphorion* of the Virgin.

The Ascension on the west pediment of the naos is a perfectly articulated composition. The two halves of the chorus of Apostles, led by Peter and Paul, move rhythmically towards the centre where the Virgin Orans stands flanked by attending angels. Everything,

the stepping, the gestures, the position of the heads, the facial expressions, the draperies and the colouring, form a closely knit whole culminating in the figure of Christ, who is seated in a "glory" and lifted to heaven by angels. Christ is portrayed long-haired, with a severe countenance. The overall tint is pale yellow with red-black contours. The figure is enveloped in an ample robe gathered in formal yet soft folds around the knees and the feet (Fig. 14).

On the same wall is painted the Dormition of the Virgin, shown lying with her head to the right, i.e. contrary to the customary iconographic model. In most of the large compositions –except for the scenes from the life of St. Nicholas– a certain mannerism is prevalent, without destroying however the balance of the whole. As a rule the heads are relatively small in comparison with the bodies, which are usually elongated with narrow shoulders (Fig. 16, Plan no. 36).

The area of the eyes has been treated in a manner similar to that encountered in the Hagioi Anargyroi and in mosaics dated to the end of the 11th-beginning of the 12th century. The nose is thin with a slightly aquiline lower end. The treatment of the sumptuous garments, the soft and flowing arrangement of folds, which quite often are folded back upon the feet, and not a few other details date the wall paintings of Hagios Nikolaos to the time between the mural decorations of Daphni and of the Cappella Palatina, notably in the first thirty years of the 12th century at the latest.

The dating of the wall paintings of the Hagioi Anargyroi and of Hagios Nikolaos has been disputed, particularly after the publication of the wall paintings of the Panagia tou Arakos in Cyprus and of St. George at Kurbinovo. It is a fact that at first sight the murals of the two churches of Kastoria and those of Arakos and of Kurbinovo give the impression of forming one group. However, a thorough study and close observation of the paintings, *in situ*, prove that the murals of Arakos and of Kurbinovo have with those of Kastoria the same relation –or difference– as that existing between an original and a dull copy on which an effort has been made to impart some vigour by craftsmen of lesser artistic merit, quite some time after the creation of the original work.

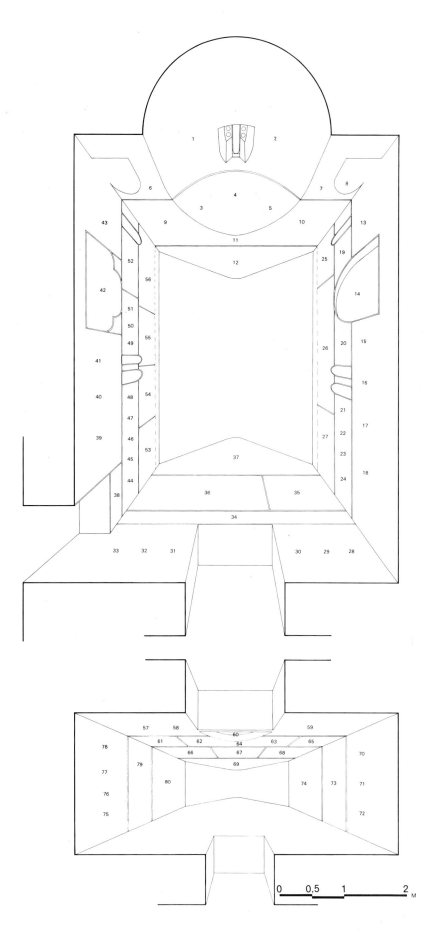

Bibliography

A. Orlandos, «Τά βυζαντινά μνημεῖα τῆς Καστοριᾶς», ᾽Αρχεῖον Βυζαντινῶν Μνημείων ῾Ελλάδος, vol. Δ´, 1938, p. 137-146.

P. Tsamisis, ῾Η Καστοριά καί τά μνημεῖα της, Athens 1949, p. 104.

S. Pelekanidis, Καστοριά. Βυζαντιναί Τοιχογραφίαι, Θεσσαλονίκη 1953, p. 24 ff., pl. 43-62.

S. Pelekanidis, "I più antichi affreschi di Kastoria", Corsi di cultura sull' arte Ravennate e Bizantina, Ravenna 1964, p. 358 ff.

Id., "Kastoria", Reallexikon zur byzantinischen Kunst, l. 1190 ff.

O. Demus, "Studien zur Byzantinischen Buchmalerei des 13. Jahrh.", Jahrbuch der Öesterreichischen Byzantinischen Gesellschaft, vol. IX, 1960, p. 84.

Id., Actes du XXIe Congrès International d' Études Byzantines, Belgrade 1961, p. 344, note 4.

L. Hadermann-Misguich, Kurbinovo, Brussels 1975, p. 35, note 45-47.

S.P.

HAGIOS NIKOLAOS TOU KASNITZI

1. Three hierarchs. 2. Three hierarchs. 3. The Archangel. 4. The Virgin. 5. The Archangel Gabriel. 6. Two saints. 7. Saint. 8. St. Romanos the Deacon. 9. The angel of the Annunciation. 10. The Virgin in the Annunciation. 11. The Holy Mandylion. 12. Deesis. 13. St. Cyril and hierarch. 14. St. Nicholas. 15. St. Demetrios. 16. St. George. 17. St. Nestor. 18. St. Mercurios. 19. Saint. 20. St. Eustratios. 21. St. Auxentios. 22. St. Mardarios. 23. St. Eugenios. 24. St. Orestes. 25. The Visitation. 26. The Nativity. 27. The Presentation in the Temple. 28. St. Cosmas. 29. St. Panteleimon. 30. St. Damian. 31. St. Cyrus. 32. Hermolaos. 33. St. John the Anargyros 34. Founder's inscription. 35. The Transfiguration. 36. The Dormition of the Virgin. 37. The Ascension. 38. St. Menas the Egyptian. 39. St. Procopios. 40. St. Theodoros Stratelates. 41. St. Theodoros Tiro. 42. The Pantocrator. 43. Two hierarchs. 44. Saint. 45. Saint. 46. St. Gourias. 47. St. Samonas. 48. St. Abibos. 49. St. Floros. 50. Saint. 51. St. Lavros. 52. St. Charalampos. 53. The Entry into Jerusalem. 54. The Crucifixion. 55. The Holy Women at the Sepulchre. 56. The Resurrection. Narthex. 57. The Virgin and Child (Hodegetria). 58. St. Elpidios. 59. The Baptism. 60. St. Nicholas. 61. The Prophet Elijah. 62. The founder Kasnitzes. 63. The wife of Kasnitzes. 64. Holy Ceramion. 65. St. Elissaios. 66. Miracle of St. Nicholas. 67. St. Nicholas in prison. 68. St. Nicholas and the Emperor. 69. Deesis with the Ancient of Days. 70. St. Constantine. 71. St. Helen. 72. St. Photeine. 73. St. Nicholas saves the maidens from prostitution. 74. Scene from the life of St. Nicholas. 75. St. Juliane. 76. St. Barbara. 77. St. Marina. 78. Woman saint. 79-80. Two miracles of St. Nicholas: the demoniac in two scenes.

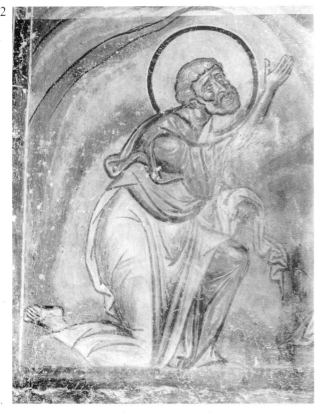

1. *Hagios Nikolaos tou Kasnitzi. Perspective plan.*

2. *Hagios Nikolaos tou Kasnitzi, west wall. St. Peter, detail of the Transfiguration.*

3. *Hagios Nikolaos tou Kasnitzi. East side.*

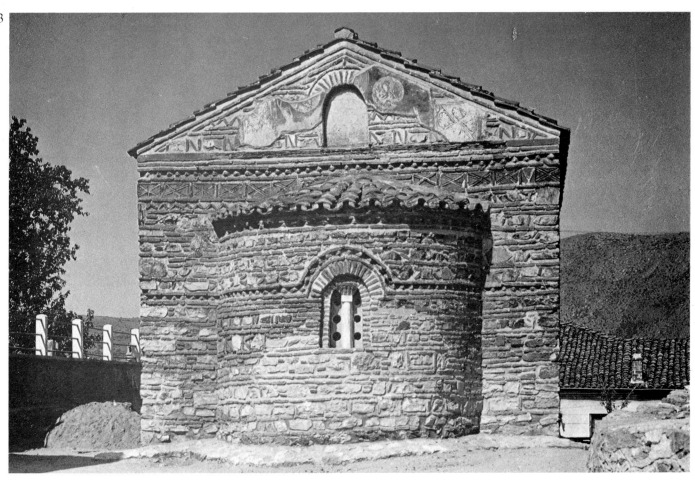

4. Hagios Nikolaos tou Kasnitzi. South wall (eastern part).

5. Hagios Nikolaos tou Kasnitzi, south wall. Section with paintings of the Presentation in the Temple and of the Sts. Mardarios, Eugenios and Orestes.

6 and 8. Hagios Nikolaos tou Kasnitzi. The Annunciation, above the apse.

7. Hagios Nikolaos tou Kasnitzi, south wall. The Bathing of the Child, detail of the Nativity.

4 5

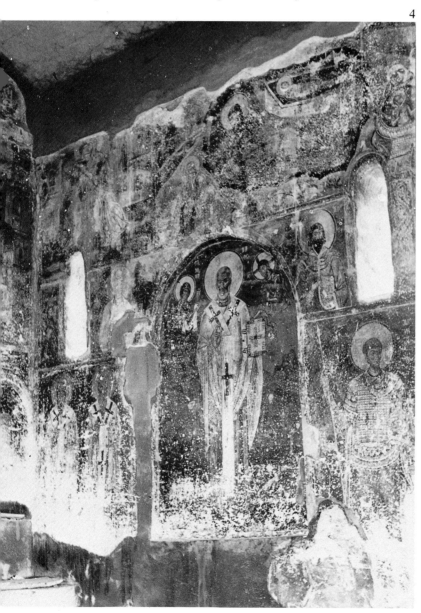 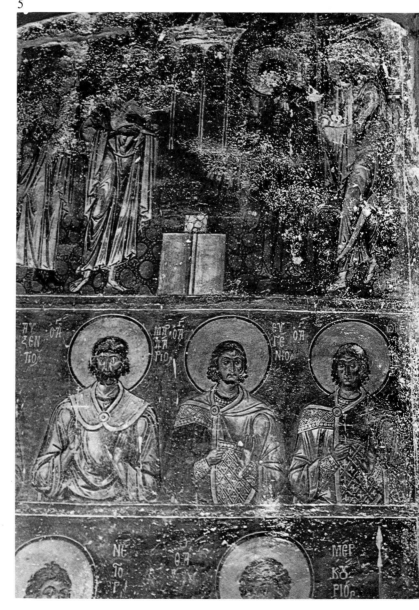

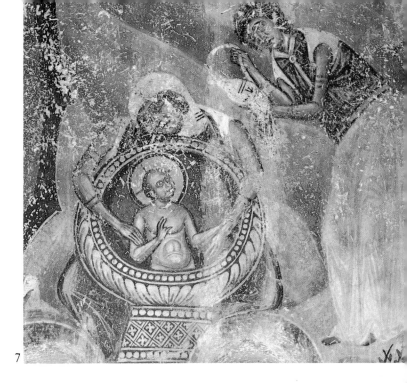

7

6

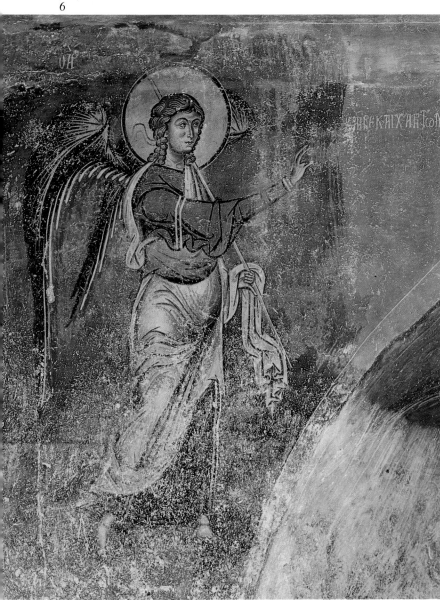

8

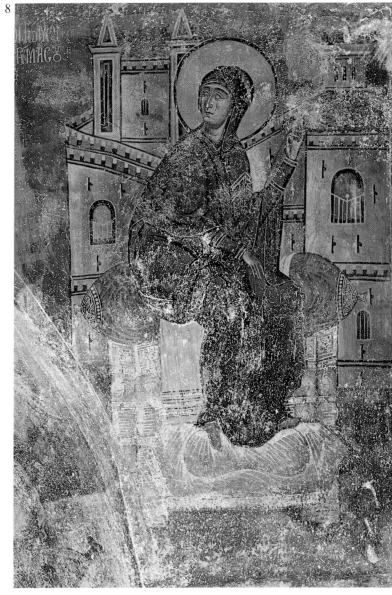

HAGIOS NIKOLAOS TOU KASNITZI

Supplementary Note

The building

It would be interesting to add that on the exterior of the church, on the pediment above the apse, the ornamental brickwork forms a series of capital N letters. These could refer either to the founder Nikephoros, or to St. Nicholas the titular saint of the church (Fig. 3).

The masonry of Hagios Nikolaos –a 12th century church– is worthy of particular study, in comparison with that of the older churches of Kastoria, so that a possible chronological evolution could be traced.

Finally, it would be worth noting that in the interior the apse has an almost pointed crown.

The wall paintings

At least parts of the outer walls of the church were initially covered with wall paintings. Some fragments are still visible on the pediment above the apse, showing the remains of a large-scale bust of St. Nicholas between the two small figures of Christ and the Virgin within roundels. The central painting is flanked by panels decorated with large palmettes (Fig. 3). The north wall has preserved near the entrance a fragment of a wall painting, the subject of which has not been identified (Tree of Jesse?). Quite probably, these wall paintings are later than those of the interior.

There can be no doubt that the style of the wall paintings of both the naos and the narthex belong to the same artistic trend, to a similar social setting and, in general, to the same period with those of the Nerezi paintings. However, the difference in rank between the founders –the one a grandson of the Emperor, the other a simple *magistros* and not an exile– must have had some effect on the quality of the work. The art of Hagios Nikolaos has neither the greatness nor the creative sensitivity manifest at Nerezi. Nevertheless they are kindred arts and their affinity can be seen in the elaborate, if more linear manner, with which the faces are treated in Hagios Nikolaos, in the cold and deeper-hued pale underpaint of the flesh to which some highlights give a relief appearance, in the few quick curvilinear brush strokes adding red colour to the cheeks and warmth to the flesh (Fig. 12, 13, 21). At Nerezi, as in the earlier imperial portraits of John Comnenos and his family in Hagia Sophia (1118-1122), a combination of red and green touches colour the cheeks in a more pictorial manner. In Hagios Nikolaos the manner in which this feature is handled differs in the various parts of the church. It would be sufficient to compare the linear and sculptural plasticity of the worshipping angel by the standing Virgin Orans in the sanctuary, with the angels of the Baptism scene (Fig. 9, 20) where the small white lights seem to sparkle. One would recognize different hands, working in the same (?) team.

The treatment of draperies presents some characteristics particular to Hagios Nikolaos. Dense folds are depicted with dark colours and the various parts of the body are indicated with lighter gradations of the same colour ending in white surfaces. When large, these surfaces often assume geometric forms, which end by lending a metallic sheen to the figures (Fig. 5, 10, 13 etc.). Variations exist, however, depending on the subject. In the Dormition of the Virgin the somewhat agitated geometric arrangement of the folds expresses pathos, whereas in the Ascension the smooth, sparse, vertical folds befit the monumental and majestic character of the representation (Fig. 14).

Examined from the point of view of the disposition of wall space, the size of some of the compositions is impressive. An example is the scene of the Nativity, which occupies almost half the length of the south wall. Perhaps the explanation for this is to be found not only in the artist's leaning towards the monumental but also in the probability that the design had been copied from a painting of a much larger church. We note the particular affinity between the scene of the Bathing of the Child (Fig. 4, 7, Plan no. 26) and the corresponding

scene in the composition of the Birth of the Virgin in the much larger church at Nerezi. Owing to the dimensions of this scene, the number of feasts depicted in the church of Hagios Nikolaos has been reduced to eleven. Similarly the Ascension, which is depicted on the eastern or the western pediment in the basilicas of Kastoria (cf. the Mavriotissa in Kastoria, but also St. George at Kurbinovo and the Theologos in Veroia) has here immense dimensions as compared with the other scenes, and spreads below the pediment over half the surface of the west wall (Fig. 14). Even in the narthex the scenes from the life and miracles of St. Nicholas are of unequal size. The whole length of the south wall is taken up by only one scene, while the corresponding surface of the north wall is painted with two scenes (Plan nos. 73-74, 79-80).

From an iconographical point of view, the sequence of these miracle scenes on the north wall is unusual: the one shows a standing naked youth; the other, probably representing the healing of the demoniac, is a scene from the life of another St. Nicholas. The afflicted youth is pictured nude, bending down with hands tied behind his back and a rope around his neck. An explanation is also required for the emphasized and rather unexpected depiction in the narthex of the little known St. Elpidios. Prominently placed opposite the doorway, the nobly attired saint –he was at the court of the Emperor Julian– turns in supplication to the similarly full-length figure of the Virgin Hodegetria standing to his right (Plan nos. 57, 58).

All the wall paintings in the interior of the naos and the narthex are related not only by their highly characteristic style and technique but also by a certain uniformity of portraiture. The slender figures are aristocratic, with the facial nobility of spirituality, wearing splendid suits of armour as if they all belonged to the family of the *magistros* Kasnitzes (Fig. 12, 13). Moreover, all the faces –such as that of the full-length St. Nicholas near the templon (Fig. 11), those of angels and of many younger saints (Fig. 6, 8, 10, 12, 13, 16)– are pictured with protruding eyeballs, which lend a certain intensity to the serious and often melancholy expression of the faces. This feature has been noted already in the Hagioi Anargyroi and in some paintings in Hagios Stephanos, but not at Nerezi. It conforms with the psychological anxiety which often grips the

figures portrayed in wall paintings and icons of the last quarter of the 12th century, and is here most apparent in the three apostles of the Transfiguration (Fig. 2 and 15).

A peaceful rhythm dominates the whole decoration, each separate composition, every human figure. This rhythm, along with the other characteristic features noted, assigns the wall paintings of Hagios Nikolaos to the sober "academic" painting trend of those times. However, the occasional appearance of certain motives shows that the painter was not unaware of the other tendency in contemporary painting. This can be seen in the Salutation of Mary and Elizabeth (Plan no. 25), where the long dress with its "mannerism" in the arrangement of folds imparts a dramatic touch to the scene. Although belonging to a different trend, the mural decoration of Hagios Nikolaos shares some common features with that of the artistic currents of the times – for example, the modelling of faces (though in the Hagioi Anargyroi the flesh is much more luminous), the protruding eyeballs etc.

Before reviewing the opinions advanced on the dating of these wall paintings, we would like to note: First, that this monument too has not been studied methodically and consequently most of the suggestions are not final, as they are based on partial observations of certain scenes only. They are not, therefore, confirmed and their validity is relative. Second, that in many instances the dating has been deduced by reference to monuments of a different class and of another category.

It should be remembered that the wall paintings are assignable to the aristocratic art of the epoch, and that the founder, the *magistros* Nikephoros Kasnitzes whose portrait shows no signs of modesty (Fig. 19, Plan no. 62), must have belonged to the local aristocracy. The expression "εἰς τόν κλαυθμῶνος τόπον" ("to the place of weeping") appearing in the archaizing founder's inscription, which reads:

πολλῶν τετευχώς δωρεῶν σῶν τρισμάκαρ
ἀφ' οὗ περ ἦλθον εἰς τό[ν] κλαυθμῶνος τόπον

having been granted many gifts from you, thrice
 blessed,
since I came to the place of weeping

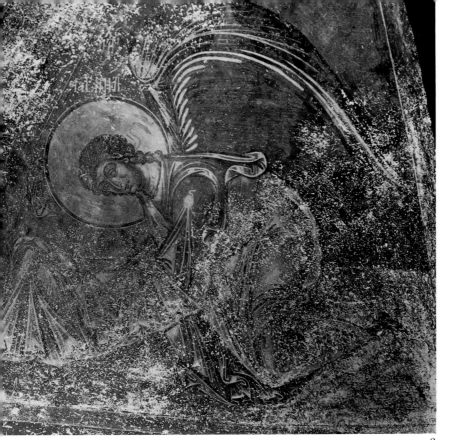

9

is more likely to be implying earthly life rather than the town of Kastoria, as it has been interpreted so far. Besides, it would not be normal to declare emphatically that the saint had favoured the *magistros* only after he had come to Kastoria, the alleged place of his banishment.

After Orlandos' earlier dating in the first half of the 13th century, Pelekanidis suggested the end of the 11th (1953), then the first third of the 12th (1961), "at least five years before Nerezi" (1964), and lastly he reverted to a chronology between Daphni and the Cappella Palatina. Rajković and Lazarev accepted the period 1160-1180, always in relation to Nerezi. Demus hesitated between the third quarter of the 12th (1958) and the middle of the same century (1961) and Kitzinger, on the basis of the relation between the scenery and the figures of the Transfiguration and in comparison with a similar representation in the Palatina, preferred the mid-12th century (1970). More recently Hadermann-Misguish (1975) prefers the last third of the 12th century and so does Djurić, while Malmquist suggests the beginning of the 13th century.

I think that all the observations made by the various scholars to this day and the supplementary remarks made above point to a dating of the wall paintings of Hagios Nikolaos after Nerezi (1164) and closer to Kurbinovo (1191).

Bibliography

L. Hadermann-Misguish, "Une longue tradition byzantine. La décoration extérieure des églises", *Zograf*, vol. 7, 1976 (1977), p. 8.

L. M. Rajković, *Sbornik, Radova, C.A.H. XLIV, Byz. Inst.*, vol. 3, Belgrade 1955, p. 209, note 4 (in Serbian).

V. Lazarev, *Storia della Pittura bizantina*, Turin 1967, p. 211.

O. Demus, "Die Enstehung des Paläologenstils in der Malerei", *Berichte zum XI. International Byzantinistenkongress*, Munich 1958, p. 25.

E. Kitzinger, "Byzantium and the West in the Second Half of the Twelfth Century", *Gesta*, vol. IX, 2, 1970.

V. Djurić, "La peinture murale byzantine, XIIe et XIIIe siècles", *Actes du XVe Congrès International d' Études Byzantines. Rapports et Co-rapports*, vol. III. Art et Archéologie. Athens 1976, p. 21 (Athens 1979, p. 177).

T. Malmquist, *Byzantine 12th Century Frescoes in Kastoria. Agioi Anargyroi and Agios Nikolaos tou Kasnitzi*, Upsala 1979, especially p. 108-109.

M. Chatzidakis, Ἱστορία τοῦ Ἑλληνικοῦ Ἔθνους, vol. Θ΄, p. 404.

A. Wharton-Epstein, "Middle Byzantine Churches of Kastoria", *Art Bulletin*, LXII, June 1980, 195.

Sv. Tomeković, "Les répercussions du choix du saint Patron sur le programme iconographique d' églises du 12e siècle à Macédoine et dans le Péloponnèse", *Zograf*, vol. IB΄, 1981 p. 25-40.

M.CH.

11

9. *Hagios Nikolaos tou Kasnitzi, apse. Worshipping angel.*

10. *Hagios Nikolaos tou Kasnitzi, north wall. St. Menas.*

11. *Hagios Nikolaos tou Kasnitzi, south wall. St. Nicholas.*

12. Hagios Nikolaos tou Kasnitzi, south wall. The Sts. Demetrios and George.

13. Hagios Nikolaos tou Kasnitzi, south wall. The Sts. Nestor and Mercurios.

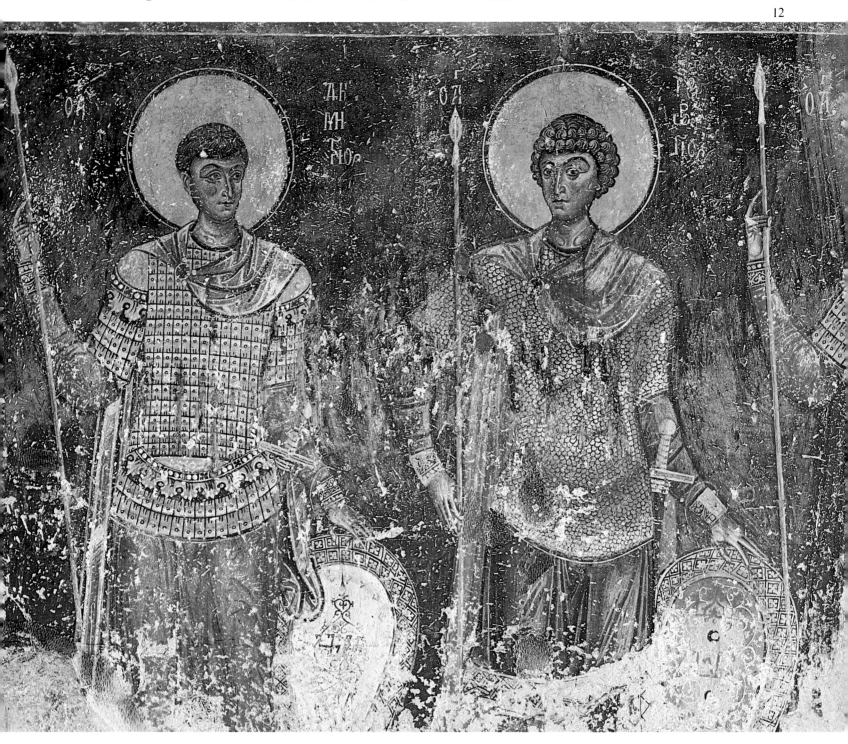

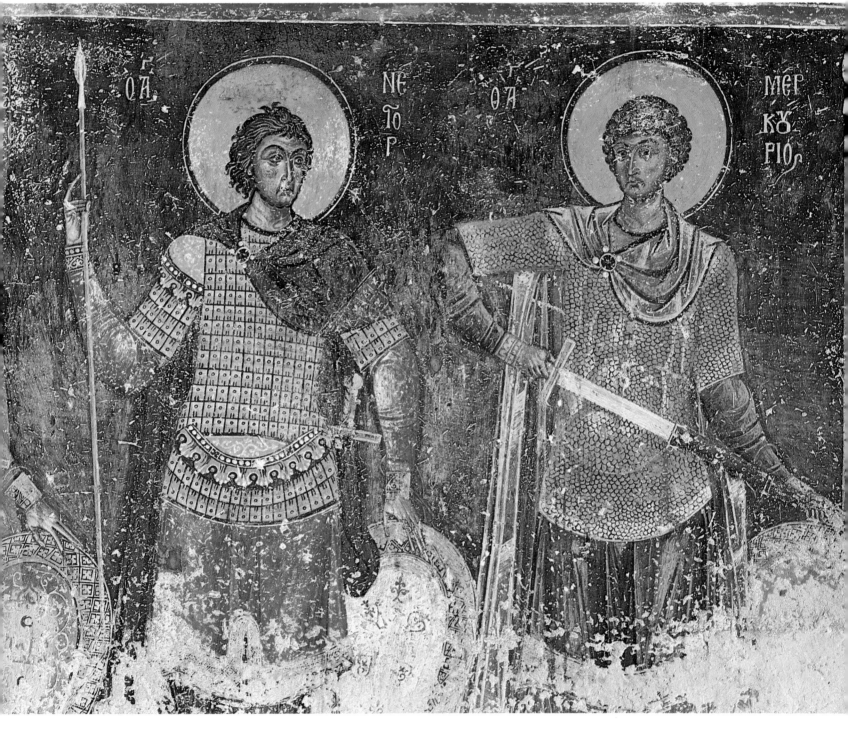

14

15

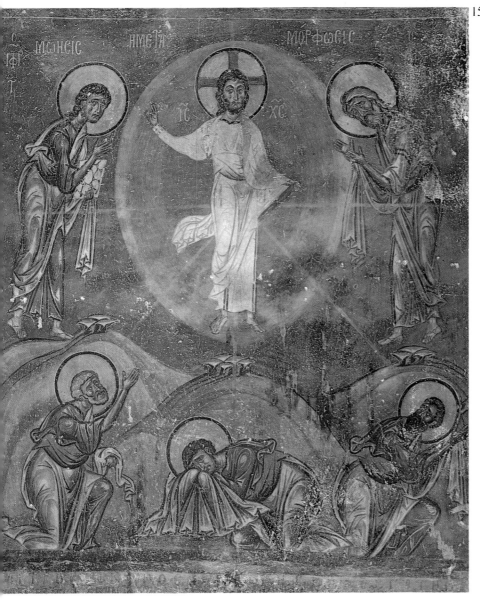

14. *Hagios Nikolaos tou Kasnitzi. West wall.*

15. *Hagios Nikolaos tou Kasnitzi, west wall. The Transfiguration.*

16. *Hagios Nikolaos tou Kasnitzi, west wall. The Dormition of the Virgin.*

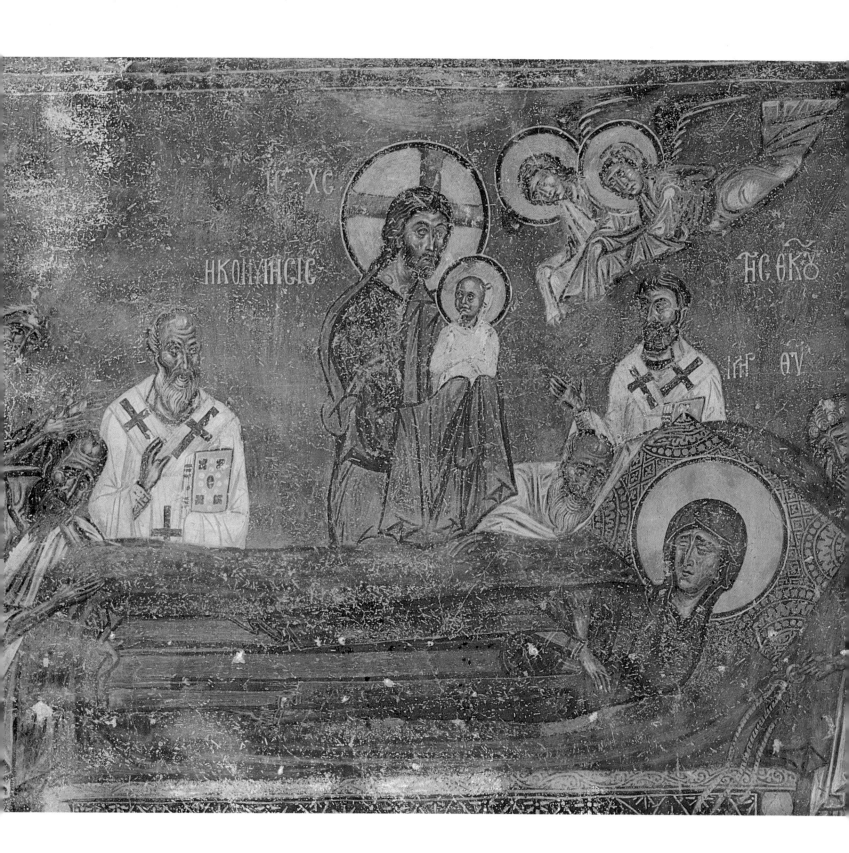

ΙC ΧC

ΗΚΟΙΜΗCΙC

ΑC ΘΚ̅Υ̅

ΙΗΡ ΘΥ

17

18

17. *Hagios Nikolaos tou Kasnitzi, narthex. The Ancient of Days.*

18. *Hagios Nikolaos tou Kasnitzi, narthex. The miracle of St. Nicholas with the eparch.*

19. *Hagios Nikolaos tou Kasnitzi, narthex. The founder, Nikephoros Kasnitzes.*

20. *Hagios Nikolaos tou Kasnitzi, narthex. The Baptism (detail).*

21. *Hagios Nikolaos tou Kasnitzi, narthex. Nikephoros' wife, Anna.*

20

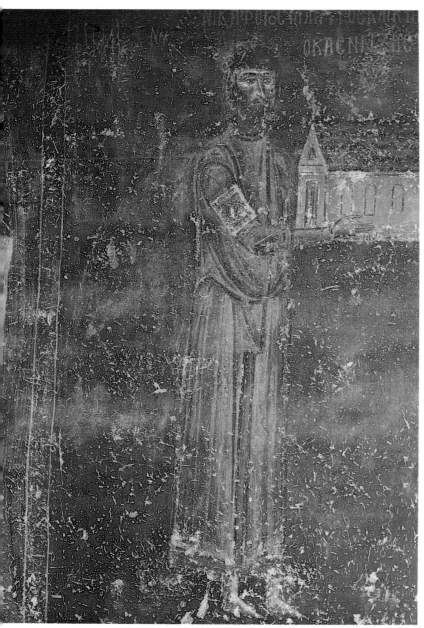

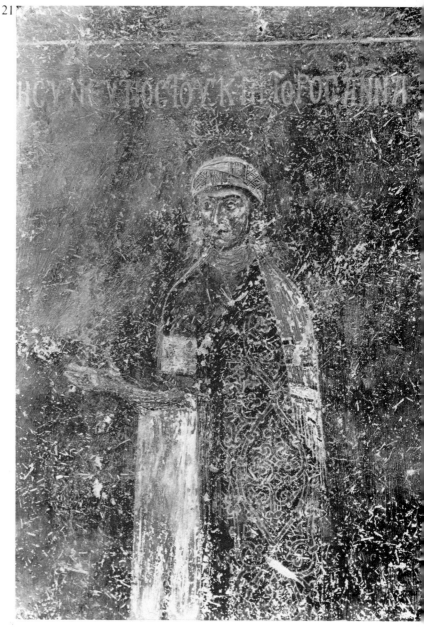

21

PANAGIA MAVRIOTISSA

The monastery of the Panagia Mavriotissa or Mesonesiotissa is situated about 3 kms. SE of the town of Kastoria, on the shore of lake Kastoria. Huge plane-trees surround the monastery, which has preserved only a few buildings of the old monastic complex.

Architecture

The katholikon of the monastery is a single-naved church terminating on the east side into a large apse, semicircular and stepped in the exterior (Fig. 3). The spacious square *lite* (deep narthex) communicates with the naos through a door (Fig. 1).

The naos and the somewhat lower lite are covered with pitched roofs. The north wall of the naos as well as the north and west walls of the lite are of later date. Also, a portion of the south wall of the naos adjoins the *parecclesion* (chapel) of St. John the Theologian built in the 16th century. Of the original windows, therefore, only one –the single window in the east wall above the apse– has survived to our days.

On the uncovered parts of the exterior face of the katholikon walls is visible the brickwork, which is more elaborate than that of the older churches of Kastoria. The west pediment of the naos is ornamented at the centre with a cross formed by bricks, between two stylized cypresses framed by arches imitating niches. The decoration of the pediment also includes smaller crosses and other brickwork. Scant traces of brickwork decoration are visible along the lower part of the south wall of the lite, which preserves a large shallow blind arch.

Painting

Today, the mural decoration of the church is fragmentary and limited to the holy bema, the west wall of the naos, the east and south walls of the lite and, also, the exterior of the south side.

In the holy bema, the composition of the Ascension occupies the east pediment (Plan no. 26), above the representation of the Virgin Platytera and Child with the two archangels in the conch of the apse. Below the Platytera, in a relatively narrow zone of the half-circle, the four Evangelists are depicted in pairs, facing each other, and seated in front of lecterns (Fig. 9, 10, Plan nos. 9, 10, 12, 13). Below them are pictured co-officiating hierarchs in three-quarter pose (Plan nos. 1-8) and on the walls on either side, several figures of saints either in full- or half-length (Fig. 8, Plan nos. 18-23). In the iconographic programme of the holy bema, between the Platytera and the Evangelists, are inserted the bust of Christ Emmanuel in a roundel and the figure of a worshipping monk named Manuel (Fig. 6).

The west wall of the naos has preserved almost all of its paintings (Fig. 12). The pediment is painted with the scene of Pentecost. The first zone below shows the Washing of the Feet, the Crucifixion and the Betrayal. The whole length of the second lower zone is covered with the composition of the Dormition of the Virgin, while the third zone, which was painted with full-length figures of saints has preserved only two: Alexios the Man of God, and John Kalybites (Plan nos. 27, 28).

In the narthex, the Last Judgement is storied on the east and south walls. Below are painted the Baptism, to

the right of the Royal Door, and the Sts. Constantine and Helen, to the left. On the south wall, below the damned of the Last Judgement, the Sts. Mardarios, Auxentios, Eustratios, Eugenios and Orestes are pictured full-length (Fig. 14, Plan nos. 38-42).

Several craftsmen, each in his own style, worked for the mural decoration of the church. Judging by their differences we can distinguish:

Painter A. Holy bema: Platytera, archangels, Annunciation and, most probably, full-length and stylite saints (Fig. 4-8).

Painter B. Holy bema: Hierarchs, Evangelists (Fig. 9, 10). Naos: Washing of the Feet, Betrayal, Crucifixion, Dormition of the Virgin (Fig. 12). Narthex: Last Judgement and full-length saints (Fig. 14).

Painter C. East pediment: Ascension. Exterior of south wall of the narthex: Tree of Jesse, Sts. Demetrios and George, and two royal figures (Fig. 20).

Painter D. Narthex: Baptism (Fig. 13).

Painter E. Apse, below the Platytera: Manuel the monk (Fig. 6).

Two new iconographic themes appear in the compositions by painter B: the fainting of the Theotokos in the scene of the Crucifixion and the episode of Jephonias in the Dormition of the Virgin. Both appear in Kastoria for the first time, though this does not imply that they had not been included in earlier depictions, either destroyed or not yet uncovered. In the scene of the fainting (Fig. 12), the Theotokos is shown to the left of the Crucified Christ, leaning forward on the point of fainting and being supported by one of the three companions that had followed her to the place of the crucifixion. The representation of the fainting fit in association with another Christological scene appears in a manuscript of the mid-11th century and shows that the subject had been known to Byzantine iconography long before Kastoria. The depiction of the episode of Jephonias in the Dormition of the Virgin is the earliest known to far (Fig. 12). However, this scene too must have appeared before, since it is mentioned in apocryphal texts of the 4th century and in Byzantine ecclesiastical writings.

The distinction of several hands is based on differences of technique and style distinct for each group of wall paintings. The Platytera with the worshipping archangels and the Annunciation are by the hand of painter A. Unfortunately, a leak in the roof has washed away over the years the additional colours used for the modelling of faces, particularly that of the Platytera. In spite of this deterioration, the paintings display certain characteristic elements of technique and style. Raw ochre was used for the underpaint of the face of the Virgin, both in the Platytera (Fig. 4, 7) and in the Annunciation (Fig. 5). The dark-coloured contour, strictly delineating the face with the pronounced chin and long robust neck, fades into lighter greenish hues. In both faces the almond eyes are well designed, with those of the Virgin in the Annunciation more lively.

Deep triangular folds transform the dark-coloured *maphorion* of the Platytera into a somewhat decorative surface, enhanced by the lights spread on the fabric in a variety of designs. This decorative treatment however, neither deprives the veil of its soft texture nor turns it into a rigid covering. By contrast, in the Virgin of the Annunciation shown standing in three-quarter view to the left, the soft cloth falls easily in symmetrical vertical but not formal folds, which terminate in stepped triangles along the gold-trimmed edge of the fabric (Fig. 5).

The foregoing features, which appeared in the 11th century, dominated and distinguished the mosaics and wall paintings of the early 12th century. The stylistic and morphological details of Christ in the representation of the Platytera and of Christ Emmanuel point to the same trend.

The Crucifixion (Fig. 12), the Dormition of the Virgin (Fig. 12) and the Last Judgement (Fig. 14), are by painter B, who works in a totally different manner, with expressive power and vivid colours. He does not shun brisk movements and depicts figures with an expressionistic tendency, which often distorts them. In the representation of the Crucifixion the oversized body of Christ with the marked curvature, the angular bending of the legs, the realistic rendering of the muscles and even of the bones, acquires superhuman dimensions as an expression of human suffering and cruel martyrdom. But even if the

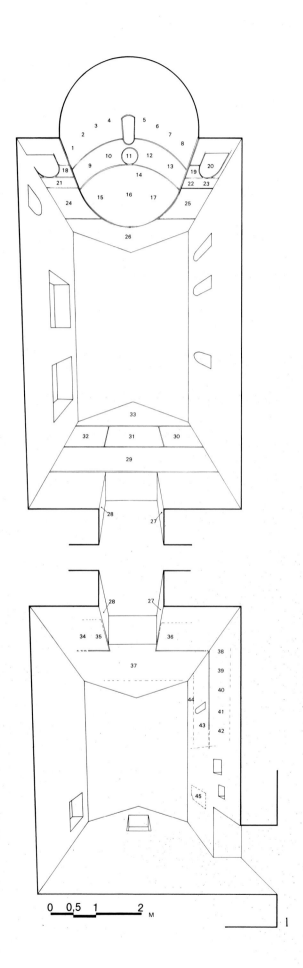

PANAGIA MAVRIOTISSA

Holy bema. 1. *St. Polykarpos.* **2.** *Gregory the Theologian.* **3.** *Hierarch.* **4.** *St. Basil.* **5.** *St. John Chrysostom.* **6.** *St. Athanasios.* **7.** *St. John the Eleimon.* **8.** *St. Gregory Thaumaturge.* **9.** *St. Mark.* **10.** *St. Matthew.* **11.** *Christ Emmanuel.* **12.** *St. John.* **13.** *St. Luke.* **14.** *Monk donor.* **15.** *The Archangel Michael.* **16.** *The Virgin enthroned.* **17.** *The Archangel Gabriel.* **18.** *St. Symeon the Stylite.* **19.** *St. Daniel the Stylite.* **20.** *St. Euplous the Deacon.* **21.** *St. Hermolaos.* **22.** *St. Cyrus.* **23.** *St. John the Anargyros (?).* **24.** *Angel of the Annunciation.* **25.** *The Virgin of the Annunciation.* **26.** *The Ascension, east pediment.* **27.** *St. Alexios the Man of God.* **28.** *St. John Kalybites.* **29.** *The Dormition of the Virgin.* **30.** *The Washing of the Feet.* **31.** *The Crucifixion.* **32.** *The Betrayal.* **33.** *Pentecost.* **Narthex. 34.** *St. Helen.* **35.** *St. Constantine.* **36.** *The Baptism.* **37.** *The Last Judgement.* **38.** *St. Mardarios.* **39.** *St. Auxentios.* **40.** *St. Eustratios.* **41.** *St. Eugenios.* **42.** *St. Orestes.* **43–44.** *The Last Judgement, punishments.* **45.** *St. Antony.*

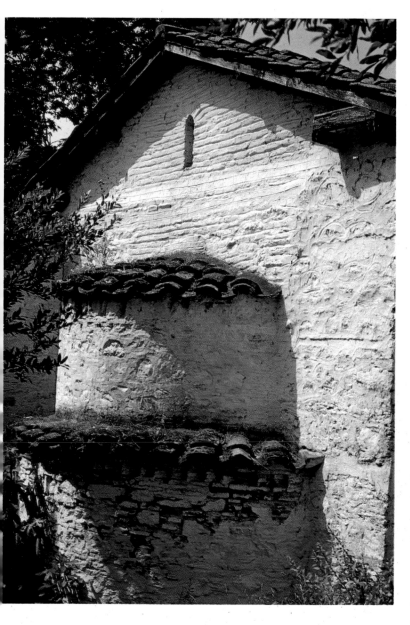

1. *Panagia Mavriotissa. Naos and lite, perspective plan.*

2. *Panagia Mesonesiotissa. Icon in the Monastery of St. Paul on Mount Athos.*

3. *Panagia Mavriotissa, apse. Exterior view.*

4. *Panagia Mavriotissa, apse. The Virgin with the Archangels and the donor.*

5. *Panagia Mavriotissa. The Virgin of the Annunciation.*

6. *Panagia Mavriotissa, apse. The monk [Mo]gilas, the "refounder".*

7. *Panagia Mavriotissa, apse. The Archangel Gabriel.*

body hung from the cross in a more natural pose, the way the face is painted would constitute by itself a sheer expression of the greatest suffering, for the tension of the whole body has been concentrated in the face. Over the pale ivory-yellow underpaint and the thin layer of ochre that smooths the surface, the brush is worked almost freely, the colours are warm, with vivid and broad wine-red shades above the eyebrows, along the upper eyelids and in the contour of the nose. Thick, straight or wavy, asymmetrical brush strokes give life to the cheeks and an epxression of agony to the face. Similar red touches colour the upper lip and the moustache, while green is mingled with the red shading of the beard and of the edge of the cheeks. The line of the mouth is curving downwards, intensifying the expression of suffering imparted by the colouring of the face. Whenever the painter wishes to register emotions similar to those of Christ, as in the Dormition of the Virgin and in the Last Judgement (Fig. 14, 15, 17, 18), he always uses the same morphological features, marked or subdued according to the scene, and the same colours, with small variations depending on the figure depicted and its role in the composition. The painter uses the same manner for the apostles in the Dormition of the Virgin, where the gestures and movements are matched to the tragic countenances (Fig. 11).

Parallel to the vivid reflection of inwardness noted above, and to the realistic rendering of the figures of the damned in the Last Judgement (Fig. 16), a sense of serenity is conveyed by the apostles in the scenes of the Washing of the Feet, of Pentecost (Fig. 12) and of the Last Judgement (Fig. 14), and by the single saints portrayed in the naos and the narthex (Fig. 8, 9, 10, 14). Using again the same palette but softer hues, the painter avoids the black-green triangular shades, which start under the eyes and run down the cheeks, and the marked outlines of the nose, and imparts a quite different feeling to the animated though calm figures.

All the above characteristic features are encountered in the wall paintings of Asinou in Cyprus, dated in 1105/6 and of Piskopi in Santorini, dated –on the evidence of a now lost inscription– to the reign of Alexios I. The close affinity between these wall paintings and

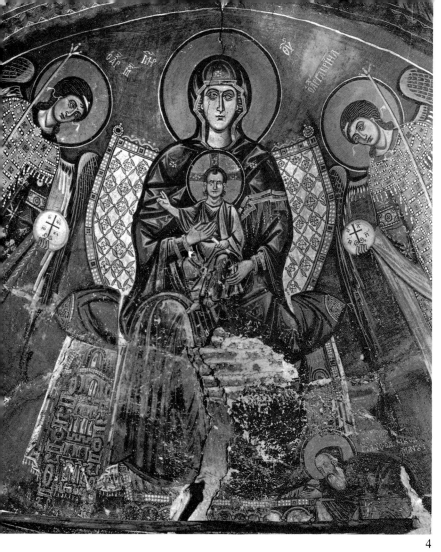

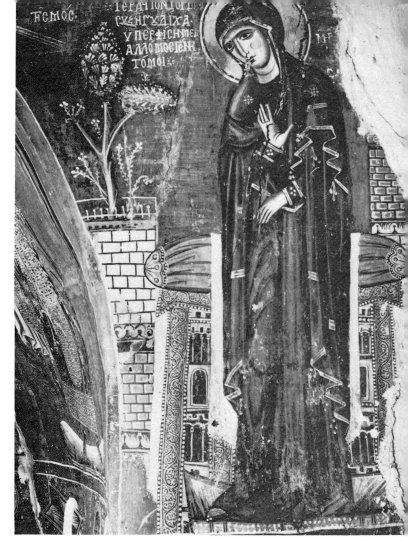

4 5

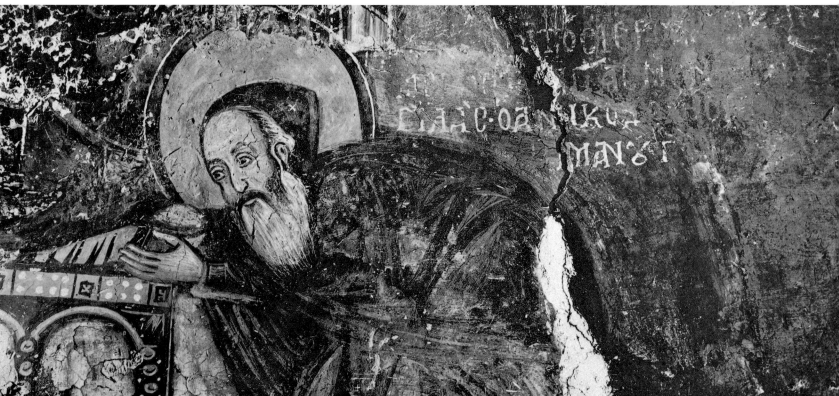

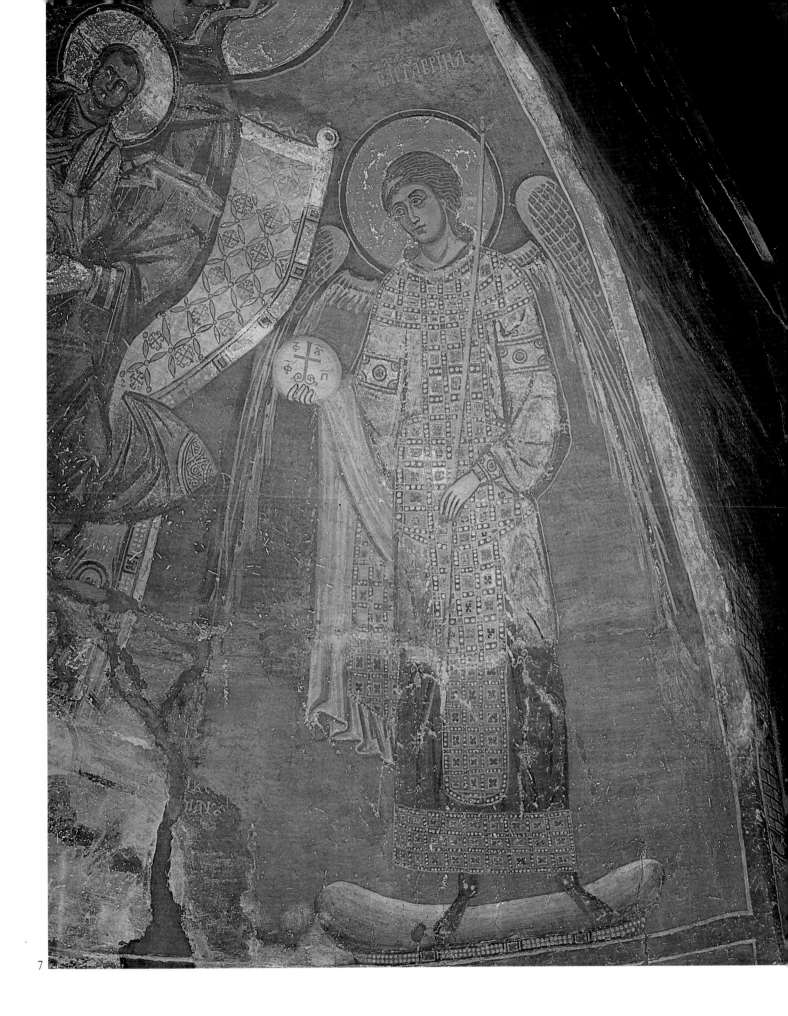

those by painter B of the Mavriotissa, as well as other positive evidence, strongly suggest a dating of the latter in the first decades of the 12th century.

As already mentioned, the Ascension on the east pediment of the naos, the Tree of Jesse, the Sts. Demetrios and George and the two imperial figures on the outer surface of the south wall of the narthex, are by painter C. This artist is distinguished not only for the plasticity of his figures but also for the effective handling of the tree in his composition of the Tree of Jesse (Fig. 20). The representation of the Theotokos, standing at the top of the symmetrical broad-leaved tree, is particularly majestic in its simplicity. A par excellence enfolded figure, with narrow shoulders and long legs accented by the nearly vertical folds of the garments, she is depicted frontally, holding the Child Christ in front of her. Her

figure crowns the whole composition, which acquires a pronounced verticalness with the arrangement of the prophets shown the one above the other. The deployed figures of the prophets, unlike that of the Virgin, have been painted with great plasticity, further enhanced by the richly draped robes and the *himatia* leaving one shoulder uncovered (Fig. 19) or by the sumptuous costumes of the crowned prophets (Fig. 20). The rosy faces are rendered linearly without sharp modelling and even the external contour is faint. The light green or yellow-pink soft shading and the highlights above the eyebrows, the eyes and the upper lip impart life and luminosity to the face. The smooth treatment of the facial skin is the same for all figures irrespective of age.

If the two royal figures are correctly identified as Michael VIII Palaeologos and his brother *Megas*

8. Panagia Mavriotissa. St. Daniel the Stylite.

9. Panagia Mavriotissa, apse. St. John the Evangelist.

10. Panagia Mavriotissa, apse. St. Luke the Evangelist.

11. Panagia Mavriotissa, naos. The Dormition of the

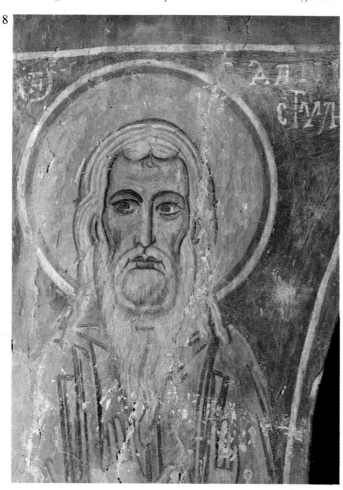

8

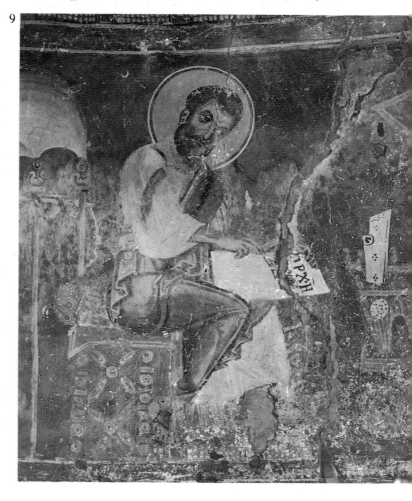

9

Domesticos John Palaeologos –which seems quite probable– then the murals by painter C must be assigned a date between 1259 and 1264. This last date is scratched on the ground of the Tree of Jesse, near the representation of the prophets.

The only work by painter D is the scene of the Baptism in the narthex (Fig. 13). It is generally accepted that its style places it in the second half of the 12th century. Painted on a layer over that of the Last Judgement and replacing an older wall painting, it provides additional proof for the dating of the works by painters A and B to the early 12th century.

Regarding the dating of the wall paintings of the naos and the narthex, it has been suggested that these are to be assigned to the early 13th century, and that the overlying representation of the Baptism, although

Virgin (part of Fig. 12).

12. Panagia Mavriotissa, naos. The west wall.

10

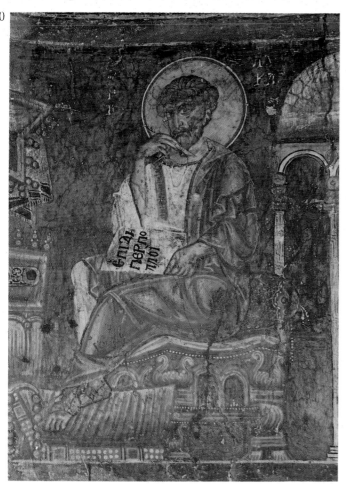

displaying traits of the Late Comnenian age, was actually painted much later in an older style. It would be superfluous to stress the dangers that such a view holds for research in the absence of sufficient data, and especially of a secure dating similar to that available for the monument to which reference is made, notably the church of St. Nicholas at Monastir in Yugoslavia.

The figure of Manuel the monk (Fig. 6) by painter E is of interest for its technique and style and for its later addition at the feet of the Platytera. In style it differs from the other representations in the katholikon of the monastery and approaches that of the portrait of the priest Theodoros Lemniotes in the church of Hagios Stephanos (Fig. 16). This may well be explained by the fact that, as a rule, in Byzantine art founders and donors are pictured in a different manner from that used for other figures. The portraits of Theodoros Lemniotes and his family in the Hagioi Anargyroi and those of Nikephoros Kasnitzes and his wife in Hagios Nikolaos tou Kasnitzi (Fig. 22, 23) are similar examples.

The monk's portrait was probably painted in the 13th century and its addition may be associated with the painting of the Ascension and the exterior decoration of the south wall of the narthex.

Bibliography

A. Orlandos, «Τά βυζαντινά μνημεῖα τῆς Καστοριᾶς», *Ἀρχεῖον Βυζαντινῶν Μνημείων Ἑλλάδος*, vol. Δ΄, 1938, p. 186.

P. Tsamisis, *Ἡ Καστοριά καί τά μνημεῖα της*, Athens 1949, p. 148 ff.

S. Pelekanidis, *Καστοριά. Βυζαντιναί Τοιχογραφίαι*, Thessaloniki 1953, p. 26 ff., pl. 63-86.

St. Pelekanidis, "I più antichi affreschi di Kastoria", *Corsi di cultura sull' arte Ravennate e Bizantina*, Ravenna 1964, p. 361 ff.

Id., "Kastoria", *Reallexikon zur byzantinischen Kunst*, I. 1190 ff.

N. Moutsopoulos, *Καστοριά, Παναγία ἡ Μαυριώτισσα*, Athens 1967.

V. Djurić, *Byzantinische Fresken in Jugoslavien*, Belgrade 1976 (see under "Kastoria" in index).

S.P.

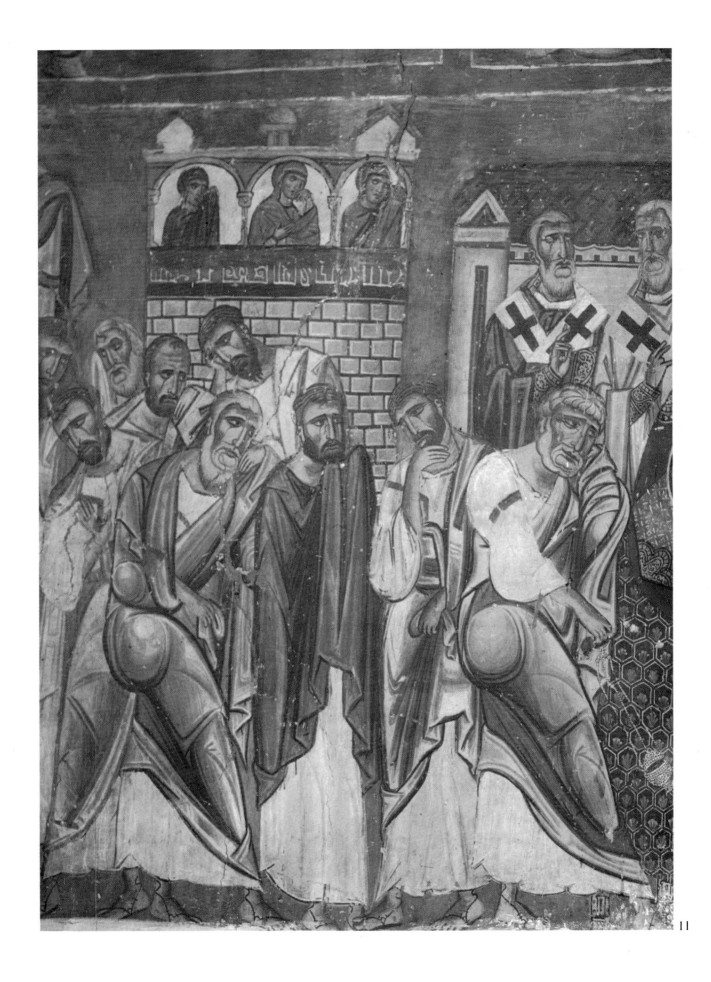

11

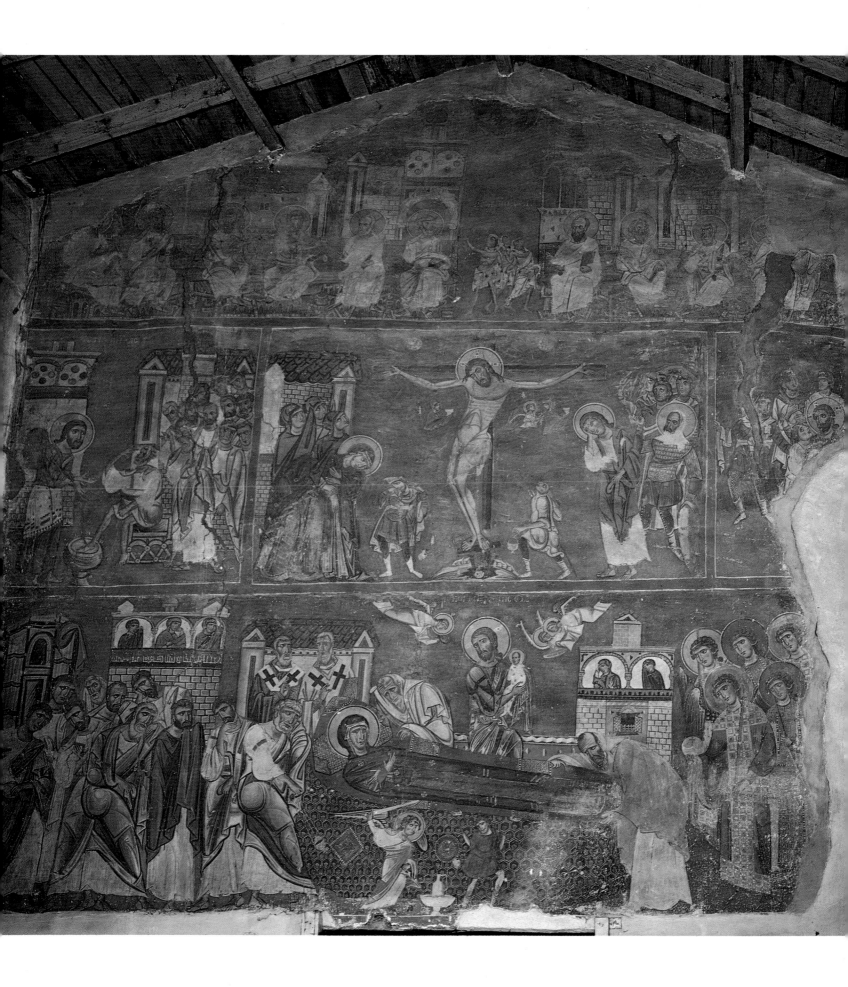

PANAGIA MAVRIOTISSA
Supplementary Note

a. History – The building

Since epigraphical evidence is lacking, it is only on the testimony of written sources that the monastery has been identified with that of the Panagia Mesonesiotissa (H. Grégoire, M. Lascaris), a foundation known from the 13th century onwards. The Mesonesiotissa had been consecrated by the Serb ruler Nicholas Bagaš Baldovin (1385) to the Athonite Monastery of St. Paul. This association is evinced by a fine unpublished icon of the 14th century kept in the Monastery of St. Paul and known as the Panagia Mesonesiotissa. Painted in the "style of NW Macedonia", it shows the Virgin Glycophilousa with a halo in relief (Fig. 2).

In the naos the large semi-cylindrical stepped apse of the sanctuary (Fig. 3) is an archaic feature (cf. Scripou), of which only the lower part retains original elements. The *lite*, the large narthex, was added later.

b. The wall paintings and the successive phases of decoration

The wall paintings, which have been partly preserved, do not provide sufficient evidence for the reconstruction of the original iconographic programme. Moreover, no systematic study of all the surviving representations has been undertaken to this day – and this is becoming a matter of some urgency. It is only on certain subjects, mostly of the west wall and the narthex, that observations reaching varying conclusions have been made at times. An additional difficulty is presented by the "exotic" character of this painting, in the sense that it is not closely related to any of the styles encountered in the known mural ensembles of Kastoria and of Macedonia in general.

Regarding the distinction of five painters (Pelekanidis), I would consider more expedient to begin by differentiating as correctly as possible the various phases of the existing wall paintings and leave the identification of "hands" for later. Far from exhausting the matter, the following observations might prove useful.

The key to the various phases of painting is provided by the large sanctuary apse and the numerous cracks which account, either directly or indirectly, for certain unusual features:

1. The figures of the Virgin Platytera and the archangels are divided in two by a long almost horizontal crack in the plaster running across the half-dome (Fig. 4). The Archangel Michael, to the left, is cut by the crack at about the waist, the Archangel Gabriel, to the right, and the enthroned Virgin are cut above the knees (Fig. 7).

2. A haloed monk making *proskynesis* at the feet of the Virgin is portrayed on plaster that had been applied over the original layer (Fig. 6).

3. The roundel with the half-length figure of Christ Emmanuel (Plan. no 11) has been inserted in the middle of the narrow zone with the Evangelists, on plaster applied over the original layer. These irregularities can be explained if we accept that the two parts of the wall paintings in the apse belong to two different phases. The part above the horizontal crack presents variations from the one below not only in style but especially in the colouring, which is more luminous and of different hues. In addition, in the upper part gold leaf has been used for the haloes and gold paint for the garments and the lyre-shaped throne (Fig. 7). Even the formal face of the Virgin Platytera with the cold expression and the broad modelling (Fig. 4) differs in every way from the expressive though less beautiful face of the Virgin of the Annunciation standing outside the conch (Fig. 5). On the other hand, the plebeian countenace of the Christ-Child resembles the plump face of Christ Emmanuel.

4. Lastly, the faces of the two archangels with the aquiline nose, linear hair and golden halo do not recur in any other part of the surviving mural decoration of the naos and the narthex. In terms of portraiture and technique, they can be identified with the monk, whose name, however, is not Manuel but rather [Μο]γίλας (Fig. 6).

5. The painted layer of the Ascension occupying the whole pedimental surface of the sanctuary is an unbroken continuation of the upper part of the conch.

A close examination of these inconsistencies and the reasons that had caused them, in combination with a parallel observation of the exterior walls of the apse (Fig. 3), prompted by certain correct remarks made by Wharton-Epstein, have led to the following conclusions: The section of the sanctuary above the horizontal crack must have collapsed along with the upper part of the Virgin Platytera and the archangels and also a small fragment –showing part of the wall with the tree– from the scenery framing the Virgin of the Annunciation (Fig. 5). The whole of that part of the sanctuary was reconstructed and repainted, with the obvious purpose to restore the original representation of the Virgin Platytera and the archangels in the conch as accurately as possible and add the painting of the Ascension on the east pediment. It is at that time that over the earlier part were added: the roundel with Christ Emmanuel, the upper portion of the wall with the tree in front of the Virgin of the Annunciation, and the figure of the monk. One could perhaps surmise that this monk –whose portrait must have been painted after he had died, as the halo indicates– was the *ktetor* of this renovation. The word ἀνοικοδομήσας ("refounder") was legible in the fragments of the accompanying inscription (Fig. 6.).

Consequently, the main part of the mural decoration, which belongs to the first phase, includes in the apse: the lower portion of the archangels and of the enthroned Virgin (Fig. 4), the Evangelists (Fig. 9, 10) and the co-officiating hierarchs (plan nos. 1-8); on the walls flanking the apse, the Virgin of the Annunciation and the busts of saints (Fig. 5, 8); in the naos, the entire west wall; in the lite, the east wall with the Last Judgement –except for the Baptism– and the south wall (Fig. 12, 14).

The next phase comprises the preserved parts of the paintings on the exterior of the lite, i.e. the two headless imperial figures, the Sts. George and Demetrios, the Tree of Jesse (Fig. 20), and the extensively damaged figure of St. Peter, painted near a now walled up door which still shows its relieving arch framing the niche with the Virgin. We believe that it is in this phase, within the Byzantine period, that the composition of the Ascension and the other parts completing the figures of the sanctuary apse were painted.

c. The character of the wall paintings

The chronological and stylistic unity of the wall paintings of the first phase does not require much proving, although this does not imply that various manners of painting have not been employed in representations of dissimilar subject and character, or even within the same composition. It is questionable whether these differences should be attributed to different hands, as the various manners used display corresponding traits in almost all the representations.

An examination of the character of these original wall paintings reveals that the whole composition of the sanctuary is of a solemn and static nature, culminating in the oversized majestic figure of the Virgin. However, the lively figures of the Evangelists, with the "disrupted" arrangement of folds and the excessively detailed depiction of the rich furniture, are at variance with the unembellished figure of the Virgin of the Annunciation, standing monumental in vertical unruffled folds (Fig. 5). The Evangelists (Fig. 9, 10) are directly related with the apostles in the scenes of the Washing of the Feet and of Pentecost (Fig. 12), and also with many figures of the Last Judgement (Fig. 18). The serene composure and abstracted countenance of the Virgin of the Annunciation is encountered again in the co-officiating hierarchs, in the group of the colossal archangels of the Dormition (Fig. 12), as well as in the Virgin of the Deesis depicted in the narthex (Fig. 14) and in other representations.

The indifference towards stylistic homogeneity within the monumental Dormition, the largest of the surviving compositions in the naos, is quite typical. The solemn character is maintained only in the compact and serene group of the very tall archangels with the court costumes and the multicoloured haloes, standing to the right (Fig. 12). At the opposite end of the same representation, the agitated congregation of the distressed apostles displays a tendency to rhythmical disposition, as the linear articulation of the

"disrupted" arrangement of folds permits compositional experiments with a geometric pattern, often leading to a distortion of the anatomy (Fig. 11). Similar attempts have been traced in the representation of the Dormition of the Virgin at Asinou in Cyprus (1105). This scene presents also certain thematic affinities with the corresponding scene in the Mavriotissa, such as the arched galleries with the lamenting women. Nevertheless, there are important differences with the Cypriot monument. The expressive style in the Mavriotissa is anticlassical, whereas in Asinou the calm rhythm of the restrained poses and gestures and the soft plasticity of the figures impart an almost classical character to the painting. Consequently, the isolated interrelation of some of the motifs in such a large composition could perhaps prove helpful in a search for the origin of the subjects and manners encountered in the Mavriotissa, but it cannot help in its dating.

In the extensive scene of the Crucifixion (Fig. 12), the ethos acquires an unexpected crudeness through the expressionistic exaggeration of the prosaic and the pragmatic: the graceless movements and rather undignified poses of the participants, the impudent, grotesque and repulsive profiles of the servant and the dwarf-soldier. The oversized emaciated figure of the crucified Christ hangs limply from the cross with the knees bent under the weight of the dead body, in the same way that the weight of her body forces forward the fainting Virgin, who is being supported by her companions in a rather perfunctory manner. The same excessive realism, expressed by a pure linearism, is used in the rendering of the numerous buildings forming the scenery in all the representations and of the furniture in the portraits of the Evangelists. There are convincing details showing that the architecture-scape was not an imaginary one. In fact, the dressed ashlar blocks and the roof tiles, the windows with the fanlights, the arched galleries (where the women lament), the friezes with the pseudo-cufic writing decorating the walls of the buildings (as in the church of the Hagioi Theodoroi in Athens), must correspond to real models, which point to the Middle East.

All the stylistic features noted reflect an essentially anticlassical character that could be associated only with that expressed in works of the first decades of the 13th century, produced in regions of the Eastern Mediterranean under Frankish rule. There can be little doubt that this trend of exaggerated realism had been selected and especially used here as an appropriate means for emphasizing the concept of the Incarnation.

d. The chronology

The wall paintings of the Mavriotissa have been dated by Pelekanidis, and lately by Wharton-Epstein and Mouriki, to the end of the 11th-beginning of the 12th century, on the evidence of parallel –and with the exception of Asinou, almost exclusively facial– features noted in monuments belonging to the same artistic trend. Comparisons were made for example with the murals decorating Sant-Angelo in Formis, the monastery of Myrtia and the columnar churches of Cappadocia (Epstein), as well as those of Santorini and Cappadocia (Pelekanidis). Even though the monuments proposed are rather unrelated between them, these comparisons have some positive ground, for the traditions of that age were continued into later times, especially in provincial works adhering to the same anticlassical trend.

The wall paintings of the Mavriotissa, however, present many deviations from the art of this early period and these are important for the dating of the monument. We note, for example, the presence of the co-officiating hierarchs, shown in an advanced form of a theme "modern" even for the second half of the 12th century, the particular manner in which the theme of the fainting Virgin is treated in the Crucifixion, and also the type of the Crucifix with the dead body of Christ hanging limply from the cross. In connection with the handling of these themes –and not with their mere presentation– we have found parallels in miniature paintings of the 13th century. We would also note the shape of both the massive throne of the Virgin and the furniture of the Evangelists, as well as a characteristic peculiarity in the portraiture: notably, the way the eye and eyebrow are combined to form a single expressive feature on the face, particularly when shown in three-quarter view. This treatment is encountered in manuscripts assigned to the end of the 12th century, e.g. Athen. 93. The figures of the damned bishops in

13. *Panagia Mavriotissa, lite. The Baptism.*

14. *Panagia Mavriotissa, lite. The east and south wall, with the Last Judgement, the Sts. Constantine and Helen, the Baptism and the five saints of Sebasteia.*

13

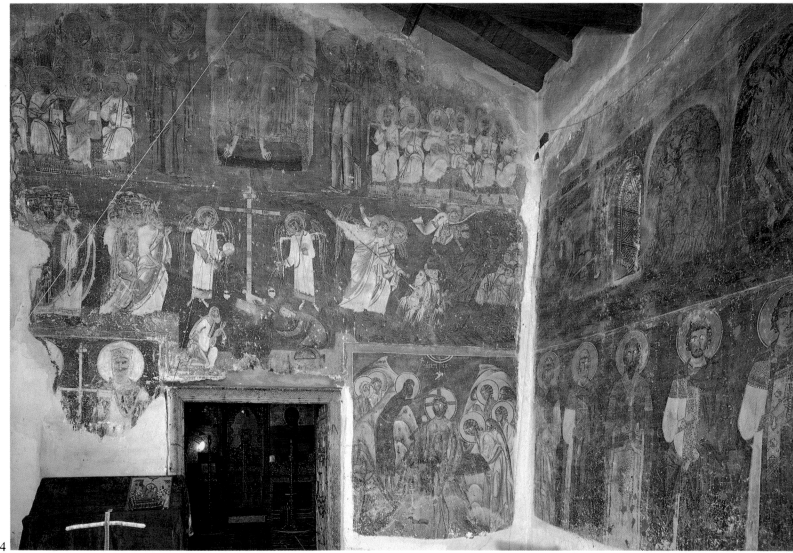

14

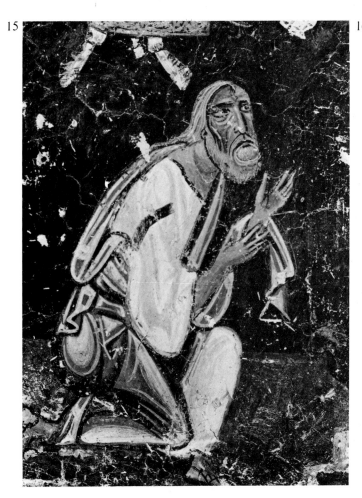

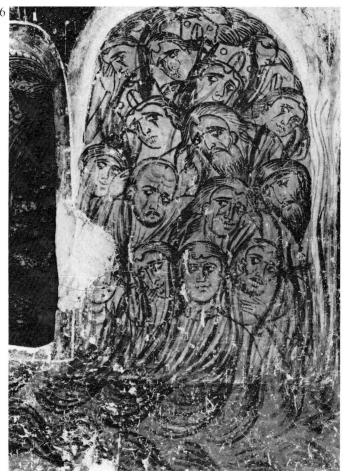

15. *Panagia Mavriotissa, lite. Adam, detail of the Last Judgement.*

16. *Panagia Mavriotissa, lite. The Damned, detail of the Last Judgement.*

the narthex (Fig. 16) also point to the 13th century (Mileševa). The painters of those times retained the practice and techniques of the 12th century or even reverted to stylistic features of the 11th century, such as the "disrupted" treatment of draperies (Hosios Loukas), of which a closely related version is encounter- ed again in Hagios Petros Kouvaras, in Attica, dated in 1232. For these reasons, we are in agreement with most of the scholars who have accepted a dating in the first half of the 13th century for the original wall paintings of the Mavriotissa.

The representation of the Baptism in the narthex (Fig. 13), obviously a work of later date than the other wall paintings of the narthex, is the only one that would allow some doubts about this dating. The tracery of lines used for the modelling of the face, and the high arched eyebrows are both features typical of wall paintings like those at Nerezi and in Hagios

Nikolaos tou Kasnitzi (Pelekanidis, Epstein). We must, however, draw attention to the harsh and distorted schematic rendering of the disproportionately tall nude body of Christ, with the exaggerated modelling of the chest. This last trait brings it closer to the nude bodies of the damned "usurer" and "sycophant" (Fig. 14 at the corner) than to the delicately modelled body of Christ in the Baptism scene of Hagios Nikolaos tou Kasnitzi (Fig. 20). Similar observations have given ground to the very likely suggestion (Djurić) that this is an older technique, as it has been known to occur at that time in the neighbouring region –of the Ochrid metropolis– at Manastir (1270, Moriovo). Furthermore, a close connection can be noticed between the faces of St. John the Baptist and the angels in this scene and those of other paintings dated to the end of the 12th century (heads of the apostles at the Moni Vatopediou and of the angels at Kurbinovo). A similar close

relationship exists between the handling of draperies of the angels in the Baptism and that of the Prophet Micah and of the Virgin in the Tree of Jesse decorating the exterior of the lite wall (13th century, Fig. 20). At any rate, it should be noted that an analogous style is not found in any other wall painting of the Mavriotissa. The Baptism is unique and the reason it has been added is not clear. In any case it cannot be associated with any of the phases mentioned above. In the murals of the last phase covering the exterior of the south wall of the narthex, the now fragmentary inscriptions accompanying the two imperial figures possibly refer to Michael VIII Palaeologos and his brother John (Moutsopoulos, Pelekanidis). This, in association with the graffiti of 1264 (Moutsopoulos), dates these wall paintings to 1259-1264. Their art is eclectic. The difference in the treatment of drapery between the figure of the Prophet Habakkuk (Fig. 19) and that of the Prophet Micah and of the Virgin (Fig. 20) is characteristic. In the former the flowing folds are rendered with supple reddish lines over the almost monochrome cloth, in the latter the folds are handled in a more traditional fashion. Without further justification Pelekanidis attributed these representations as well as the Ascension of the east pediment to painter C. A comparison between the figures of the apostles with their freely treated draperies and that of the Prophet Habakkuk justifies at least the chronological relation. Nevertheless, for a number of reasons, we find it difficult to accept the same painter for these works (note the differences in the depiction of trees). On the other hand, the layer on which the Ascension is painted continues without interruption into the upper part of the sanctuary apse, where the original figures of the enthroned Virgin and the archangels have been completed.

In view of the above, we are led to believe that the complementary paintings were also executed after the middle of the 13th century. A comparison of the Virgin with the one in the church of Hagios Demetrios at Perlepe-Varoch, founded by the Emperor Andronicos II and his wife Irene of Montferrat (1284-1290) confirms this dating. It must be emphasized here that this is a rare and most instructive instance, allowing us to observe an attempt by Byzantine painters to complete earlier paintings, imitating as much as possible the technique and to a certain degree the style of the older work. This explains the difference in the manner employed for the completed parts of the apse and for the adjoining representation of the Ascension, which was not subject to such limitations.

To conclude, we recapitulate our suggestions regarding the phases of construction and painting during the Byzantine age and their dating:

a. Building of the naos in circa 1000? Wall-painting?

b. Addition of the spacious lite-narthex, wall-painting of the naos and narthex, all after 1200.

c. Collapsing of the upper part of the sanctuary and possibly of the side walls of the naos, after the addition of the narthex but before 1259.

d. Restoration, involving repair of the sanctuary and completion of its wall-painting, and wall-painting of the exterior south side of the narthex and naos, in 1259-1264.

It is not the purpose of these supplementary remarks to present a definitive solution for this ever problematic mural decoration. The colouring, luminous and vivid, with an unusual extravagant use of white dots; the profusion of decorative motifs at some places and the parallel absence of ornamental bands – so abundant and beautiful in the Hagioi Anargyroi; other problems pertaining to both iconography and programme; the eventual association of the spirit of realism with contemporary ideological issues; all these and many other questions are awaiting methodical study.

Bibliography

M. Lascaris, "Byzantinoserbica", *Byzantion*, vol. 24-25, 1957, p. 320.

M. Chatzidakis, "Aspects de la peinture murale du XIIIe siècle en Grèce", *Symposium de Sopoćani*, 1965, Belgrade 1967, p. 64-65.

L. Hadermann-Misguish, *Kurbinovo*, Brussels 1975, p. 37-38, note 53, 55 – "Une longue tradition byzantine la décoration extérieure des églises", *Zograf*, vol. Z´, 1976 (1977), p. 6-10.

T. Malmquist, *Byzantine 12th Century Frescoes in Kastoria*, Upsala 1979, p. 127-128.

Ann Wharton-Epstein, "Middle Byzantine Churches of Kastoria", *The Art Bulletin*, vol. LXII, June 1980, p. 190-207, especially p. 202-207.

D. Mouriki, "Stylistic Trends in monumental Painting of Greece during the 11th and 12th c.", *Dumbarton Oaks Papers*, l. 34-35, 1982.

M. CH.

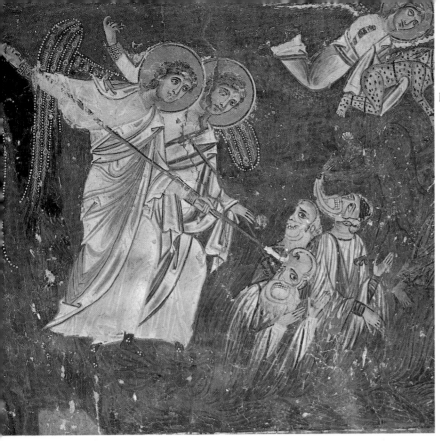

17. *Panagia Mavriotissa, lite. The Angels and the Damned, detail of the Last Judgement.*

18. *Panagia Mavriotissa, lite. The Just, detail of the Last Judgement.*

19. *Panagia Mavriotissa, exterior wall paintings. The Prophet Habakkuk, detail of the Tree of Jesse (Fig. 20).*

20. *Panagia Mavriotissa, exterior wall paintings. The Sts. George and Demetrios, two imperial figures, and the Tree of Jesse.*

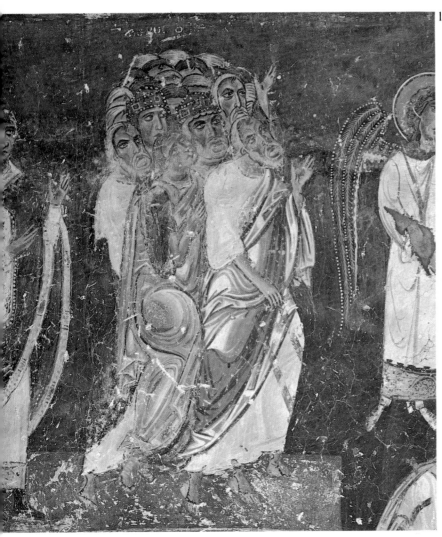

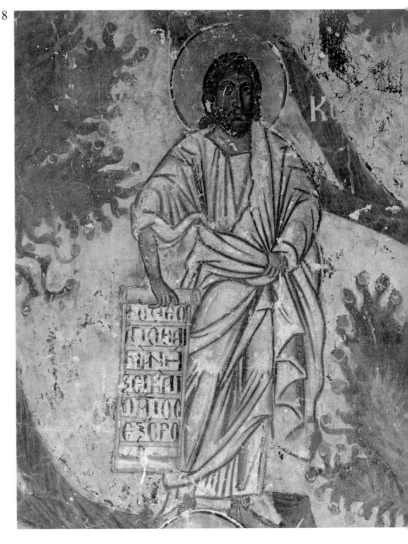

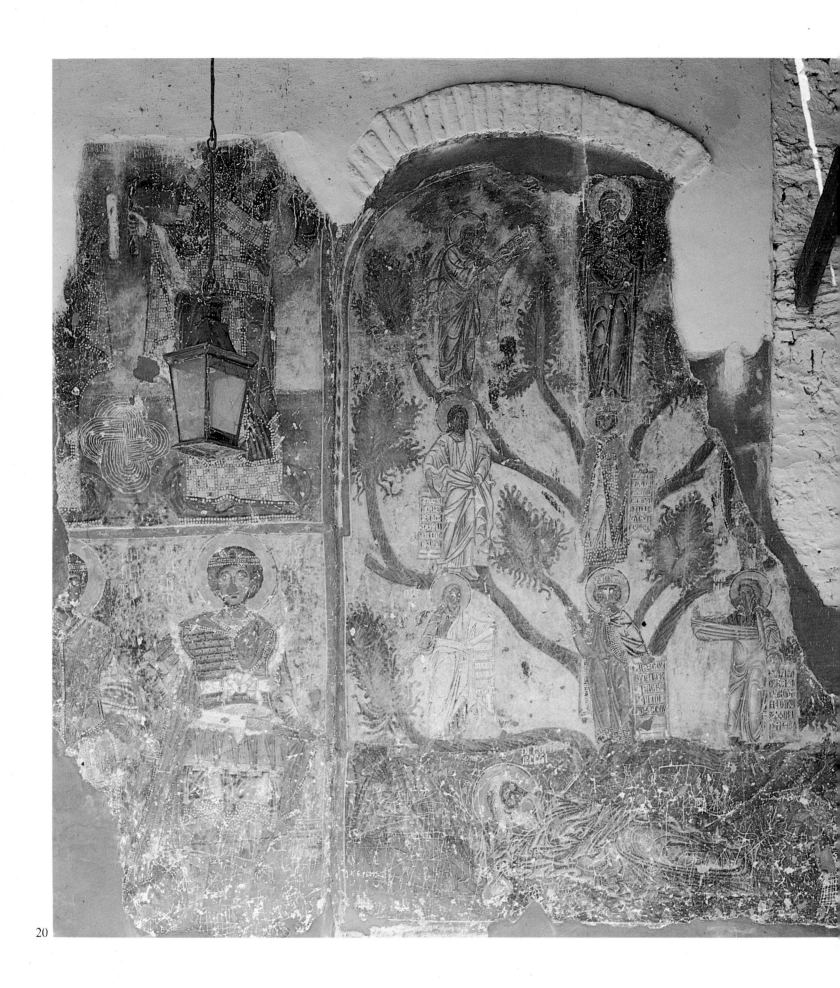

PANAGIA KOUBELIDIKI OR KASTRIOTISSA

The small triconch church with dome of the Panagia Kastriotissa or Koubelidiki, as it is known today (Fig. 3), stands in a prominent place of the Byzantine citadel of Kastoria. The second appellation dates from the time of the Turkish rule and is due to the characteristic tall drum of the dome (*kubeh* in Turkish), which marks it out from all the other churches of the town.

As recorded by a no longer existing inscription at the base of the drum of the dome, in Byzantine times the church was named Kastriotissa by reason of its close proximity to the walls of the citadel (*kastro* in Greek). Investigation has confirmed that the wall of the east section of the acropolis passed so close to the east side of the church that it blocked the sole single window of the east conch of the naos.

This evidence is helpful in assigning an approximate date to the building. For, if the restoration of the Justinian wall had been carried out during the peaceful period that followed the death of Krum (814) until the declaration of war against the Byzantines by Simeon (894), then the Koubelidiki –which is proved older than the city walls– is datable in the mid-9th century.

This view is further supported by the close affinities of the Koubelidiki with the churches of Hagios Stephanos and of the Taxiarches of the Metropolis, which are dated to the same period.

Architecture

The core of the Koubelidiki, the only triconchial church in Kastoria, is formed by a central square whose east, north and south sides have projecting apsidal terminations. Supported by the four arches of the square, the slightly oval, over-tall drum of the dome rises above the central area. A narrow narthex, covered by a transverse barrel-vault, extends along the

west side of the square. The second, larger, narthex is of much later date (15th century), and was covered with a pitched roof after the collapse of the original vault.

Four small single windows at the base of the drum and one in each of the three conches light the interior dimly (Fig. 2).

The exterior of the church shows the same isodomic and ornamented masonry as the other older churches of Kastoria. Some peculiarity is presented by the toothed bands which articulate the building at various heights, encircle the drum of the dome at mid-height and frame the windows or only their arches. Similarly decorative are the friezes of coloured glazed tiles, which form three bands around the drum. With the tiles arranged as squares, rectangles or lozenges, they lighten, along with the toothed band, the effect created by the disproportionate tallness of the drum.

With the passing of time earth deposits covered the building to mid-height. Moreover, during the Greek–Italian war (1940) three quarters of the dome were destroyed by bombing. The monument was restored to its original form in 1949.

Painting

The naos is completely covered with wall paintings. Unfortunately, over the years many of the murals were painted over, or ruined by leaks and the bombardment. Today, it is often difficult not only to determine the iconographic programme but also to study the technique and style of the paintings.

The Pantocrator was depicted on the crown of the dome, the Prophets on the drum and the Evangelists (only fragmentarily preserved at present) on the

pendentives. Part of the Holy Mandylion is barely visible at the base of the drum. In the holy bema (Fig. 4) the bust of the Virgin Platytera, the scene of the Breaking of Bread and the figures of the co-officiating hierarchs are severely damaged or partly painted over. The soffit of the arch in front of the conch of the apse was painted with the two halves of the chorus of apostles from the scene of the Ascension, and the wall above the conch with the representation of Christ being lifted to heaven (Plan nos. 8, 9). The walls are covered with full-length figures of saints.

The scenes of the Baptism, Crucifixion, Resurrection and Pentecost are missing from the cycle of the Twelve Feasts. The main scenes shown from this cycle are: the Annunciation, on the face of the east wall of the holy bema (Plan nos. 18, 39); the Nativity, on the face of the south wall and on the soffit of the arch below it (Plan no. 19); the Presentation of Christ in the Temple, on the half-dome of the south conch (Plan no. 17); the Transfiguration and the Raising of Lazarus, in the corresponding parts of the north side (Plan nos. 38, 35). The Dormition of the Virgin occupies the whole of the west wall, while the apostles "who had come from the ends of the earth" are painted on the soffit of the west arch (Fig. 5, Plan nos. 29-32).

From the composition of the Entry into Jerusalem, painted in the narthex, only the part showing the city of Jerusalem and the crowd of Jews has been preserved (Fig. 11, Plan no. 67). The narthex is also storied with scenes from the life of the Virgin to whom the church was dedicated: the Birth of the Virgin, the Presentation of the Virgin in the Temple, the Trial by Water and the Betrothal. The lower zone shows one of the archangels and full-length saints. The representation of the Holy Trinity occupies the entire surface of the barrel-vault of the narthex. This is one of the earliest known instances of an anthropomorphic representation of the Holy Trinity.

The exonarthex has preserved paintings of the Nativity, Transfiguration and Pentecost, three scenes from the Annunciation probably inspired from the Akathistos Hymn, and figures of saints, all dating from the 17th century.

The wall paintings on the outer faces of the west wall of the exonarthex (Fig. 3) are dated by an inscription to 1496, and are representative of their time. They depict a Deesis, various narrative scenes from the Banquet of Herod and the Beheading of St.

John the Baptist, the Virgin of the Passion, and the Prophet Elijah with the crow bringing him bread.

Of all the wall paintings two themes depart from the standard Byzantine iconography: the Dormition of the Virgin and the Holy Trinity. In the Dormition, Christ is not depicted, as usually, standing behind the couch of the Theotokos and holding in his arms her soul, shown as a swaddled infant. Instead, he is pictured seated in a multicoloured glory, holding the soul of the Virgin and being lifted up to heaven (Fig. 10). This version of the Dormition in the Koubelidiki is unique for a Byzantine church. Somewhat related representations are found in Serbia and Anatolia, but they differ substantially from the one at Kastoria.

As noted above, the second rare theme is the representation of the Holy Trinity. Occupying the whole length of the barrel-vault, God the Father is portrayed oversized, in a mandorla, seated on an arch symbolizing heaven. On the Father's chest, from the opening of the richly draped mantle appears, in bust, the Son as a mature man holding a grey disc on which the Holy Spirit is painted in the form of a white dove (Fig. 7, Plan no. 68). Western theologians have interpreted the representation as an illustration of the *filioque* doctrine, because it had escaped their attention that the miniature of Cod. Suppl. gr. 52 (11th-12th century) of the Vienna Library was accompanied by the Creed according to the Orthodox dogma. An analogous depiction is contained in a Vatican Codex of the same epoch. Thus, this painting of the Koubelidiki is one of the few known early anthropomorphic representations of the Holy Trinity.

The variety in the colour scheme is seldom encountered in wall paintings of similar small provincial monuments. Though they have flaked off or have been painted over, the murals clearly reveal the artist's working method. The face and some of its details are first drawn in thin lines of ochre. Then, light green colour is used for the underpaint, over which are applied brown-red for the contours, deep red for the eye sockets and the lips, and light blue for the hair and the beard. The folds of garments are painted in the same colour as the fabric but in darker gradations. The scale of colours includes many shades of raw and burnt ochre, red, pale yellow, brown, violet and grey.

The painter of the Koubelidiki keeps in line with a style familiar after the first decades of the 13th century and shows a certain initiative in the arrangement of his

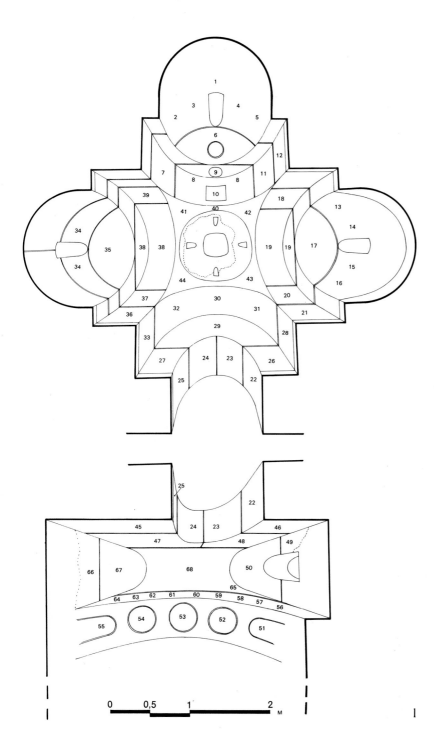

PANAGIA KOUBELIDIKI OR KASTRIOTISSA

17th century. 1. *The Breaking of Bread.* **2.** *St. Clement of Alexandria.* **3.** *Hierarch.* **4.** *Hierarch.* **5.** *St. Gregory the Theologian.* **6.** *The Virgin Platytera.* **7.** *St. Romanos the Deacon.* **8.** *The Ascension, Apostles.* **9.** *The Ascension, Christ.* **10.** *Christ Emmanuel.* **11.** *St. Stephanos the Deacon.* **12.** *St. Nicholas.* **13th century. 13.** *St. John the Theologian.* **14.** *Saint.* **15.** *Warrior saint.* **16.** *Warrior saint.* **17.** *The Presentation of Christ in the Temple.* **18.** *The Virgin of the Annunciation (17th cent.).* **19.** *The Nativity.* **20.** *St. John of Damascus.* **21.** *Warrior saint.* **22.** *St. Peter.* **23.** *St. Mardarios?* **24.** *Saint.* **25.** *St. Paul.* **26.** *St. Symeon the Stylite.* **27.** *Stylite saint.* **28.** *Warrior saint.* **29.** *The Dormition of the Virgin.* **30.** *The Dormition of the Virgin, Apostles "from the ends of the earth".* **31.** *The Prophet David.* **32.** *The Prophet Solomon.* **33.** *Saint.* **34.** *Traces of four saints.* **35.** *The Raising of Lazarus.* **36.** *Saint.* **37.** *St. Cosmas of Maiouma.* **38.** *The Transfiguration.* **39.** *The Angel of the Annunciation (17th cent.).* **40.** *The Holy Mandylion (17th cent).* **41. 42. 43. 44.** *The Evangelists.* **45.** *The Archangel Micael.* **46.** *The Archangel Gabriel.* **47.** *The Trial by Water.* **48.** *The Betrothal.* **49.** *Saint.* **50.** *The Birth of the Virgin.* **51.** *St. Cosmas (17th centr.).* **52.** *The Archangel Gabriel (17th cent.).* **53.** *The Virgin (17th cent.).* **54.** *The Archangel Michael (17th cent.).* **55.** *St. Damian (17th cent.).* **56. 57. 58. 59. 60. 61. 62. 63. 64.** *The Prophets "from above" (17th cent.).* **65.** *The Presentation of the Virgin in the Temple (13th cent.).* **66.** *St. Nicholas (15th cent.).* **67.** *The Entry into Jerusalem (13th cent.).* **68.** *The Holy Trinity (13th cent.).*

2

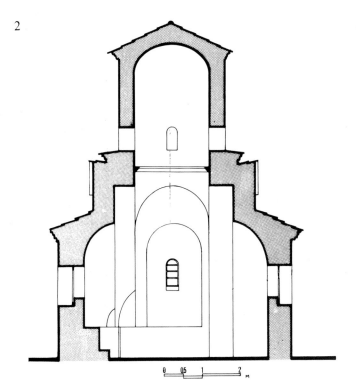

3

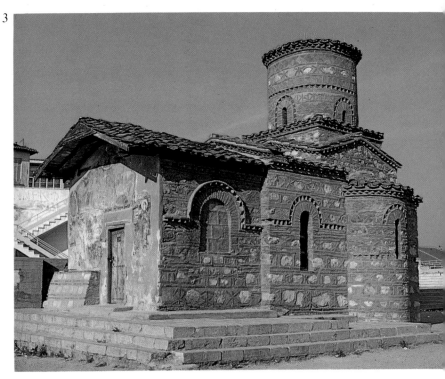

1. Panagia Koubelidiki. Perspective plan. Naos and esonarthex.

2. Panagia Koubelidiki. Section.
3. Panagia Koubelidiki. Southwest view.

serene compositions and in the depiction of his figures. In paintings with an architecture-scape, the function of the buildings is quite obvious. This, however, only serves to set off or discreetly frame the figures without confining them. On the whole, the bodies –often powerful with their voluminous forms outlined by the draperies– are depicted harmoniously, without monumentality or vigorous movement. The green underpaint and the broadly applied luminous pale brown tint usually impart a sense of serenity to the faces. The eyes are accented with a thin stroke of red paint on the upper eyelid.

As already noted, the peculiarities and judicious solutions present in the compositions and figures of the Koubelidiki reveal that the painter, although well acquainted with the artistic trends of his age, was an individualist who left the mark of his personality on his work.

The iconographic and stylistic features briefly noted here –such as the position and relation of the figures within the landscape and the architecture-scape, the juxtaposition of cold and warm colours, the use of highlights in certain parts of the face and the

garments which lend plasticity to the forms– and affinities with monuments of the middle and the second half of the 13th century, especially in Serbia, date the wall paintings of the Koubelidiki to 1260-1280.

Bibliography

A. Orlandos, «Τά Βυζαντινά μνημεῖα τῆς Καστοριᾶς», Ἀρχεῖον Βυζαντινῶν Μνημείων Ἑλλάδος, vol. Δ΄, 1938, p. 125 ff.

P. Tsamisis, Ἡ Καστοριά καί τά μνημεῖα της, Athens 1949, p. 110 ff.

S. Pelekanidis, Καστοριά. Βυζαντιναί τοιχογραφίαι, Thessaloniki 1953, p. 29 ff., pl. 102-117.

S. Pelekanidis, "Kastoria", Reallexikon zur byzantinischen Kunst, I, 1190 ff.

C. Mavropoulou-Tsioumi, Οἱ τοιχογραφίες τοῦ 13ου αἰώνα στήν Κουμπελίδικη τῆς Καστοριᾶς, Thessaloniki 1973.

S.P.

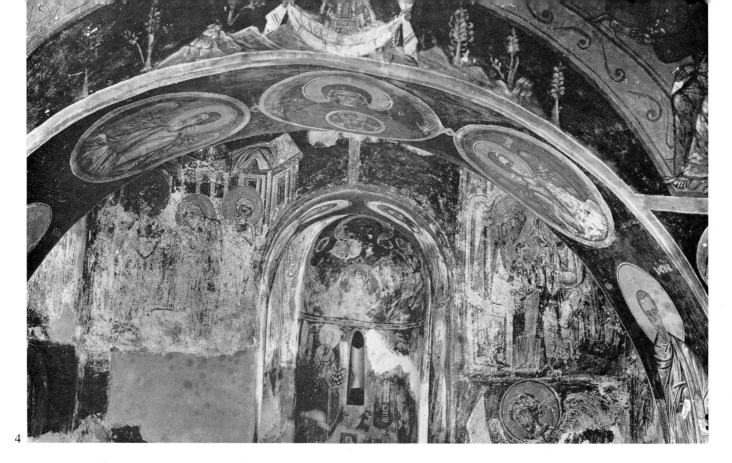

4

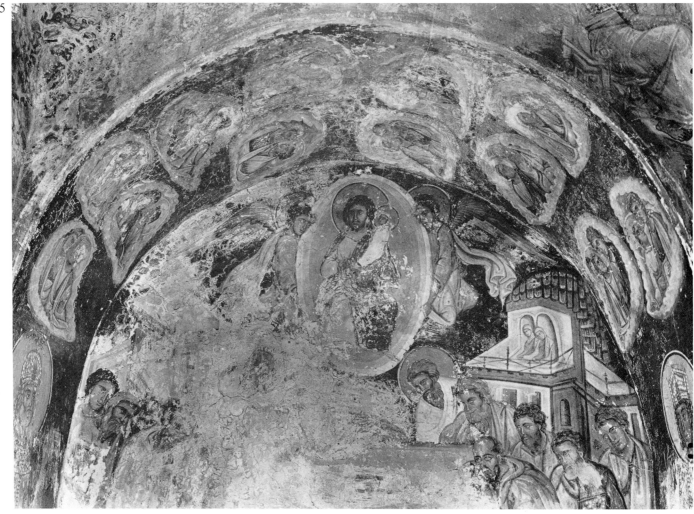

5

4. Panagia Koubelidiki, view from the esonarthex to the sanctuary. The Trial by Water and the Betrothal of the Virgin.

5. Panagia Koubelidiki, naos. The Dormition of the Virgin (fragment).

6. Panagia Koubelidiki, exonarthex. St. Menas (15th cent.).

PANAGIA KOUBELIDIKI OR KASTRIOTISSA
Supplementary Note

The manner in which the successive interventions to the mural decoration of this church have been effected is different from that encountered in Hagios Stephanos and in the Taxiarches. In the Koubelidiki, wall paintings of various epochs are intermingled, while over-painting has substantially altered some of the older ones. In other words, the almost absolute respect towards the original works observed in the other two churches is absent here. It is not easy to ascertain the reason for this difference.

The earliest known –so far– layer of wall paintings is dated to the 7th or 8th decade of the 13th century and is largely well preserved (Fig. 1). The main characteristics of its style are the broad soft modelling in greenish hues of the somewhat flaccid faces with the equally nerveless expressions (Fig. 8, 9), and the lavish broad undulating folds suggesting voluminous bodies without spiritual exaltation (Fig. 7). From the iconographic point of view, the presence of certain "westernizing" motifs is indicative – for example, in the

"synthronus" Holy Trinity and in the Dormition of the Virgin (Fig. 5, 10).

Similar features have been noted in a series of scenes from the life of the Virgin in the Metropolis of Mistra, which we have assigned to the 7th decade of the 13th century. This relationship is mentioned here in order to demonstrate more clearly the fact that the "voluminous" style encountered in the wall paintings of the Koubelidiki echoes a more general current of an important art centre. The refined colouring, which displays harmonious combinations of green with violet or of almond-green with wine-red (Fig. 7, 8), confirms the select provenance.

Bibliography

L. Hadermann-Misguish, "Une longue tradition byzantine. La décoration des églises", *Zograf*, vol. Z΄, 1976 (1977), p. 6-10.

M. Chatzidakis, «Νεώτερα γιά τήν ἱστορία καί τήν τέχνη τῆς μητρόπολης τοῦ Μυστρᾶ», *Δελτίον Χριστιανικῆς Ἀρχαιολογικῆς Ἑταιρείας*, vol. Θ΄, 1977-1979, Athens 1979, p. 143 ff.

M. CH.

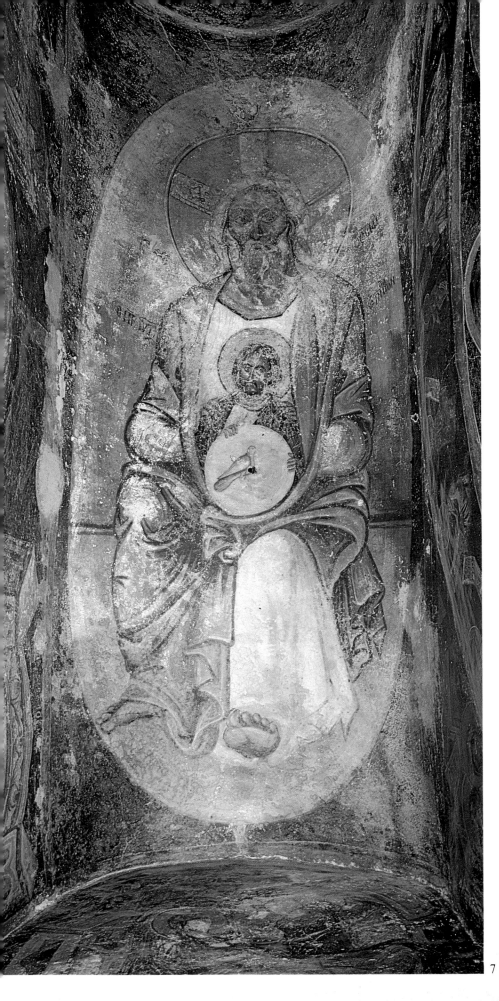

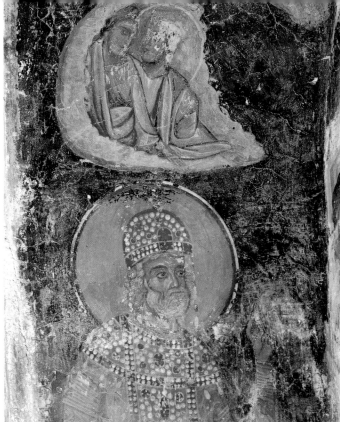

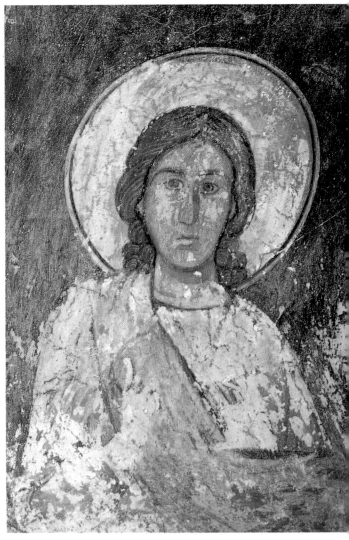

7

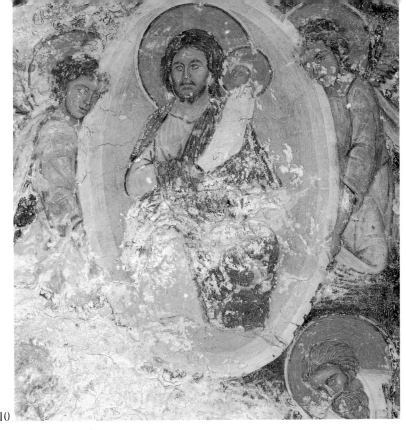

10

7. *Panagia Koubelidiki, transverse vault of the esonarthex. The Holy Trinity.*

8. *Panagia Koubelidiki, naos. The Dormition of the Virgin (detail).*

9. *Panagia Koubelidiki, naos. Martyr.*

10. *Panagia Koubelidiki, naos. The Dormition of the Virgin (detail).*

11. *Panagia Koubelidiki, esonarthex. The Entry into Jerusalem (detail).*

11

TAXIARCHES OF THE METROPOLIS

The church of the Taxiarches (Fig. 3) is located a short distance from Omonoia Square, in the vicinity of the Cathedral and Metropolitan's palace of Kastoria.

Probably the church was built over the ruins of an Early Christian basilica. This supposition, however, is supported only by the scant ancient architectural members –columns, bases and imposts of double colonnettes– re-used in the construction of the Byzantine church.

The numerous portrayals of richly attired "κεκοι-μημένοι" (deceased) and the accompanying written invocations in their favour, on the blind arches of the exterior of the south wall, suggest that the monument had served as a cemeterial church for the burial of the nobles and notables of Kastoria in the surrounding grounds. This suggestion is further supported by the location of the church at the SE end of the town and its consecration to the Archangel Michael.

From the older layer of wall paintings dating to the 9th century and from the founder's inscription on the west wall, over the lintel of the door leading to the naos, it appears that the basilica was built in the 9th century and re-painted in 1359/60, during the reign of the king Simeon Uroš Palaeologos.

Architecture

The church is a basilica divided into three aisles by two colonnades, each having two columns. The middle aisle terminates in a projecting semi-cylindrical apse, and the two side aisles in small conches hollowed into the thickness of the wall. A rather narrow narthex extends along the width of the west side of the naos. The central aisle with its excessively high clerestory –as in all the basilicas of Kastoria– is covered by a barrel-vault (Fig. 2, 3). The side aisles were covered by vaults of quadrant section, which collapsed and were replaced by sloping timber roofs. Transverse arches secured in the walls support the vaults of the narthex –

a barrel-vault in the middle and two "scaphoid" vaults on the sides. The width of each of these three vaults corresponds to the width of each of the three aisles of the main church (Fig. 1). This provides further evidence that the narthex is organically connected and contemporary with the main church, contrary to what had been maintained earlier. The exterior masonry is similar to that of the other Byzantine churches of the town.

Extensive interventions were effected on the north part of the monument. At some unverified time, the north and part of the east and west walls of the north aisle and of the narthex collapsed. They were reconstructed to twice the original width. Only half of the east wall with the small semicircular conch has been preserved from the original construction. In 1937, two buttresses were built on the south side to consolidate the wall (Fig. 3).

Painting

First layer. Two periods can be distinguished in the storying of the church. The first has been preserved fragmentarily and in very poor condition on the east wall of all three aisles and in the narthex. Parts of a decorative band are visible along the edge of the arch of the sanctuary conch. The conch of the north aisle was covered with a full-length portrait of Christ (Plan no. a), and that of the south aisle with a portrait of St. Matthew the Evangelist (Plan no. δ). It is difficult to ascertain whether the narthex had been re-painted, as there is no trace of any wall paintings dating from 1359/60.

The whole height of the wall of the narthex, over the tympanum crowning the Royal Door, is occupied by a representation of Christ enthroned and dressed in a violet *chiton* and dark blue *himation* (Plan no. ε). The tympanum is painted with a Deesis showing the three figures in bust, with the Lord depicted frontally and

larger than the Theotokos and St. John the Baptist. The west wall of the narthex, above the doorway, has a representation of the Virgin enthroned with the Christ-Child in a mandorla, and two saints holding scrolls on either side (Fig. 8, Plan no. ια). The transverse vault of the central section was covered with a many-figured composition, now showing faintly in the middle figures of angels, possibly from a painting of the Ascension (Plan nos. στ, ζ, η, θ), such as the one depicted in the corresponding position of the Hagioi Anargyroi. The tympanum above the door leading to the south aisle shows Christ, in bust, with arms spread out in blessing (Plan no. κα). The soffit of the north transverse arch is divided into two registers, each painted with two unidentified saints. On the soffit of the south arch can be distinguished the portraits of St. George, St. Sozon and another unidentified saint (Plan nos. ιγ, ιδ, ιε).

Conclusions regarding the totality of the first storying of the church cannot be reached from the surviving fragments of the first layer of wall paintings. Nor does their poor state of preservation permit a distinction between different painters. Differences do exist in the faces, the hair and, more generally, the facial features, but a detailed examination is impossible due to their damaged condition. Only the relatively well preserved painting of St. Matthew the Evangelist, in the conch of the south aisle, makes possible a more systematic study of this archaic style, which characterizes the first layer of mural decoration in the Taxiarches – a style often encountered in the early wall paintings of Cappadocia and the mosaics of the 8th and 9th centuries.

Second layer. The wall paintings of the second layer are limited to the holy bema and the entirely painted central aisle. The vault covering the clerestory has preserved only fragments of the lower parts of a few representations from the cycle of the Twelve Feasts (Plan nos. 13-15, 17-20).

In the conch of the sanctuary the Virgin Orans is depicted standing frontally, between two kneeling archangels whose hands are covered with a cloth (Fig. 4, 7, 9, Plan nos. 8, 9). Below the Virgin Orans, the Hierarchs Basil and Gregory the Theologian, John

Chrysostom and Athanasios are painted in pairs, on either side of a double window, facing the Breaking of Bread depicted in the centre. Each pair of hierarchs is attended by an angel dressed in deacon's vestments and holding a fan (Fig. 5, 6).

The wall surfaces of the central aisle are divided into four main zones painted with scenes from the Twelve Feasts and the Lord's Passion and with portraits of saints. In the upper zone of the east wall, above the apse –and below the Ascension– are depicted the Annunciation with the Holy Mandylion (Fig. 7). On the south wall are painted the Betrayal, the Helkomenos (Christ Being Led to the Cross), the Ascent on the Cross (Fig. 12, Plan nos. 23, 24) and the Crucifixion (Fig. 10, Plan no. 25), on the north wall the Deposition (Fig. 11, Plan no. 26), the Lamentation for Christ (Fig. 23, Plan no. 27), the Myrrh-Bearing Women (Fig. 15, Plan no. 28) and the Descent into Hell (Plan no. 29), on the west wall the Transfiguration (Plan no. 17) and, below, the Dormition of the Virgin (Fig. 14, Plan no. 31). On the evidence of the iconographic remains, we can deduce that the other representations from the Twelve Feasts cycle, such as the Nativity, the Entry into Jerusalem and other scenes from the earthly life of Christ, were painted on the original barrel-vault covering the aisle.

The second zone shows saints, alternatingly depicted full-length and in bust (Fig. 16, 17, Plan nos. 51, 35). In the latter case the paintings imitate portable icons hanging on the face of the wall above the arches. Full-length saints fill every available space, including the pilasters on either end of the colonnade and the soffits of the arches. The four Evangelists are portrayed in pairs, on the soffits of the middle arch of both arcades. This is an iconographic principle which recurs in arcaded, either three-or one-aisled, churches of oblong plan, in imitation to domed churches where the Evangelists occupy the four pendentives.

The evangelical scenes decorating the clerestory present characteristic differences between them, both in style and composition. The representations on the south wall are drawn hastily, postures are angular, the figures primitivistic and the shapes elaborate. Generally, these compositions show restlessness and a lack of rhythm. By contrast, the compositions on the north

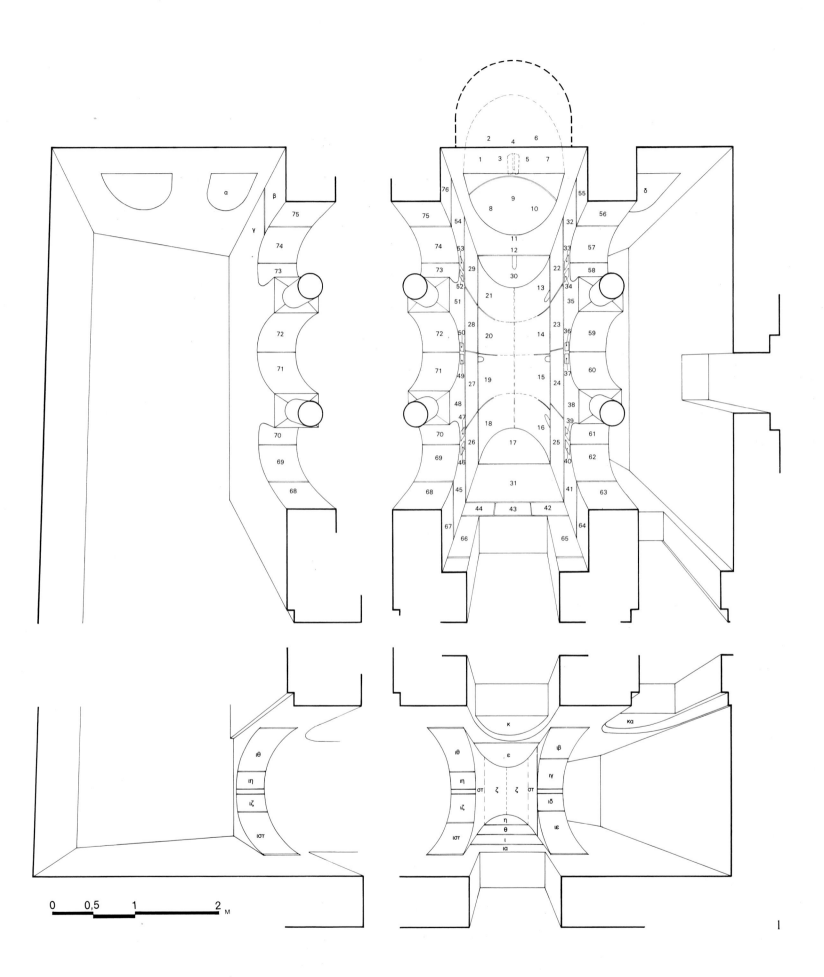

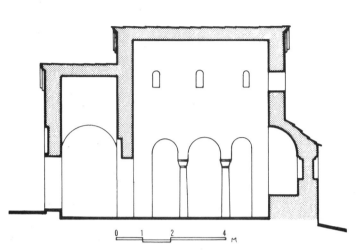

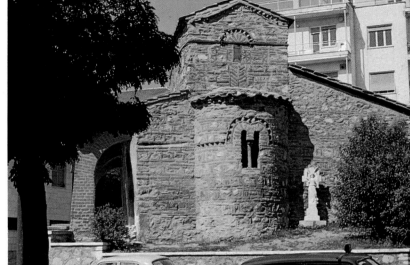

TAXIARCHES OF THE METROPOLIS

1. Taxiarches of the Metropolis. Perspective plan.

2. Taxiarches of the Metropolis. Section.

3. Taxiarches of the Metropolis. East view.

First layer. α. *Christ.* **β.** *Traces of full-length saint.* **γ.** *Traces of full-length saint.* **δ.** *St. Matthew.* **Narthex. ε.** *Christ enthroned.* **στ-ζ-η-θ.** *Traces.* **ι.** *Saint.* **ια.** *The Virgin with the Sts. Cosmas and Damian?* **ιβ.** *Saint.* **ιγ.** *St. George?* **ιδ.** *St. Sozon?* **ιε.** *Saint.* **ιστ.** *Half-length saint.* **ζ-ιη-ιθ.** *Saint.* **κ.** *The Deesis.* **κα.** *Bust of Christ.* **Layer of 1359. 1.** *St. Gregory the Theologian.* **2.** *St. Basil.* **3.** *Saint.* **4.** *The Breaking of Bread.* **5.** *Angel.* **6.** *St. John Chrysostom.* **7.** *St. Athanasios the Great.* **8.** *The Archangel Michael.* **9.** *The Virgin of the apse.* **10.** *The Archangel Gabriel.* **11.** *The Holy Mandylion.* **12.** *The Annunciation.* **13.** *The Nativity.* **14.** *The Presentation of Christ in the Temple.* **15.** *The Baptism.* **16.** *The Raising of Lazarus.* **17.** *The Transfiguration.* **18.** *The Entry into Jerusalem.* **19.** *The last Supper.* **20.** *The Washing of the Feet.* **21.** *The Prayer in the Garden.* **22.** *The Betrayal of Judas.* **23.** *Christ Being Led to the Cross (Helkomenos).* **24.** *The Ascent on the Cross.* **25.** *The Crucifixion.* **26.** *The Deposition.* **27.** *The Lamentation for Christ.* **28.** *The Women at the Sepulchre.* **29.** *The Resurrection.* **30.** *The Ascension.* **31.** *The Dormition of the Virgin.* **32.** *Romanos the Melodist.* **33.** *St. Clement.* **34.** *St. Gregory Thaumaturge.* **35.** *St. Tryphon.* **36.** *St. Platon.* **37.** *St. Porphyrios.* **38.** *St. Gourias.* **39.** *St. Samonas.* **40.** *St. Abibos.* **41.** *St. John of Damascus.* **42.** *Saint and St. Markianos.* **43.** *Founder's inscription.* **44.** *St. Martyrios and Saint.* **45.** *St. Cosmas of Maiouma.* **46.** *St. Pegasios.* **47.** *St. Akindynos.* **48.** *St. Anempodistos.* **49.** *St. Aphtonios.* **50.** *St. Elpidophoros.* **51.** *St. Sozon.* **52.** *St. Antypas.* **53.** *St. Eleutherios.* **54.** *St. Ephraim Syrus.* **55.** *St. Ignatios the Theophoros.* **56.** *St. Cyril.* **57.** *St. Blasios.* **58.** *St. Achilleios.* **59.** *St. John the Theologian.* **60.** *St. Mark.* **61.** *St. Damian.* **62.** *St. Cosmas.* **63.** *St. George.* **64.** *St. Theodoros Stratelates.* **65.** *St. Procopios.* **66.** *St. Nestor.* **67.** *St. Theodoros Tiro.* **68.** *St. Demetrios.* **69.** *St. Panteleimon.* **70.** *St. Hermolaos.* **71.** *St. Luke.* **72.** *St. Matthew.* **73.** *St. Amphilochios.* **74.** *St. Nephon.* **75.** *St. Sophronios.* **76.** *St. John the Eleimon.*

wall –with very few exceptions– cover the surface harmoniously. Their lines are soft, the figures judiciously placed, the bodies display naturalism and the faces reflect inwardness, while emotions are moderate and colour contrasts well balanced.

A fine example of this type of painting is the representation of the Stone of the Tomb or of the Myrrh-Bearing Women (Fig. 15). The angel, dressed in a luminous *himation* with multiform flowing folds rendered with deep-coloured lines, is seated on the cube-shaped stone, majestically occupying the centre of the scene. The figure is enlivened even more by the turn and inclination of the head in the direction of the Women, and the counter motion of the wings. Curling and undulating locks crown the head of the angel, who points with his right hand to the empty sepulchre. Below, to the right, are the sleeping soldiers of the guard. To the left, three Myrrh-Bearing Women –the third indicated by the visible part of her halo– terrified and ecstatic, hold each other's hand and shoulder. The group of women with their dark-coloured veils contrasting the luminous attire of the angel, and the exquisite

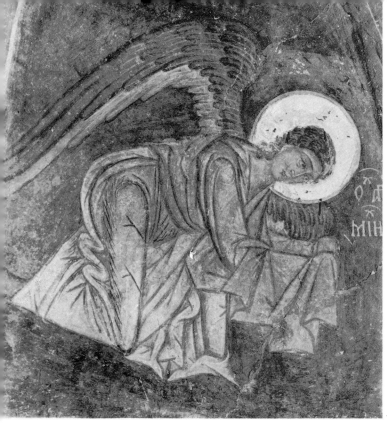

4. *Taxiarches of the Metropolis, sanctuary. The Archangel Michael worshipping.*

5 *and* 6. *Taxiarches of the Metropolis, sanctuary. The Hierarchs Gregory, Basil, John Chrysostom and Athanasios co-officiating.*

7. *Taxiarches of the Metropolis. The east wall with the sanctuary apse.*

8. *Taxiarches of the Metropolis, narthex. The Theotokos between two Saints (first layer).*

9. *Taxiarches of the Metropolis, sanctuary. The Virgin Orans (see Fig. 7).*

5

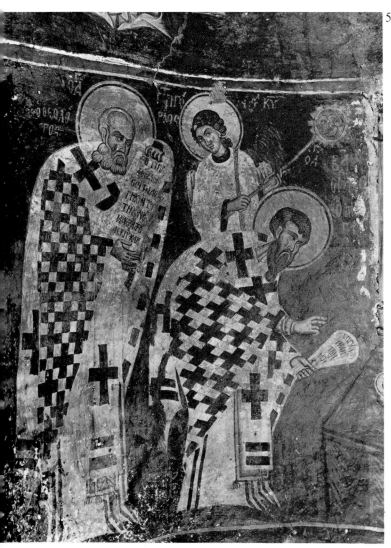

6

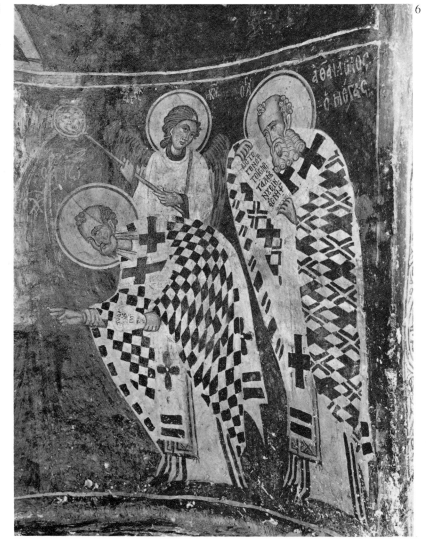

treatment of folds on the first woman's pale brown dress, reveal the high class of this painter's talent.

The same skill is displayed in the clever disposition of the many figures which crowd the reduced space of the Dormition of the Virgin, in the postures, the expressive power of faces and the variety of restrained gestures (Fig. 14).

The differences noted in the large-scale compositions are even more pronounced in the portraits of single saints. This lends support to the suggestion that more than one painters had worked in the church, either independently or as members of a team. In view of the fact, however, that certain details have been rendered everywhere in the same style and technique, it would be reasonable to surmise that the church was storied by one master painter working with his worthy assistants.

8

9

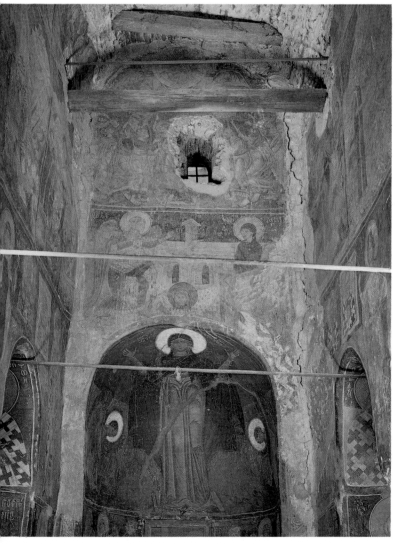

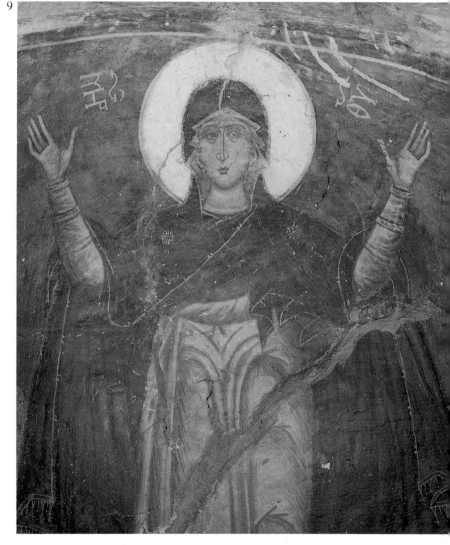

This painter –or painters– has been judged by some as lacking in skill and experience. In addition to the not very successful imitation of certain older compositions, his work shows in fact an occasional negligence in the drawing and the proportions and an overcrowding of the scenes, which produce a somewhat heavy effect. This however is not the general rule, as indicated by the representations of the Virgin Platytera, the Stone of the Tomb, the Descent into Hell, the Dormition of the Virgin etc.

Similar painting ensembles contemporary with those of the Taxiarches are not known to exist. Their relationship with the murals of the monastery at Zemen, Bulgaria, is not as close as some foreign scholars have maintained for the two monuments to have been interdependent or to have been both painted by the same atelier. They share, perhaps, the same tradition but not the same provenance.

On the outer face of the west wall of the narthex, on the tympanum of the doorway, the Theotokos Hodegetria is shown between two half-length worshipping angels. To the right and left, the full-length, oversized, frontally portrayed Archangels Michael and Gabriel cover the entire height of the wall (Fig. 21).

These wall paintings depart from the style of the interior murals. Technical and stylistic features, the modelling of the face with a basic colour and light ochre, the few green shades on the edge of the cheeks, the rendering of the eyes, nose and mouth, all point to the 13th century.

Bibliography

A. Orlandos, «Τά βυζαντινά μνημεῖα τῆς Καστοριᾶς», ᾿Αρχεῖον Βυζαντινῶν Μνημείων ῾Ελλάδος, vol. Δ´, 1938, p. 61 ff.

P. Tsamisis, ῾Η Καστοριά καί τά μνημεῖα της, Athens 1949, p. 108 ff.

S. Pelekánidis, Καστοριά. Βυζαντιναί τοιχογραφίαι, Thessaloniki 1953, p. 31 ff., pl. 118-141.

S. Pelekanidis, "Kastoria", Reallexikon zur byzantinischen Kunst, I. 1190 ff.

V. Djurić, Byzantinische Fresken in Jugoslavien, Belgrade 1976, p. 113, note 100-101.

S.P.

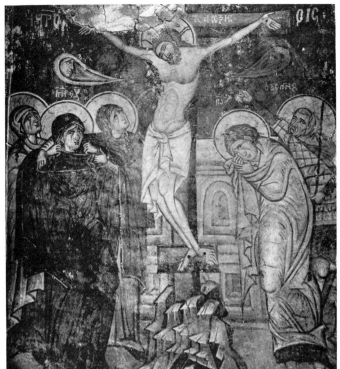

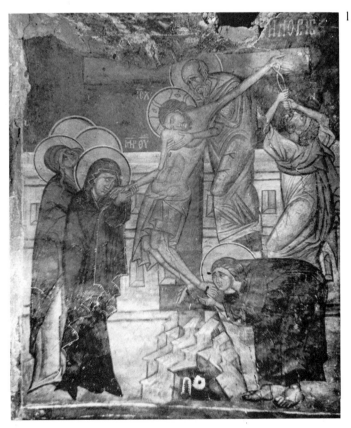

10. Taxiarches of the Metropolis. The Crucifixion.
11. Taxiarches of the Metropolis. The Deposition.
12. Taxiarches of the Metropolis. The Ascent on the Cross.

12

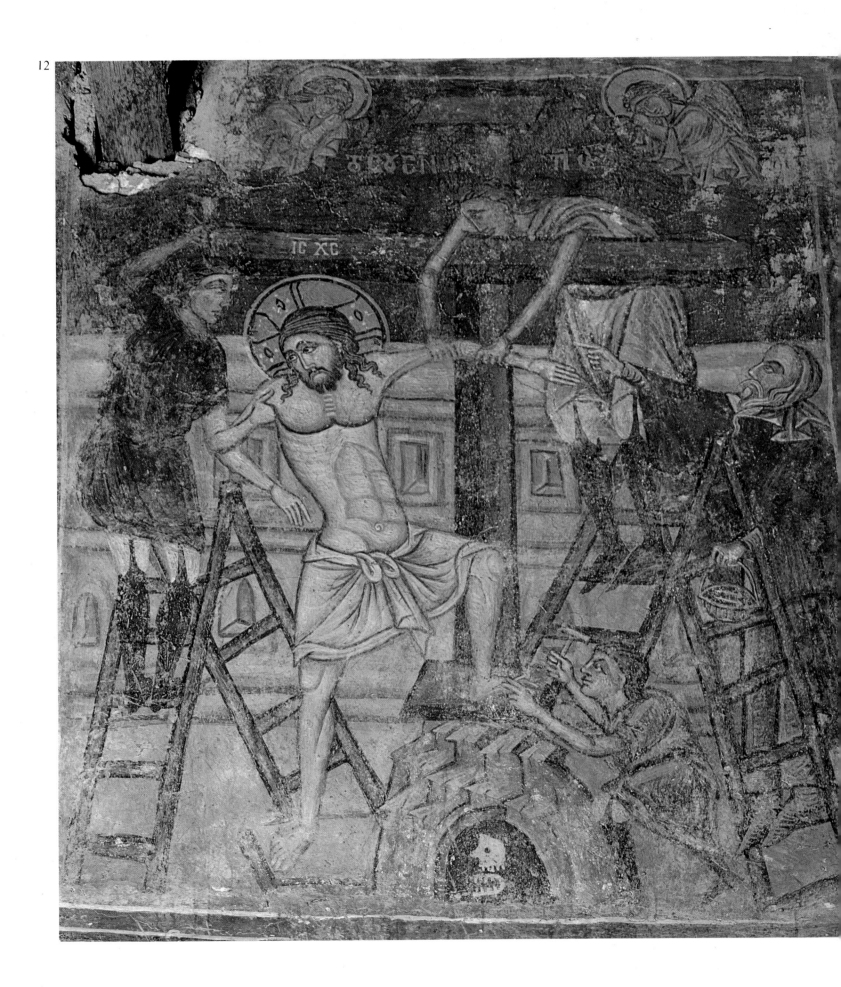

IC XC

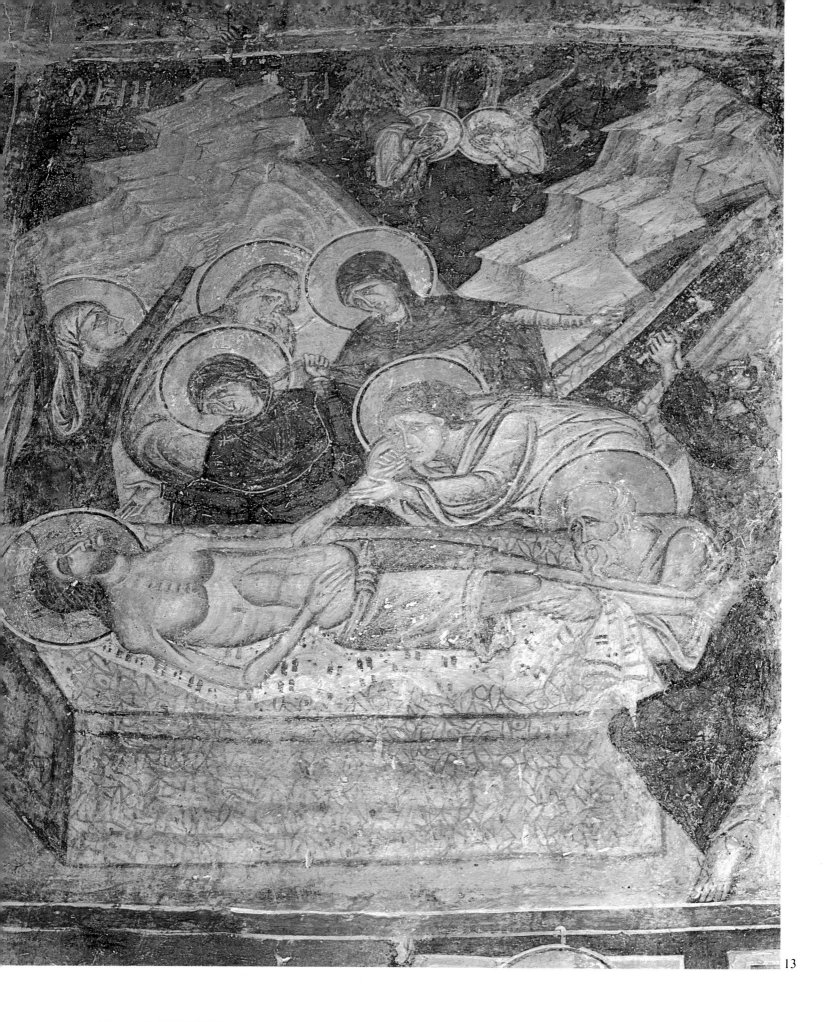

13

13. *Taxiarches of the Metropolis, naos, north wall. The Lamentation for Christ.*

14. *Taxiarches of the Metropolis, naos, west wall. The Dormition of the Virgin.*

15. *Taxiarches of the Metropolis, naos, north wall. The Holy Women at the Sepulchre — The Stone of the Tomb.*

14

15

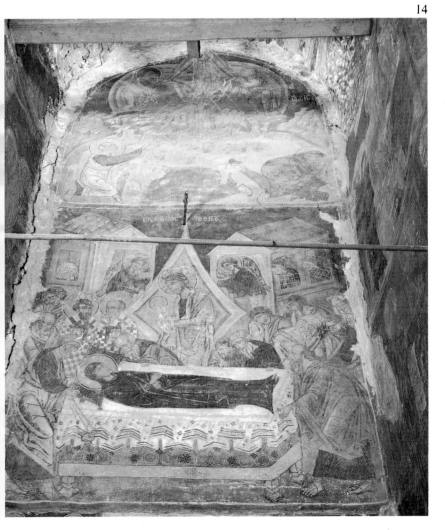
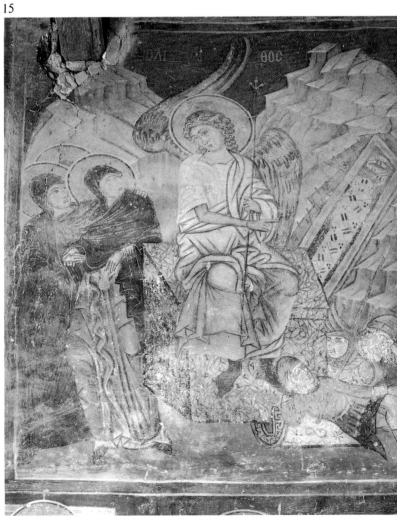

TAXIARCHES OF THE METROPOLIS
Supplementary Note

The Taxiarches is the second church in Kastoria, after Hagios Stephanos, which has preserved to a considerable extent wall paintings of the 10th century. In the naos, apart from the paintings of that date mentioned by Pelekanidis, we would add two full-length unidentified figures of saints on the pilaster of the north colonnade in the north aisle (Plan nos. β, γ). Quite probably, traces at least of the mural decoration have survived on the wall above the arches of the north aisle, for there, too, the original layer of plaster has been preserved over the whole surface.

The narthex presents an ensemble of wall paintings and possibly an example of the iconographic programme of that early date, when the decoration comprised figures of saints only and not scenes. The imposing size of the enthroned Christ, occupying the whole height of the tympanum above the entrance to the naos, is remarkable (Plan no. e.). The very small human figures, visible in the four narrow zones on the tympanum opposite to the one with the enthroned Christ, do not confirm the assumption that the scene depicted is the Ascension. I consider as more likely that these figures represent attendants of the majestic Christ. However, the poor condition of the paintings does not permit at present a more precise identification.

We witness here a repetition of the occurrence noted in Hagios Stephanos, where the ground-floor of the naos and the two storeys of the narthex have not been covered –except sporadically– by a later layer of murals. In the Taxiarches, too, the wall paintings of the narthex and of the lateral aisles, although in a much worse state of preservation than those of Hagios Stephanos, have not been painted over. The poor condition of the paintings does not allow specific comparisons of style between the two churches. Nevertheless, the double rows of pearls which, here too, form the contour of haloes, and the background of the preserved figures, which is painted in brick colour to the height of the shoulders, are indicative of a close relationship between the two monuments. The second layer of paintings, of 1359/60, decorat-

ing the walls and arches of the central aisle, as well as the vault, belong to an anticlassical artistic trend characterized by flatness, linear contours and an intense expressiveness of faces, postures and movements. It should be noted, however, that a masterly attempt to adapt compositional elements to a geometric pattern is obvious in large-scale representations, such as the Virgin Orans in the apse (Fig. 7, 9) and the Dormition of the Virgin (Fig. 14). This reveals that the anticlassical style has been a conscious selection. Moreover, the high artistic quality of these paintings shows clearly that they are not the product of a simple provincial art. We can even discern a tendency of regression to much older models. In the Dormition, the compositions of epic grandeur of the beginning of the century are ignored in favour of the less elaborate arrangements of the 11th century, where the apostles crowd the sides leaving the centre free for the main theme, Christ and the Virgin.

The murals, painted by a number of artists, are not unique. The wall paintings of Hagios Nikolaos tou Kyritzi in Kastoria and others in Ochrid belong to the same artistic current and use similar manners of expression.

Of particular significance are the exterior wall paintings, both on the west façade (Fig. 21, 22) and the south side, where the wall of the narthex and the blind arches are painted with portraits of the deceased buried there at various dates. These murals provide valuable evidence on the people, the costumes and the local art. The earliest of the exterior wall paintings, decorating the tympanum of a small side door, shows the Panagia Glycophilousa (Our Lady of Tenderness) –in a type popular in Macedonia– flanked by the figures of St. Peter and St. Paul.

Bibliography

M. Chatzidakis, Ἱστορία τοῦ Ἑλληνικοῦ Ἔθνους, vol. Θ΄, Athens 1979 p. 44.

M. CH.

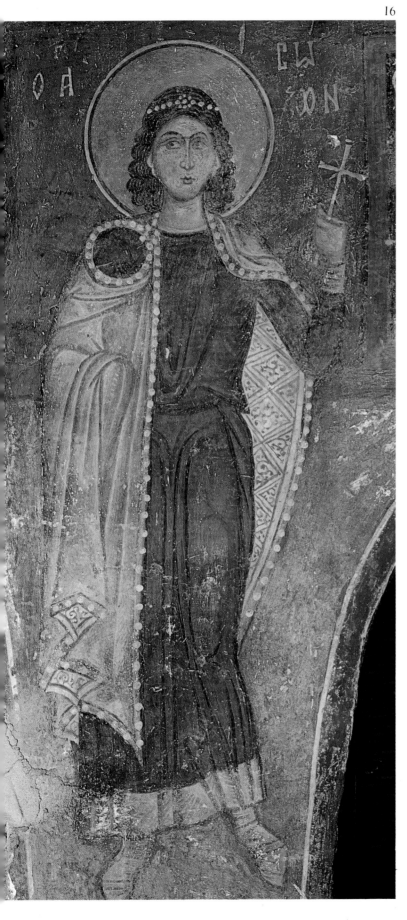

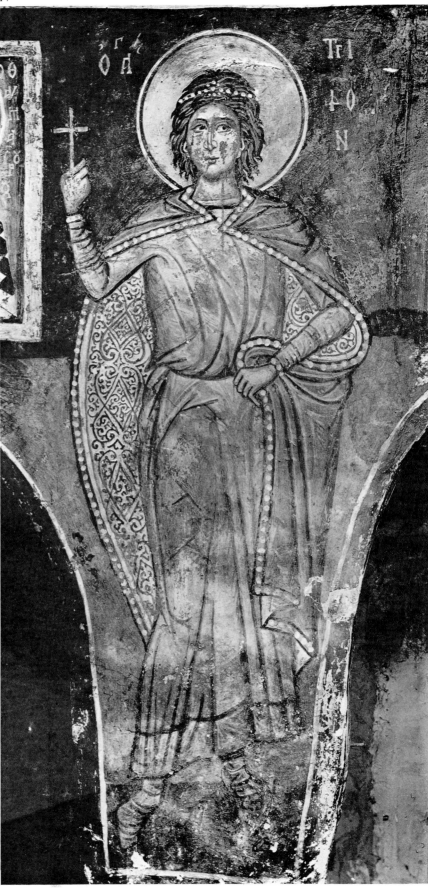

16 and 17. Taxiarches of the Metropolis, naos. St. Sozon (north wall) and St. Tryphon (south wall).

18. Taxiarches of the Metropolis, naos. St. Theodoros Stratelates.

19. Taxiarches of the Metropolis, naos. St. George Gorgos.

20. Taxiarches of the Metropolis, naos. St. Ignatios Theophoros.

21. Taxiarches of the Metropolis, south wall. Exterior wall paintings.

22. Taxiarches of the Metropolis, south wall, exterior wall paintings. Irene Palaeologina, mother of the donor John Asanes (see Fig. 21).

18 19

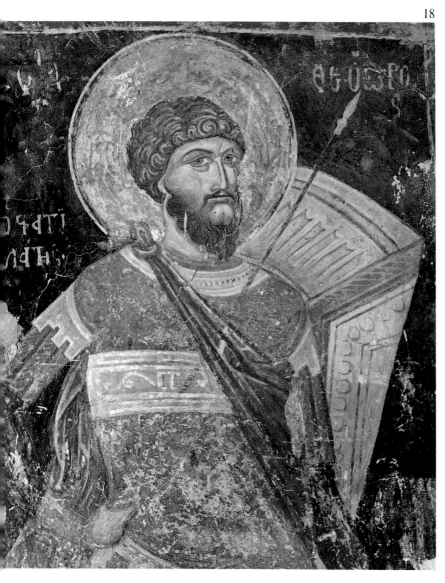
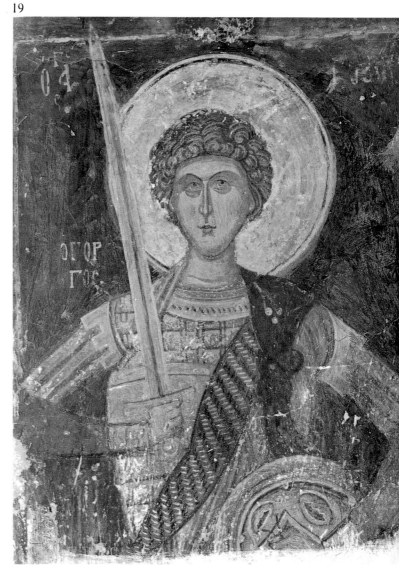

21

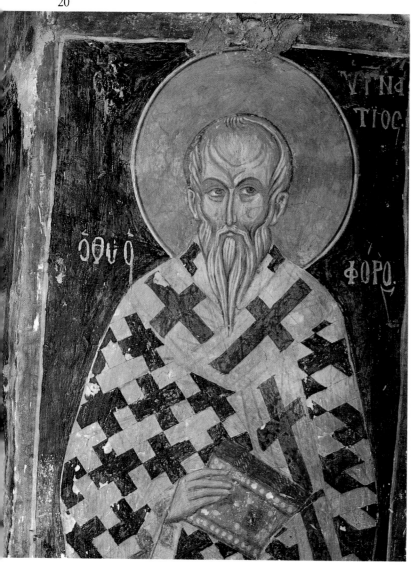

20

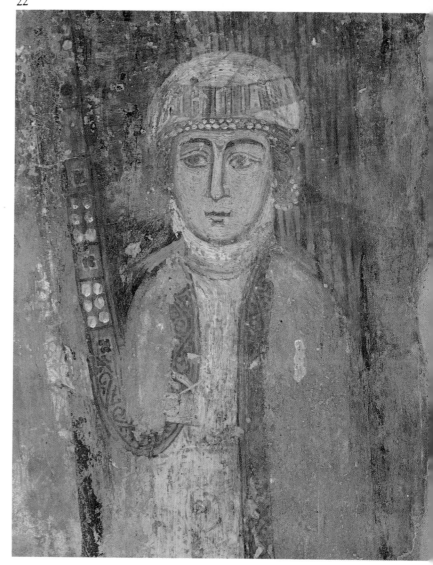

22

HAGIOS ATHANASIOS TOU MOUZAKI

The small church dedicated to St. Athanasios is situated near the Metropolis. Measuring 6.25×3.45 m., it is one-aisled, timber-roofed and has a narthex of later date (Fig. 1). The calligraphic but wrongly composed and misspelt founder inscription on the west wall records that the church was built and decorated with wall paintings in 1384/5, by the brothers Stoias and Theodoros Mouzakes, local rulers of the time, and the hieromonk Dionysios. This assigns the church to the brief period between the Serbian (1374) and the Turkish (1386) occupation of Kastoria, when the town was ruled by the old Albanian family of the Mouzakes. Works for the consolidation of the building were carried out in 1951, and for the conservation of the wall paintings quite recently.

The church has preserved all the wall paintings dating from 1384/5. The decoration is divided, as was customary, into three zones: a lower wide zone with full-length figures of saints, a second narrower one with roundels enclosing busts of saints, and an upper zone with Christological scenes. The lower part of the wall imitates marble revetment (Fig. 2).

The half-dome of the sanctuary is painted with a bust of the Virgin Platytera above, the Communion of the Apostles (Fig. 5) in the middle, and four co-officiating hierarchs below. The front of the apse, above the conch, shows remains of the figures of the Apostles from the Ascension, which occupied the whole pediment. In the middle zone, the Annunciation marks the beginning of the Christological cycle. The Virgin is portrayed seated in front of a complex of many-storeyed buildings with a reddish low rampart in the background (Fig. 3), which is continued behind the

figure of the Archangel Gabriel, standing on the other side of the apse. The lower zone of the north wall shows in the prothesis the Vision of St. Peter of Alexandria (Plan nos. 63, 64). St. Stephanos the Deacon is portrayed in the conch of the prothesis, and next St. Symeon the Stylite (Plan nos. 8, 9). The procession of co-officiating hierarchs of the sanctuary is continued on the south part of the east wall with St. Cyril (Plan no. 10), and on the south wall with two local hierarchs, St. Clement of Ochrid and St. Achilleios of Prespa (Plan nos. 16, 17). Within a painted arched frame next to the templon, St. Athanasios is portrayed full-length and on a larger scale (Plan no. 18). Next are depicted the Sts. Nicholas (Plan no. 19), Demetrios Grand Duke the Apokaukos (Plan no. 20), the two Sts. Theodoroi, who have deposited their weapons on the ground and turned with hands raised in prayer to the small figure of Christ above them (Fig. 14, Plan nos. 21, 22), and last the Sts. Procopios and Mercurios (Plan nos. 23, 24). In the same zone, on the west wall, are pictured the Sts. Constantine and Helen (Plan nos. 44, 45), the Archangel Michael and St. Barbara (Plan nos. 46, 47, Fig. 8). On the north wall are portrayed the Sts. Nicholas the Younger and Alexander of Pydna or Thessaloniki (Fig. 12, Plan nos. 55, 56) and St. George of Cappadocia (Plan no. 59). This zone is dominated by the Deesis. The composition shows under a triple arch the enthroned Christ and the standing Virgin in royal costumes (Fig. 13) (cf. St. Helen on the west wall, Fig. 8). The inscription accompanying the image of Christ ΒΑΣΙΛΕΥΣ ΤΗΣ ΔΟΞΗΣ (King of Glory) and the evangelical passage "Then shall the King say...

Come, ye blessed of my Father" (Mat. 25, 34) explain the royal attire with the high domed mitre and the crossed *loros* (imperial jewelled stole), a representational type that prevailed in post-Byzantine painting under the title "the King of Kings and High Priest". The depiction of the Virgin Queen is inspired from Psalm 45, 9 "... upon thy right hand did stand the Queen...". St. George and another unidentified saint participating in the Deesis next to the Virgin are robed like great lords, in costumes and high head-dresses of that epoch.

We note that with the exception of the full-length portraits of the Sts. Helen and Barbara and the small busts of the Sts. Paraskeve and Kyriake (Plan nos. 57, 58), the selection of saints in the church shows little appreciation of female saints. Preference is given to warrior and local saints. In addition to the two local hierarchs already mentioned, the Sts. Nicholas the Younger and Alexander of Pydna or Thessaloniki are portrayed on the north wall, wearing lordly garments with picturesque head-dresses and postured as if conversing (Fig. 12).

The above mentioned Christological cycle (Plan nos. 11, 12, 38-42, 50, 51, 53, 82-86 and 15) begins in the upper zone with the Annunciation on either side of the sanctuary conch, is continued on the south wall with the Nativity, the Presentation in the Temple, the Baptism (Fig. 6), the Raising of Lazarus (Fig. 7) and the Entry into Jerusalem (Fig. 4). The monumental Transfiguration dominates the pediment of the west wall (Fig. 8), while the middle zone is painted with the Dormition of the Virgin (Fig. 9), Christ before Caiaphas and Peter's Denial (Fig. 10).

The scenes of the Passion are continued on the north wall with the Helkomenos (Christ Being Led to the Cross) (Fig. 11), the Crucifixion, the Lamentation for Christ, the Myrrh-Bearing Women and the Descent into Hell. Fragments of the Ascension have been preserved on the front of the sanctuary (Fig. 2).

With respect to sequence of programme, iconography and style, the models for these sixteen compositions are to be sought in monuments of the region of Thessaloniki dated in the first decades of the 14th century. Outstanding among the scenes is the Raising of Lazarus, with the horizontally placed sarcophagus-tomb in which the risen Lazarus sits up (Fig. 7). Along with the emphasized eschatological and triumphant character of the Deesis, with its royal costumes and other clothing anachronisms, the Raising of Lazarus reveals the strong tendency of the age towards an iconographic initiative of rather aristocratic origin. The compositions, of a classical character with a close and well-balanced disposition of figures, display a certain nobility of stature but are also noted for brisk attitudes and dramatic gestures (Fig. 5, 9, 10). Realistic details are not lacking. For instance, in the Raising of Lazarus many of those present are emphatically shown taking precaution against the fetid smell of the corpse (Fig. 7), and in the Entry into Jerusalem the riding animal is pictured shying and a young boy shamelessly taking off his clothes (Fig. 4).

These wall paintings have been attributed to an atelier which has been recognized in other churches within a wider region – e.g. the church of the Nativity (1369) on the islet of Mali-Grad in what is today the Albanian part of Lake Prespa, and the church of the Zoodochos Pege (1390) at Borje (Emporium) in the region of Koritsa. The wall paintings of Kastoria, however, excell both in the variety of programme and in the quality of painting.

Bibliography

A. Orlandos, «Τά βυζαντινά μνημεῖα τῆς Καστοριᾶς», ᾿Αρχεῖον Βυζαντινῶν Μουσείων ῾Ελλάδος, vol. Δ΄, 1938, 147-158.
S. Pelekanidis, Καστοριά, Βυζαντιναί τοιχογραφίαι, Thessaloniki 1953, pl. 142-154.
Id., "Kastoria", Reallexikon zur Byzantinischen Kunst, vol. III, 1. 1190 ff.
Lena Grigoriadou, "L'image de la déesis Royale dans une fresque du XIVe siècle à Castoria", Actes du XIVe Congrès international des études byzantines à Bucarest 1971, Bucarest 1975, p. 47-53, pl. 1-10, with ref. to earlier bibliography.
V. Djurić, "Mali-Grad, Saint-Athanase à Kastoria, Borje", Zograf, No 6, 1975, p. 31-50 (in Serbian, with summary in French).

M.CH.

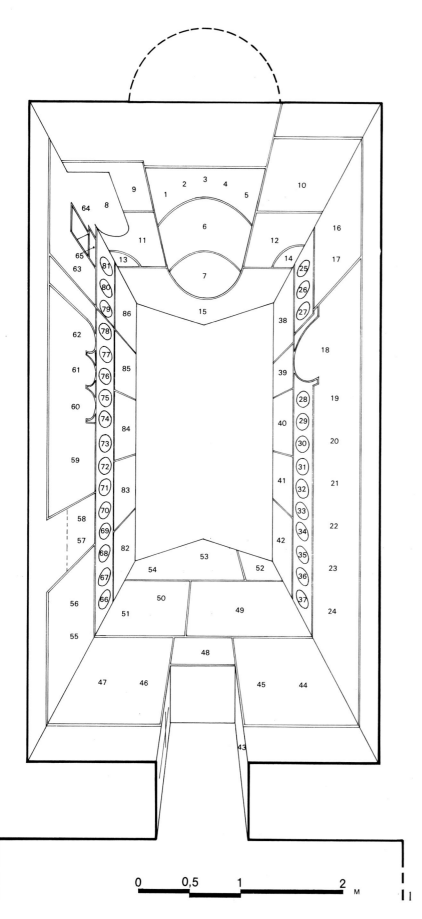

1. *Hagios Athanasios tou Mouzaki. Perspective plan.*

2. *Hagios Athanasios tou Mouzaki. The east side with the sanctuary, and part of the south side.*

HAGIOS ATHANASIOS TOU MOUZAKI

1. *St. Gregory the Theologian.* **2.** *St. Basil.* **3.** *The Holy Table.* **4.** *St. John the Eleimon.* **5.** *St. Gregory of Nyssa.* **6.** *The Communion of the Apostles.* **7.** *The Virgin Platytera.* **8.** *St. Stephanos the Deacon.* **9.** *St. Symeon the Stylite.* **10.** *St. Cyril of Alexandria.* **11.** *The Angel of the Annunciation.* **12.** *The Virgin of the Annunciation.* **13.** *Prophet.* **14.** *The Prophet Habakkuk.* **15.** *The Ascension.* **16.** *St. Clement of Ochrid.* **17.** *St. Achilleios of Prespa.* **18.** *St. Athanasios.* **19.** *St. Nicholas, the Ardent Protector.* **20.** *St. Demetrios.* **21.** *St. Theodoros Tiro.* **22.** *St. Theodoros Stratelates.* **23.** *St. Procopios.* **24.** *St. Mercurios.* **25.** *St. Dionysios the Areopagite.* **26.** *St. Gregory of Agrigentum.* **27.** *St. Hypatios.* **28.** *St. Eustratios.* **29.** *St. Auxentios.* **30.** *St. Eugenios.* **31.** *St. Mardarios.* **32.** *St. Ananias.* **33.** *St. Azarios.* **34.** *St. Misael.* **35.** *St. Arethas.* **36.** *Saint.* **37.** *Saint.* **38.** *The Nativity.* **39.** *The Presentation of Christ in the Temple.* **40.** *The Baptism.* **41.** *The Raising of Lazarus.* **42.** *The Entry into Jerusalem.* **43.** *Traces.* **44.** *St. Constantine.* **45.** *St. Helen.* **46.** *The Archangel Michael.* **47.** *St. Barbara.* **48.** *Founder's inscription.* **49.** *The Dormition of the Virgin.* **50.** *Christ before Annas and Caiaphas.* **51.** *Peter's Denial.* **52.** *The Prophet Zechariah.* **53.** *The Transfiguration.* **54.** *The Prophet David.* **55.** *St. Nicholas the Younger.* **56.** *St. Alexander of Pydna.* **57.** *St. Paraskeve.* **58.** *St. Kyriake.* **59.** *St. George of Cappadocia and an unidentified saint.* **60.** *The Virgin.* **61.** *Christ.* **62.** *St. John the Baptist.* **63.** *The Vision of St. Peter of Alexandria.* **64.** *Christ in the Vision of St. Peter.* **65.** *Inscription.* **66.** *St. Julitta.* **67.** *St. Kerykos.* **68. 69. 70. 71. 72. 73. 74. 75.** *Saints.* **76.** *St. Elizabeth.* **77.** *St. Cosmas.* **78.** *St. Damian.* **79.** *St. Germanos of Constantinople.* **80.** *St. Polykarpos.* **81.** *St. Ignatios.* **82.** *Christ Being Led to the Cross.* **83.** *The Crucifixion.* **84.** *The Lamentation for Christ.* **85.** *The Myrrh-Bearing Women.* **86.** *The Resurrection.*

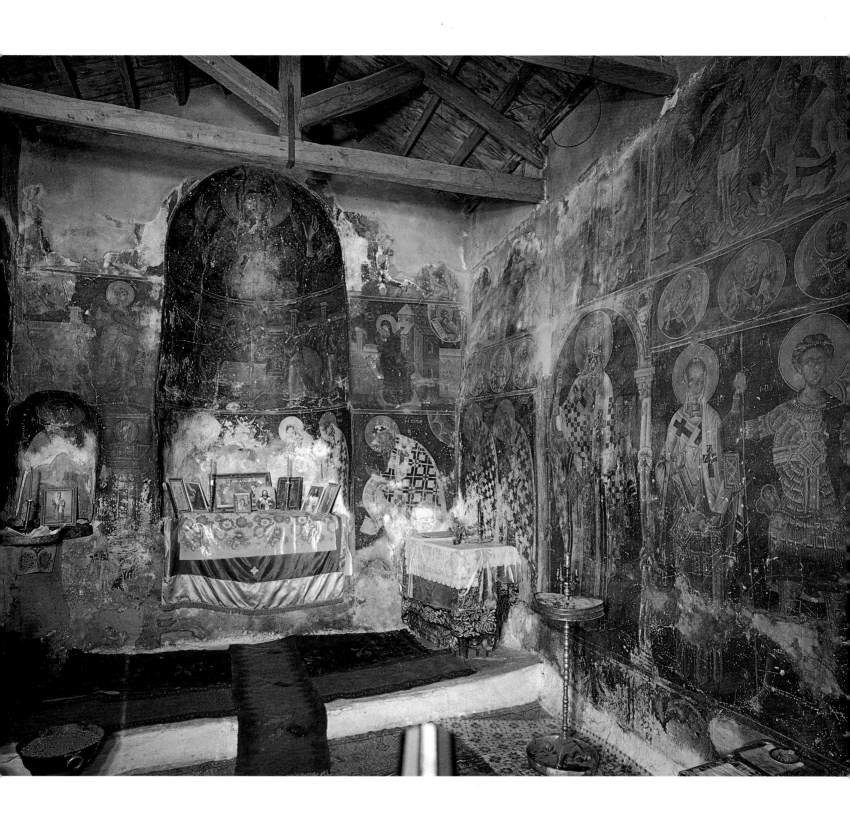

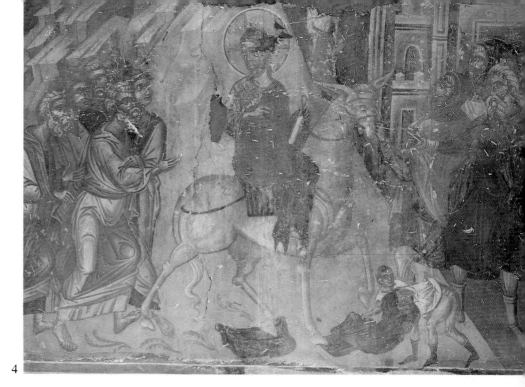

4

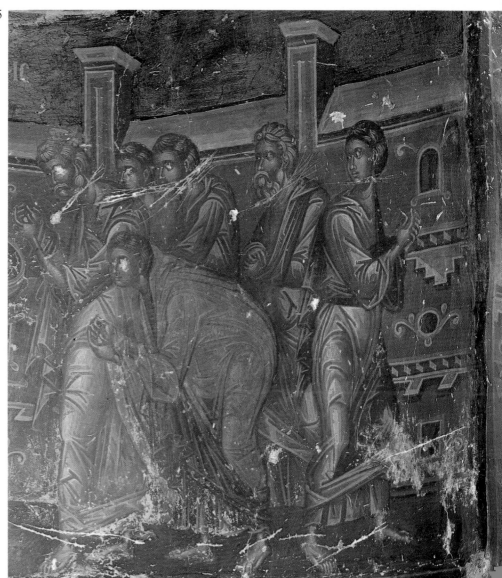

5

3. *Hagios Athanasios tou Mouzaki, sanctuary. The Virgin of the Annunciation.*

4. *Hagios Athanasios tou Mouzaki, south wall. The Entry into Jerusalem.*

5. *Hagios Athanasios tou Mouzaki, sanctuary. The Communion of the Apostles (south part).*

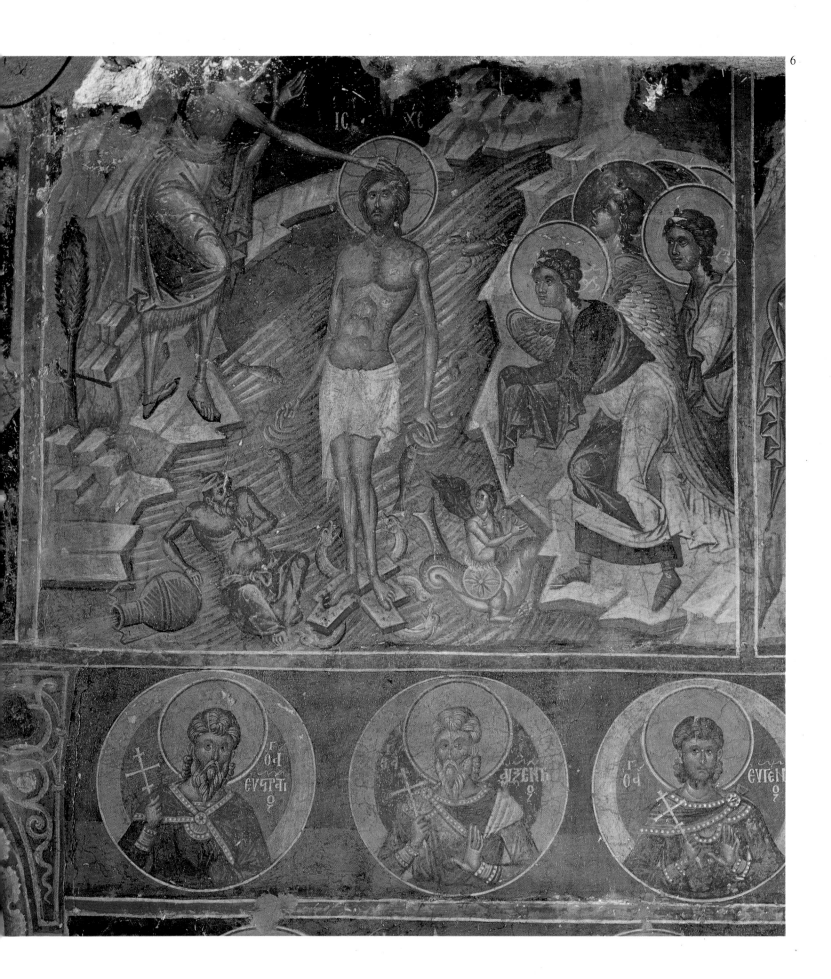

6

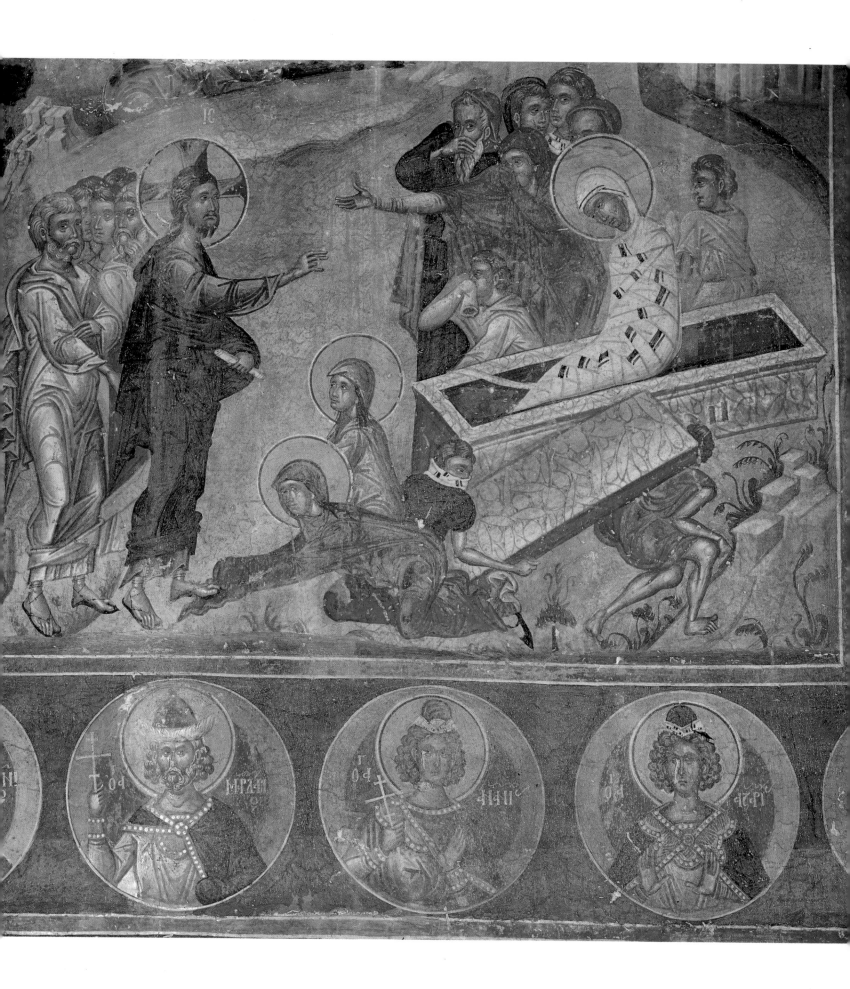

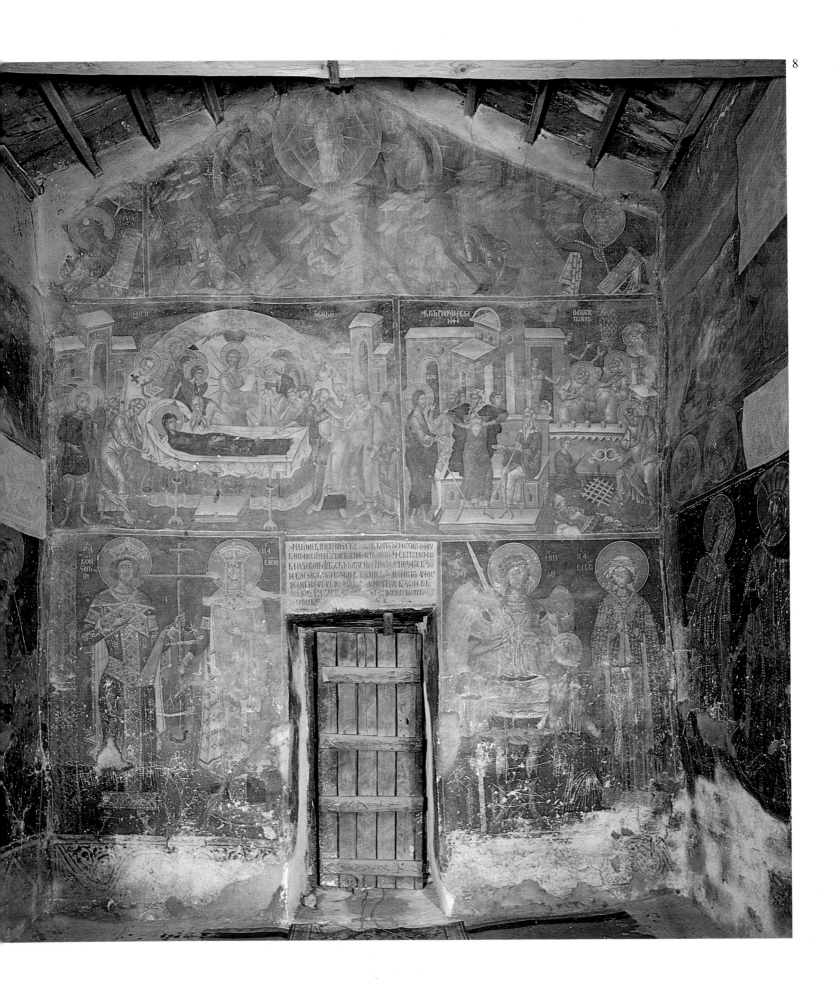

6. *Hagios Athanasios tou Mouzaki, south wall. The Baptism and the Sts. Eustratios, Auxentios and Eugenios.*

7. *Hagios Athanasios tou Mouzaki, south wall. The Raising of Lazarus and the Sts. Mardarios, Ananias and Azarias.*

8. *Hagios Athanasios tou Mouzaki. West wall with the founder's inscription.*

9. *Hagios Athanasios tou Mouzaki, west wall. The Dormition of the Virgin (see Fig. 8).*

9

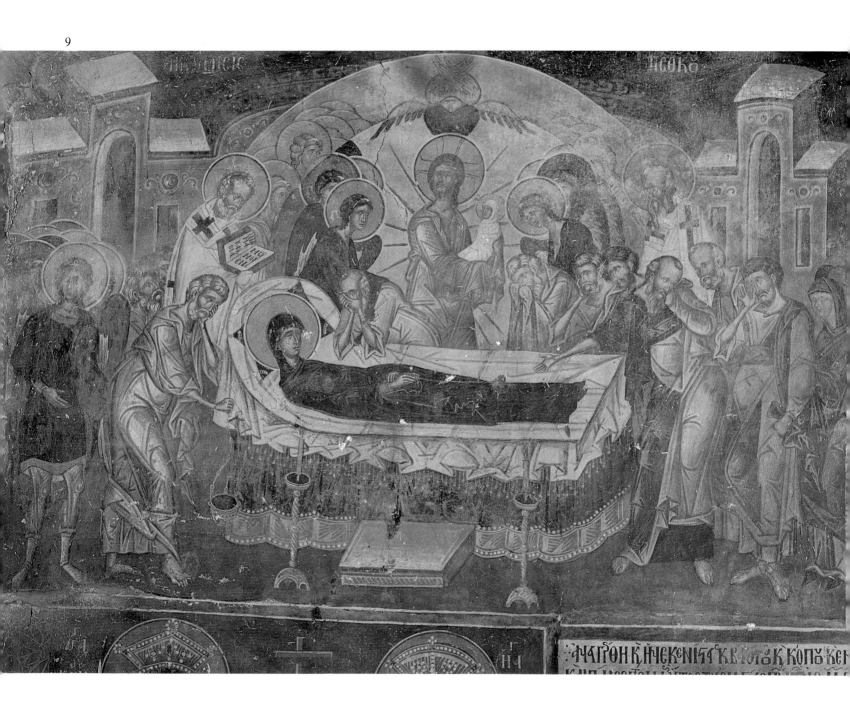

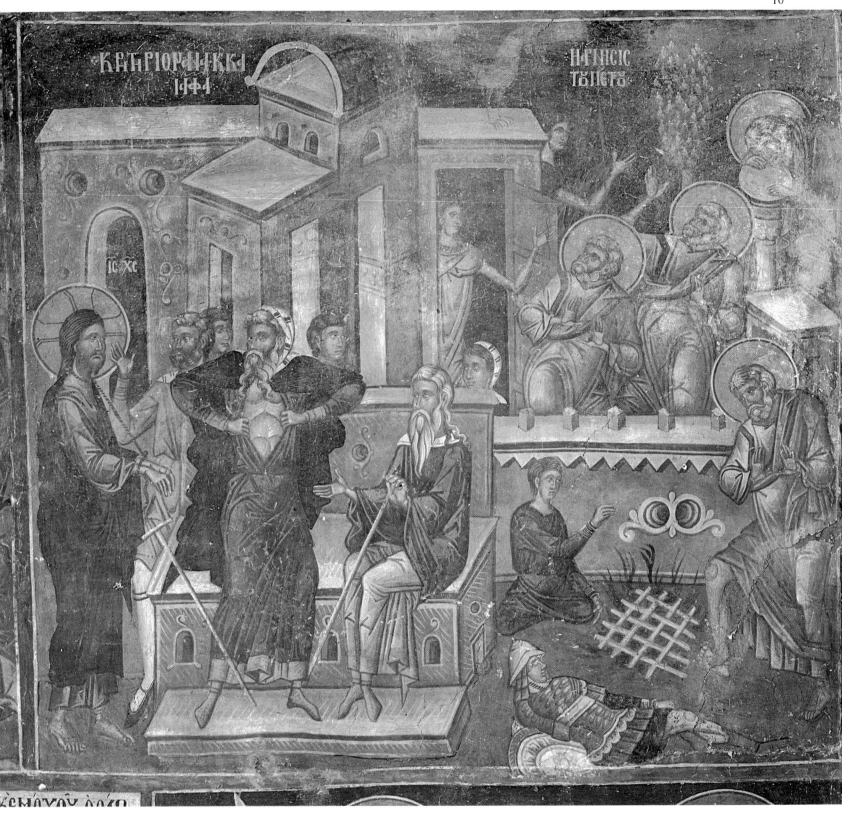

10. *Hagios Athanasios tou Mouzaki, west wall. Christ before Annas and Caiaphas and Peter's Denial (see Fig. 8).*

11. *Hagios Athanasios tou Mouzaki, north wall. Christ Being Led to the Cross (Helkomenos).*

11

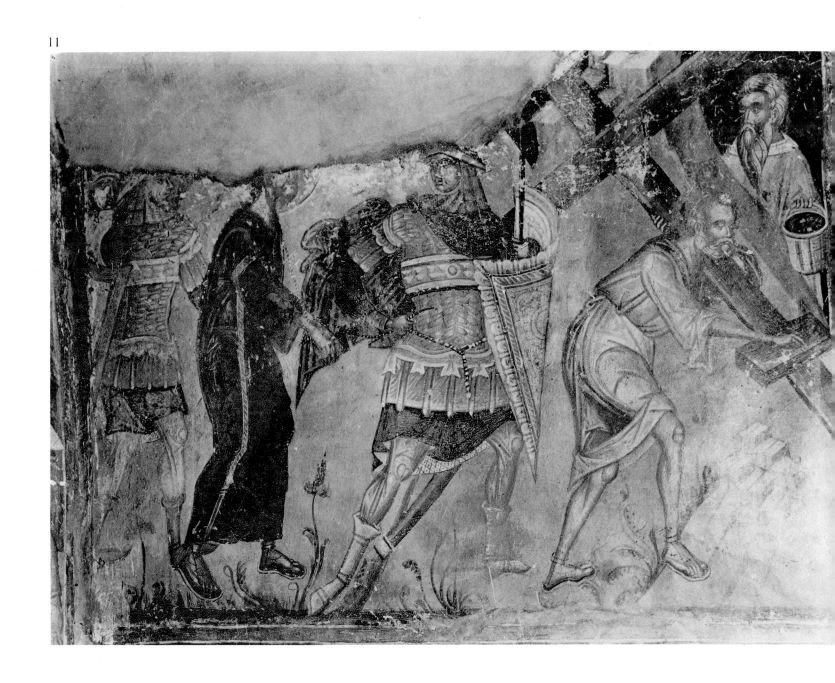

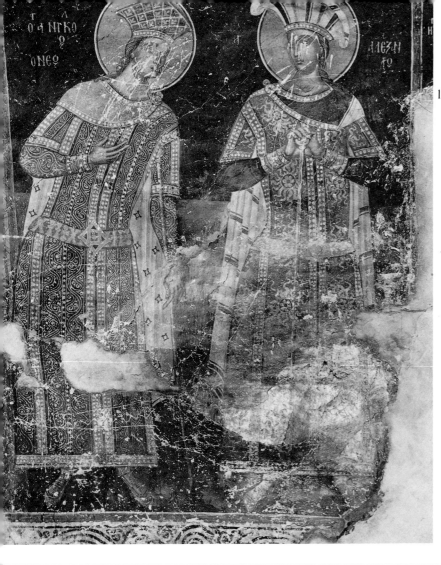

12

12. *Hagios Athanasios tou Mouzaki, north wall. The local Saints Nicholas the Younger and Alexander of Pydna.*

13. *Hagios Athanasios tou Mouzaki, north wall. The Deesis (part).*

14. *Hagios Athanasios tou Mouzaki, south wall. The two Saints Theodoroi and Christ.*

13

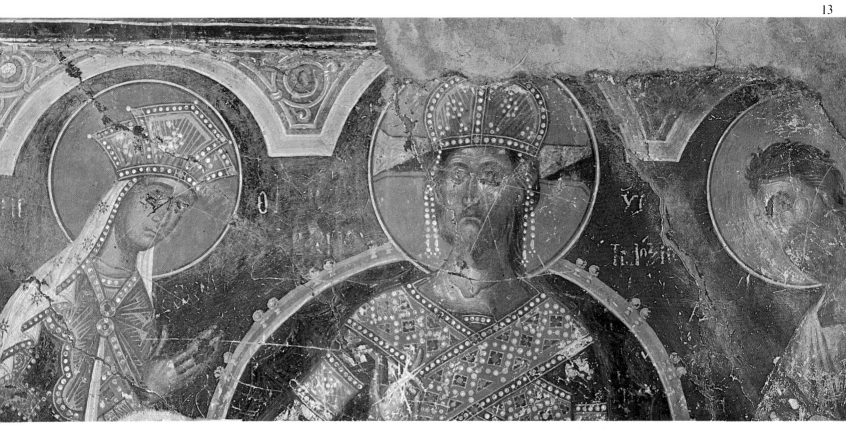

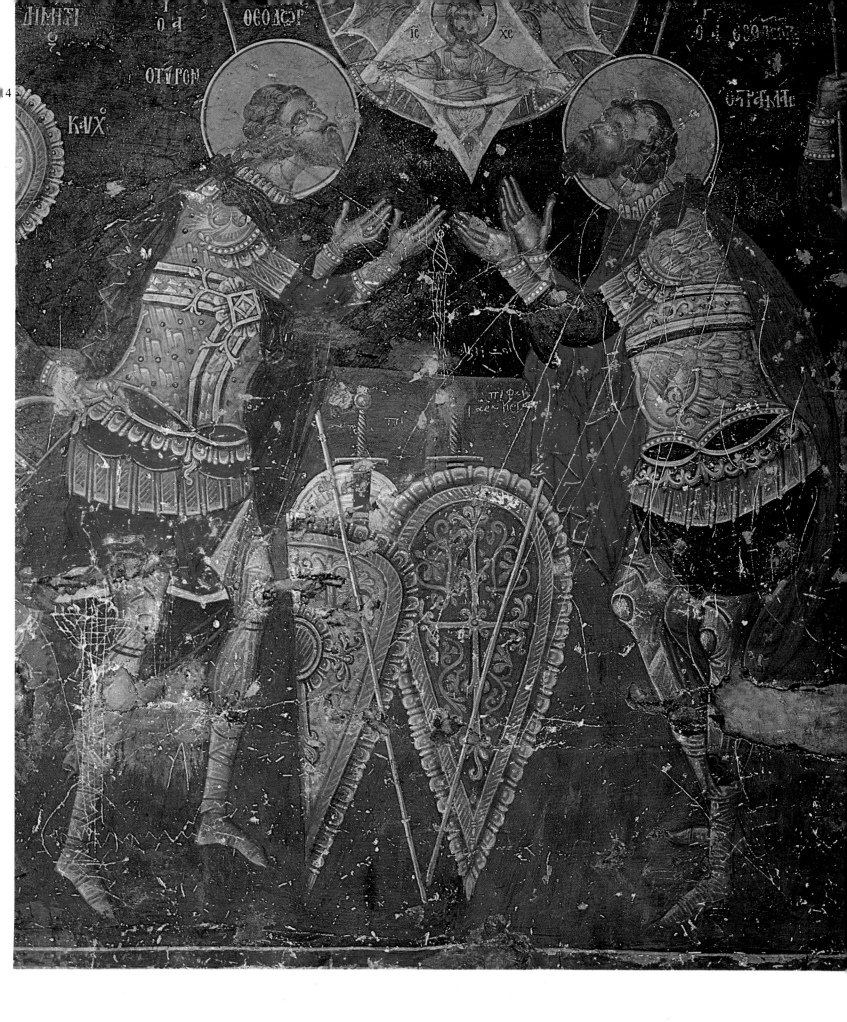

ΔΗΜΗΤ[ΡΙΟ]Σ

Ο Α[ΓΙΟΣ] ΘΕΟΔΩΡΟΣ

Ο ΤΥΡΩΝ

ΚΥΧ̅[?]

ΙC XC

Ο Α[ΓΙΟΣ] ΘΕΟΔΩΡΟ[Σ] Ο CΤΡΑΤΗΛ[ΑΤΗΣ]